MW00855701

KYRGYZSTAN

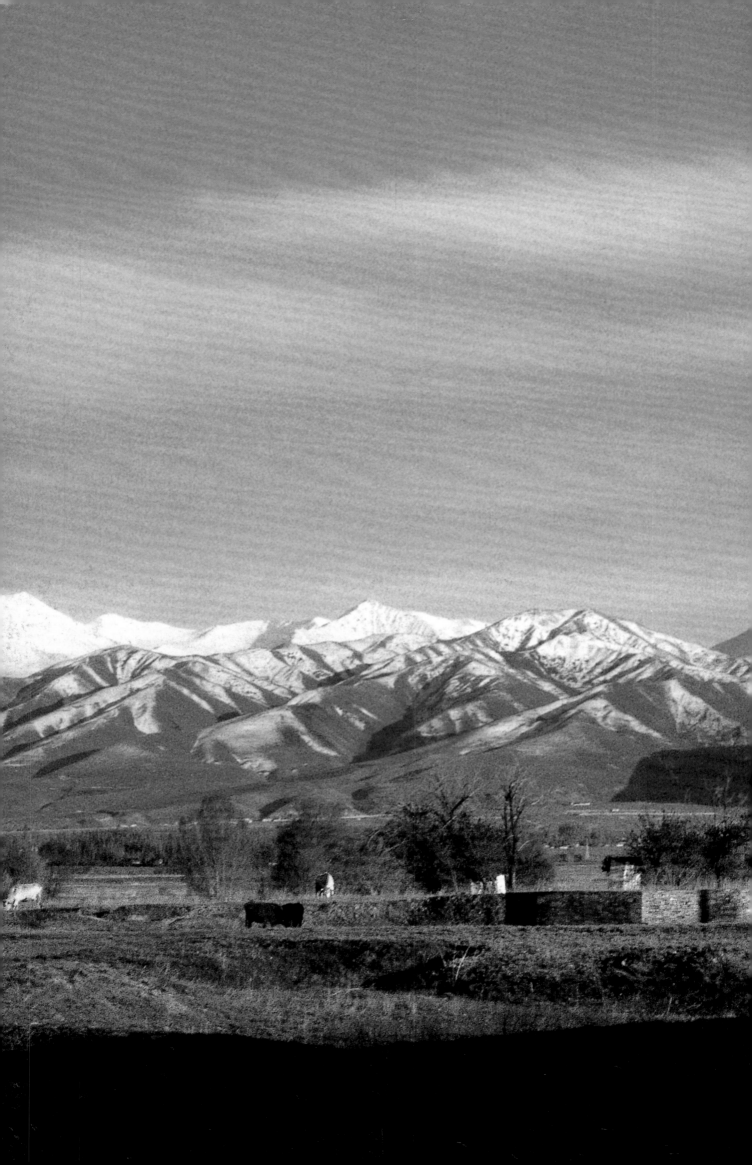

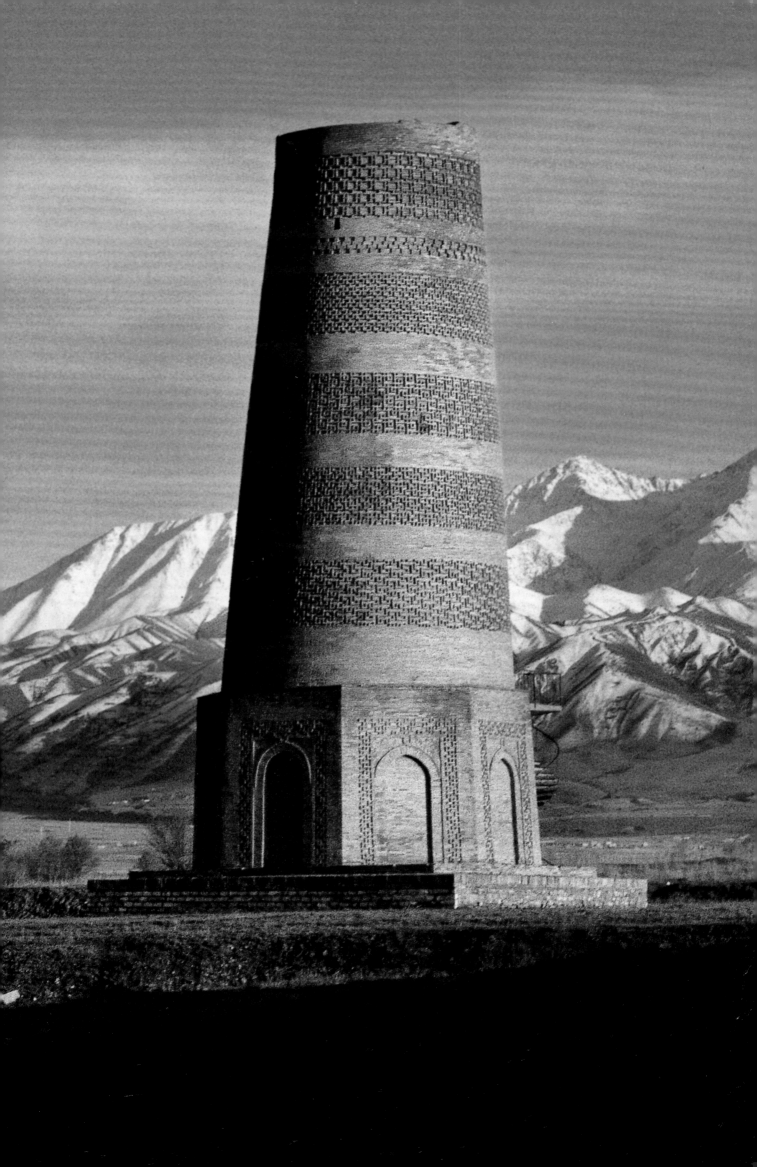

Isabel and Jimmy
to Rolando

This book is based on the transcript of interviews with Klavdiya Antipina by Philippe Labreveux and Dinara Chochunbaeva. With photographs by Rolando Paiva and watercolour illustrations by Termibek Musakeev.
Translated and edited by Stephanie Bunn. Prefaces by Damira Sartbaeva, Stephanie Bunn and Bibira Akmoldoyeva. Foreword by Mateo Paiva. Produced by Mateo Paiva.
Note: Support of this book will go towards a Kyrgyz and Russian edition for circulation in Central Asia.

KYRGYZSTAN

Photographs by Rolando Paiva
Watercolours by Temirbek Musakeev
Text by Klavdiya Antipina

Editor
Paola Gribaudo

Design
Marcello Francone

Editorial Coordination
Marzia Branca

Copy Editing
Emanuela Di Lallo

Layout
Antonio Carminati

Translation
Stephanie Bunn

First published in Italy in 2006 by
Skira Editore S.p.A.
Palazzo Casati Stampa
via Torino 61
20123 Milano
Italy
www.skira.net

Printed and bound in Italy. First edition

ISBN-13: 978-88-8491-970-0
ISBN-10: 88-8491-970-3

Distributed in North America by Rizzoli
International Publications, Inc., 300 Park Avenue
South, New York, NY 10010.
Distributed elsewhere in the world by Thames and
Hudson Ltd., 181a High Holborn, London WC1V
7QX, United Kingdom.

Page 8
Old-style Kyrgyz embroidered felt
kalpak (*sayma kalpak*)
Northern Kyrgyzstan, early twentieth century

Page 10
Man wearing felt *kementai* or *chepken* of quilted felt,
white felt *kalpak* edged in black velvet and *ötük*
(boots)
Southern and northern Kyrgyzstan style, end of the
nineteenth or beginning of the twentieth century

Page 14
Woman wearing northern-style *beldemchi* (warm
winter overskirt edged in fur, open at the front)
Northern Kyrgyzstan, early twentieth century

Contents

9 Foreword
 Mateo Paiva

11 The Ethnographic Heritage of Klavdiya Antipina
 Bibira Akmoldoeva

15 Introduction
 Stephanie Bunn and Damira Sartbaeva

21 Traditional Kyrgyz Costume
 Klavdiya Antipina
 translated and edited by Stephanie Bunn

183 Glossary of General Terms

184 Glossary of Clothing Terms

186 Bibliography

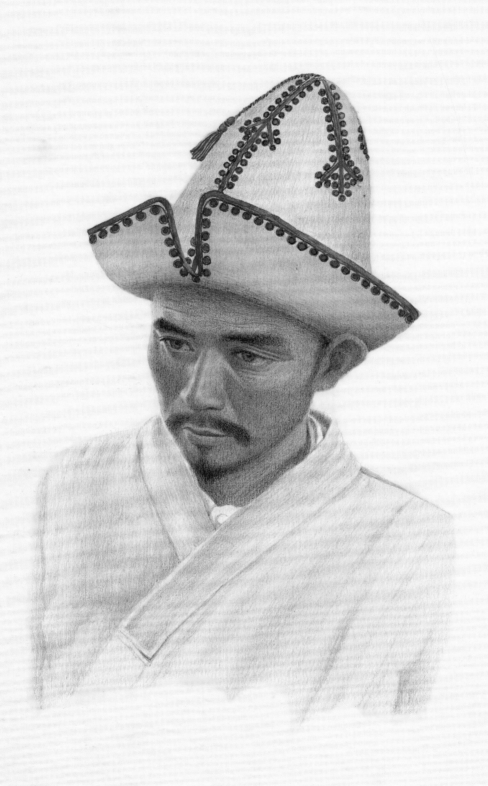

Foreword

Mateo Paiva

I undertook to finish this book as a promise that my sister Luna and I made to our father, Rolando. I want to dedicate this book to his memory and acknowledge the immense debt to each of the persons who made this project a reality.

Philippe Labreveux, my father's friend who started this impossible task and let me finish it.

Bibira Akmoldoeva, for letting us interrupt her work for hours on end, working nights to get us the translated text, for access to Klavdiya Antipina's work, and most importantly, for her enthusiasm to seeing this work through.

Stephanie Bunn, for her unconditional support and diligence, that brought Antipina's work to a larger audience.

Dinara Chochunbaeva, for her friendship and insight into everything about the story before, and most importantly, for her influence to get things moving when they stalled.

Temirbek Musakeev, for his faithful collaboration and allowing us to use his work.

Damira Sartbaeva, for her insight into Kyrgyz culture and Antipina's work.

Roza Otunbayeva, for taking time from her busy schedule to meet us to tell Klavdiya Antipina's story, and for her support in the book.

Aida Alymova, for giving us all the help to enter the country and into the Museum, so that in her absence, everything would run smoothly.

Akylai Sharshenalieva, for her help in accessing the Museum's archives, and bringing us to John Sommer's book.

Daniar Bolotbaev, for being a translator, a driver, a friend and a great insight into Kyrgyzstan. Without him, the trip would have been all work and no play.

Roza Sadyrbekova, for guiding my father through his trip in Kyrgyzstan.

Teresa Anchorena, for her restlessness on all things great and small to make things happen.

Paola Gribaudo, without whom this book would not have been realized. She overviewed every step of the production and always pushed me to make it better.

Justin Lee, for being a good friend who always rises to the occasion.

Svetlana Ischenko and her daughter, Vicky for their resourcefulness on our behalf.

Bernard Dupaigne, for his knowledge and interest.

Nuran Niyazaliev, for his enthusiasm and making the administrative side of all things easier.

And Lily Ling Lim, for sharing this adventure with me.

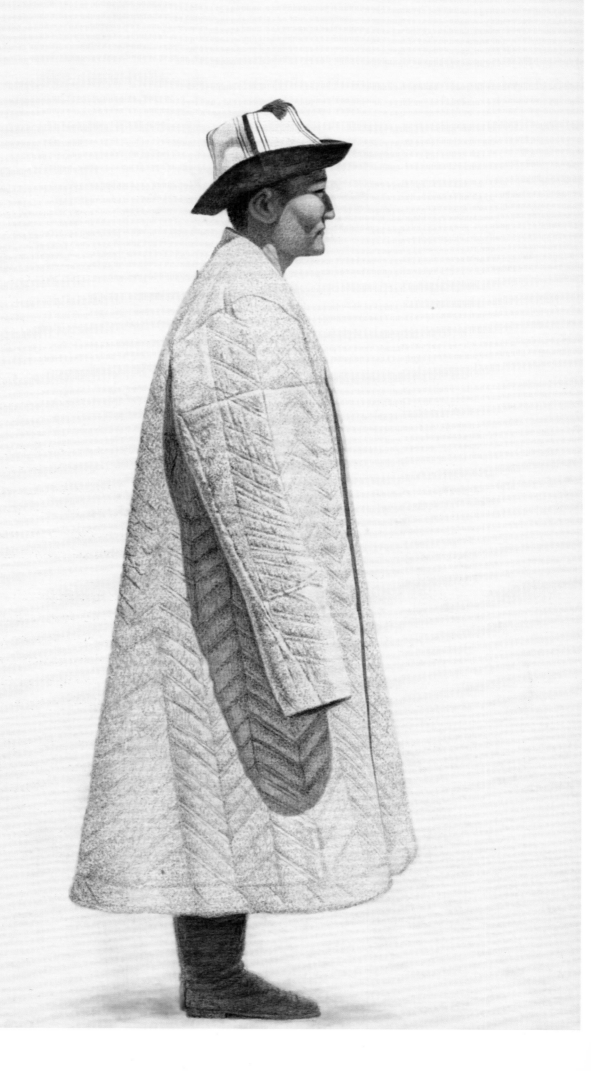

The Ethnographic Heritage
of Klavdiya Antipina

Bibira Akmoldoeva

Klavdiya Ivanovna Antipina was born on 5 May 1904. In 1932, she graduated from Moscow State University, Faculty of Anthropology. She was a student of several outstanding scientists who became legends of Soviet ethnography, including Nikolay Cheboksarov. In 1937, a tragic year for the inhabitants of the USSR, she was expelled from Moscow to Frunze (the former name of the capital of the Kyrgyz Republic) as the wife of "an enemy of the people". For a long time she lacked the opportunity to work in her field, which is why her career started rather late, at the age of forty, and only commenced thanks to a fortuitous encounter with Nikolay Cheboksarov, who arrived on a scientific mission to Frunze.

After this meeting, she began working in the Historical Museum of KSSR. Her special anthropological training allowed her to accomplish noteworthy things in this museum, such as gathering, describing and systematizing the collections of Kyrgyz material culture.

As a participant in the 1953–55 Kyrgyz Complex Archaeological and Ethnographical Expedition, Antipina collected unique ethnographic material that she later used for writing her dissertation and the monograph *Special Features of Material Culture and Applied Art of the South Kyrgyz*. She is also one of the authors of the fifth volume by the Kyrgyz Complex Archaeological and Ethnographical Expedition, *Popular Applied Decorative Art of the Kyrgyz*. Unfortunately, these books were published in small numbers and are not yet well known abroad.

Klavdiya is called the "baybiche" (grandmother) of Kyrgyz ethnography. She shared her ideas generously, and a number of young scientists are very grateful to have met her. I was among them. In 1972, I became acquainted with Klavdiya, and this meeting truly influenced my decision to become an ethnographer. Klavdiya Antipina became my tutor, colleague and friend. Her consultation greatly contributed to the writing of my first scientific work, *Women and Islam*, in 1975, and subsequently my thesis on Kyrgyz ornamental felt patterns.

Klavdiya also took part in drawing up the itinerary of my first field studies in 1975–77, 1979–82 and 1983–87. When I chose the topic for my doctoral dissertation, *Horse-Breeding and its Place in the System of Kyrgyz Traditional Stock-Breeding*, in 1979, Klavdiya was very interested in it and discussed several areas of my research with me. She longed to publish a joint book devoted to horse harnesses. Later, she actively participated in discussions about the creation of a "Horse Museum". Unfortunately, this museum was never realized.

Klavdiya Antipina paid particular attention to folk craftsmen. Many of them spent days and months in her house, and she learnt the details of their traditional culture which

they had "received with their mother's milk". Klavdiya did a great deal for "re-collecting" the people's memories through her communication with masters and through popularizing their art.

Her life was bright and creative. Right to the end, she was full of ideas and plans that would be realized by future generations of researchers. The significance of Klavdiya Ivanovna Antipina's research for the Kyrgyz people and their culture is priceless. The historical importance of her studies is evident today when foreign researchers, who are not bearers of local knowledge, conduct fundamental studies on the history of the Kyrgyz people.

Klavdiya made her mark on Kyrgyz ethnography. She managed not just to review, but also to see, evaluate, collect and describe the special features of Kyrgyz native culture, and thus passed on to posterity these invaluable samples of unique tradition, which are also a part of world culture. Being a professional researcher-ethnographer, she studied the material culture of the Kyrgyz throughout her life. Thanks to her efforts, we have descriptions of different types of embroideries and weavings, carpets and rugs (pile, non-pile, felt), ornamental patterns and their colour spectrums, which were almost, or already, lost. She did not just describe and preserve the knowledge of many artisan processes of Kyrgyz masters, but also participated in replenishing the collections of the State Historical Museum with her fieldwork.

She collected the ethnographic material for this monograph on traditional Kyrgyz costume during an extended period. Her personal archives include thousands of photos, drawings and notes. Her photos are truly exceptional, because in them are not only unique items of material culture from the past, but also the faces of Kyrgyz people of the period. These photos were taken quite professionally and provide an opportunity to re-create in detail specific traditional costumes and other items. Their only "weak point" is that it is impossible to touch the textiles used in the clothing, and to see the actual colours. But the wonderful field notes left by Antipina more than make up for this. However, even these notes can be interpreted incorrectly if read by a non-specialist. This was the case during work on *Traditional Kyrgyz Costume*. As an expert in Kyrgyz traditional weaving and ethnic clothing, she painstakingly sought to reconstruct all details. While she was working on this album, she changed several painters because she was not satisfied with their work. She collaborated with the talented artist Bolot Karakeev, who made numerous, impeccably-drawn illustrations. However, the ethnographer Antipina was not happy with his work, because she had been looking for details in the cut, anthropological type and ethnic specificity. She then began collaborating with Temirbek Musakeev, an artist and specialist in animated cartoons. This creative union was very productive and sped up the album preparation. Many coloured illustrations were made, thereby enlivening the black-and-white photos. The most attractive of these were included in the album *Traditional Kyrgyz Costume*, which was given to a publishing house, but disappeared for many years.

The life and activity of Antipina were devoted to serving science. The colossal archive of material that she left clearly shows her highest professional and scientific achievement. The huge amount of photos, pictures, notes and manuscripts attests to her professional and scientific ethic. Klavdiya Antipina never depreciated the achievements of her colleagues, and always consulted the works of her predecessors. She was a scientific adviser for a number of historical films and theatrical performances, where traditional life of the Kyrgyz had to be precisely represented.

The invaluable scientific archive of Antipina, which has been handed over to the School of Future Elite, is available to young scientists who research the Kyrgyz people. Her scientific heritage is currently being systematized. Part of her work has been translated into English and included as separate sections in two books published in the United States (B. Akmoldoeva, J. Sommer, K. Antipina, *Ethnographer of the Kyrgyz*; J. Sommer, *The Kyrgyz and their Reed Screens*). These books have attracted huge interest in the Kyrgyz. Thanks to the work of Antipina and to these books about her, the Kyrgyz are recognized around the world. People are impressed that Kyrgyz *chiy* (decorative sedge matting) is a unique art. Kyrgyz embroideries have both special and original patterns and colour spectrums. The Kyrgyz people have managed to save their ethnic uniqueness and cultural traditions, which are easy to identify from all other cultures. In turn, the Kyrgyz are a part of a broader ethnic community, the peoples of Central Asia, who have had a common historical fate, which is reflected in the similarity of their material and spiritual culture.

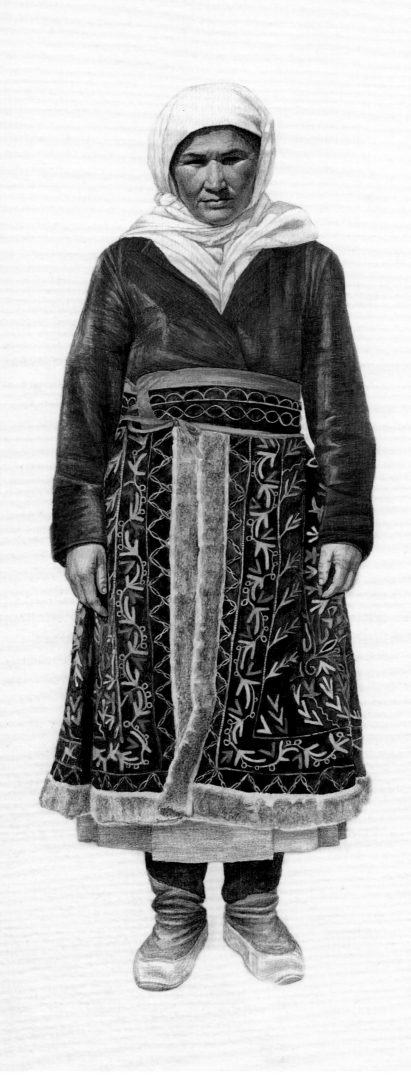

Introduction

Stephanie Bunn and Damira Sartbaeva

This book is unique on two counts. Firstly, never before has an account of the costumes of the nomadic peoples of Central Asia been published in America or western European literature. Secondly, it features the work of the eminent Russian anthropologist, Klavdiya Ivanovna Antipina, who died in 1996 at the age of 92 years. Klavdiya Antipina was one of only a small number of Soviet anthropologists who devoted their lives to research among the nomadic Kyrgyz, and she herself lived most of her life in Kyrgyzstan, having moved there in 1937 with her young son. Her work particularly focused on the material culture of the southern Kyrgyz. The costumes and documentation in this volume represent a substantial body of research collected by Klavdiya Ivanovna during the middle years of her life in Kyrgyzstan, and have never been published before.

Kyrgyzstan is a small Central Asian republic and was one of the five Central Asian States of the former Soviet Union. The country is almost entirely mountainous, lying within the Tien Shan mountain range, on the borders between China and the CIS About 85% of the land is over 1,500 metres above sea level.

The Kyrgyz were traditionally a nomadic people, travelling each year with their herds of sheep, cattle and horses from high mountain summer pastures (*jailo'o*) to the lowland valley winter pastures (*kyshto'o*) practising a form of animal husbandry sometimes known as "vertical pastoralism". The territorial boundaries of Kyrgyzstan neither accurately reflect the limits of the land Kyrgyz people now occupy, nor define its ethnic composition. When the Soviet Union formed Kirghizia in the 1920s with the intention of delineating Kyrgyz territory, the Russians of the time lacked understanding of the ethnic composition of the area, and also confused Kyrgyz and Kazakh groups. The result was that the original Kirghizia contained a large proportion of Kazakhs. The Kyrgyz SSR was finally formed in 1936, and a recent census shows that the Kyrgyz still only make up 40% of the population—the remainder being Russians, Germans, Ukrainians, Kazakhs, Tadjiks, Uyghurs, Dougans and others. There are also many other groups of Kyrgyz living elsewhere in Central Asia, from Xinjiang to Tadjikistan to Tuva. These factors highlight some of the problems that western, settled academics face when trying to understand land and ethnicity of an essentially nomadic society.

The Russians first began to seriously increase their influence in west Central Asia, or western "Turkestan", during the latter half of the nineteenth century as a part of the jostle for power in Asia between Russia, Great Britain and China. The area corresponding to modern-day Kyrgyzstan was first conquered from the south by the Khokand Khanate earlier that century. The subsequent resistance of the northern Kyrgyz resulted in increasing Russian influence in the region, as the Russians took on the role of "protectors" to the north-

ern Kyrgyz "tribes" and capitalized on the unsettled situation in the region from the 1850s onwards. By the end of the 1870s, the land had been declared the Tsar's "property".

The effect of the Khokand Khanate's and the Russian Empire's attempts to command influence and allegiance in the region has left a mark still in evidence today—the southern Kyrgyz of Pamir Alay having greater links with the neighbouring Uzbeks and Tadjiks, whereas the northern Tien Shan Kyrgyz have greater links with the northern neighbours, including Russians, Kazakhs and peoples from the Altai, from whence the Kyrgyz are reputed to have originated. These different ethno-cultural contacts were further consolidated at the turn of the last century as different administrative boundaries were set in place by the Russians. The region where the northern and western Kyrgyz lived became a part of Semi-Rechye (in Russian) or Jeti-Su'u (in Kyrgyz)—the Seven Rivers region which also included areas inhabited by nomadic Kazakhs and more concentrated populations of Russian settlers. The southern Kyrgyz were included in the Ferghana administrative region which was also inhabited by Uzbeks and Tadjiks.

The diverse influences and allegiances are reflected in the different styles of Kyrgyz dress that developed during this period. Klavdiya Antipina's material goes some considerable way to illustrate those differences and the dynamics of the process of changing in traditional dress at the turn of the century.

The Kyrgyz traditional way of life as nomadic pastoralists was intimately connected with their material culture—the clothes they wore, the homes they lived in and the artifacts they made. Travelling to the *jailo'o* in the high mountains in summer and back down to the winter *kyshto'o*, each Kyrgyz group had its own migration route and pastureland according to "tribal" allegiances. The allegiance was likewise reflected in dress style.

There are a number of Kyrgyz "tribes", or *chong uru'u* (large families) as they are known in Kyrgyz. The exact figure is difficult to agree upon. All Kyrgyz people take great interest in their family history and ancestry and will know seven generations of ancestors back through their fathers' line, as well as their own *chong uru'u*. This is known as *jeti-ata*, or seven fathers. Many *chong uru'u* are named after animals traditionally hunted by the Kyrgyz, such as Bugu, reindeer, or Sary Bagysh, yellow elk, though some indicate other features of significance, such as connections with other families or nationalities, as is the case, for instance, with Mongoldor (suggesting Mongolian links). All *chong uru'u* are traditionally linked with specific areas of pastureland and families would pasture their animals on these lands, moving from one to another, according to season, and living in felt frame tents, known as yurts, or *boz üy* in Kyrgyz.

The yurt is the traditional nomadic dwelling in Central Asia and has been used for millennia. The first existing reference to the nomadic felt-covered dwelling in Central Asia was made by Herodotus in his *Histories* (450 BC). Tombs lined with felt from that era have been excavated in the Pazyryk regions of the Altai mountains by Soviet archaeologists. The Turkic form of yurt, as used by the Kyrgyz has a domed roof created by curved roof poles and a circular trellis walled frame. The whole is covered with felt.

The interior of the Kyrgyz yurt is traditionally very highly decorated and its beauty reflects upon the variety of textile skills of the woman of the house. It is also a symbolic space, where the position of every item follows a time-honoured design of interior domestic order. Nearly all artifacts—tent decorations, furnishings and felt carpets—were traditionally made by women. The more beautifully decorated the tent, the prouder a man could be of his wife. Even today, craftsmanship and domestic skills are highly complemented in a woman, although many textile skills such as embroidery and band weaving are now quite rarely practised, especially by the young. Traditionally, the interior decoration of the yurt and its furnishings, and the quality and design of hand-made clothing were some of the key indicators of position, cultural grouping and status.

Because the Kyrgyz kept animals, their main textiles were made from animal fibres and skins—wool, woven cloth and leather. Because they were nomadic, their possessions had to be limited to what could be carried. The effect of this was that the emphasis was upon quality rather than quantity and each item was made to an extremely high standard. Hand-made artifacts such as textiles and cloths were also rarely traded, as was the case with raw materials and animals: they were rather made for use or gifts, with the result that the making process was not in any way alienating, but rather enabled the maker to embody her skill and care for the task at hand—or the recipient of the gift. All this has helped lead to the development of a textile tradition of uniqueness, quality and skill.

Russian academics began to research about the Kyrgyz as long ago as the eighteenth century, but it was really in the nineteenth century that significant research began, with the work of Bichurin, Levshin, Valikhanov, Radlov and Aristov. The earliest field drawings were made by Kosharov in the 1860s from his expedition around Lake Issyk-kul with the scholar A. P. Semenov-Tienshanov. At the turn of the century, the Russian ethnographer and artist S. M. Dudin realized a unique collection of photographs of the southern Kyrgyz from Pamir and Talas. This is now housed in the State Ethnographic Museum at St. Petersburg. Many of these photographs provided the inspiration for the paintings in this volume. One of the first Soviet ethnographers, Fyelstrup, also made a collection of photographs now in the State Ethnographic Museum from his expedition in 1924–25 around the area then known as Pri-Issyk-kul, now known as Tang.

Most Soviet ethnographic research took the form of large multidisciplinary expeditions with archaeologists, historians, ethnographers, geographers and linguists all travelling and working together; some scholars worked within several disciplines themselves. Among the most important Soviet researchers of Kyrgyzstan were Barthhold, a historian, and Bernshtam, an archaeologist and ethnographer who led the Pamir-Ferghana archaeological and ethnographical expedition of 1950–51. This important expedition was then supplemented by the work of the Kyrgyz Complex Archaeological and Ethnographical Expedition of 1953–55. These two expeditions really formed the foundations for much of the subsequent historical and ethnographical research in Kyrgyzstan: Klavdiya Antipina was one of the key ethnographers involved.

This multidisciplinary approach to field research has given Soviet ethnography quite a different flavour to European or American anthropology. The influence of the social evolutionary ideas of Marx has meant that there is a strong tendency to fit everything into a progressive social developmental scale. There is a great Soviet passion to discover the origins of Kyrgyz "ethnogenesis", which is matched by the Kyrgyz own great interest in their family history and ancestry. At the same time there is a wealth of tremendously rich, detailed ethnographic material recorded, reflecting the desire to map out across the region the different cultural characteristics of each Kyrgyz ethnic group. This is very much what Klavdiya Antipina set out to do in terms of the regional and ethnic differences in Kyrgyz clothing. Local differences in Kyrgyz traditional costume were seen as an important illustration of both the ethnic and cultural relationships of different families, and also as a fundamental instrument to shed light on issues of ethnic origins—a long-standing feature of the Soviet academic debate.

While contemporary western research may be somewhat critical of this approach, feeling there is a danger of "reification", where "people, like languages, are reduced to their classification in pseudo-scientific terms" (Lindisfarne-Tapper and Ingham 1997), at the same time, Kyrgyz people themselves are very interested in how their different styles of clothing over the past 150 years can reveal historical and ethnic relationships and shed light upon the complex nature of Kyrgyz identity.

Ultimately, Kyrgyz traditional costume is a synthesis of Kyrgyz material and spiritual culture. It combines the uniqueness of each person's original contribution with a more general cultural meaning, and skills in art and technology. Traditional costume is both a thing and a sign. It arises from lived necessity and belief, and it also represents that way of life and belief. It both indicates and embodies status, ethnicity, religion, economic standing, age, sex and so on.

Among nomadic people, the visual significance of material things is especially important. From afar, in the mountains, or open landscape, special features of nomadic clothing indicated the essential external characteristics of a person before verbal contact. This was a fact of no mean importance in the martial nomadic way of life. Women's clothing, especially different ways of wearing and decorating headwear, particularly stood out and in Kyrgyz traditional costume, the symbolism attached to headwear was very important. The material presented in this book, especially in combination with the immense body of information already in existence about Kyrgyz epic poetry—most particularly the ongoing, still living and sung Kyrgyz epic Manas—could pave the way for new insights into traditional rituals and ceremonies of age and sex. The use of traditional patterns and colour combinations in clothing is also important, and is considered by researchers to indicate status, occupation and membership of specific family groups. These features, for example, distinguished the Alai Kyrgyz from those of Kemin, or the Bugu *chong uru'u* from Kushchu. They emphasize the complexity and varied origins of the Kyrgyz people.

Books' destinies resemble human destinies—unique and sometimes fantastic. Numerous people have been waiting for this book for several decades. This is not only due to its perfectly executed drawings, done by young Kyrgyz artist Temirbek Musakeev, and not only to the fact that it is Kyrgyzstan's first ever systematized collection of national garments, which could serve as a source for further research. First and foremost, it will give a pulse of inspiration to the development and enrichment of the whole culture of the Kyrgyz people, which is now looking to its roots, in search of its ethnic identity.

Rumours of the interesting material Klavdiya Ivanovna had collected on Kyrgyz traditional costume began to circulate in the late 1970s. It was originally intended to have been developed as a part of the planned *Atlas of Central Asian Peoples at the USSR Academy of Science's Ethnography Institute* (during the Soviet period every scholar used to develop a subject that could be adapted as a part of the institutionally collective theme). The aim was that the material collected in the different Republics was to be mapped and provide an opportunity to make a comparative analysis of the different Central Asian people's cultures and to study significant features about each of the different people's ethnic and cultural history. It is not known why Klavdiya Antipina delayed the submission of her work, or why she subsequently did not publish it. Possibly, it is because she felt the objectives of the project to be too academic and the mapping of material culture, including clothing, too formalized. If this was the case, one could say she was ahead of her time—many contemporary anthropologists would be in sympathy with her. Nevertheless, she was very enthusiastic about her work—showing her sketches and pictures to her friends, among whom were artisans, artists, ethnographers, students and just people interested in ethnography. She would spend many hours telling people about the interesting features of style, fabric and decoration of Kyrgyz garments. In this context, it became quite acceptable for people concerned with their own traditional sources to approach Klavdiya Antipina as a person who possessed vast knowledge of Kyrgyz history and lifestyle and invaluable materials collected during numerous field expeditions, and as a person who was a strong advocate of the importance of traditional art. The process of reclaiming ethnic and cultural identity began in this way using traditional or folk art as a means of reflecting upon culture and history.

The 1970s and 1980s witnessed a resurgence of interest in the people's artistic and historical roots in Kyrgyzstan. Much of the more innovative part of the intelligentsia, tired of the limitations imposed by socialist realism, turned to the traditional arts, to epic poetry and to contemplation of traditional themes and motifs for inspiration. Artists, writers, architects and others, after attempting without success to find relevant publications on traditional culture would visit Antipina and were always met with a cordial welcome. This interest in "folk" art was a natural response to the kitsch which swept the local markets and the vulgarized interpretations of Kyrgyz traditional imagery, such as carpets with proletariat chiefs' portraits on them, napkins with the hammer and sickle, ferro-concrete *kalpak* bus shelters and so on. Kyrgyz "national" costume did not escape this reworking,

and re-emerged as cultural ideologists took as their symbol of Kyrgyz national dress the folk theatrical costumes, based on Moscow artists' sketches.

Over the last twenty years, three books stand out as classic works on Kyrgyz material culture. These are: Ryndin's *The Kyrgyz National Pattern*; the Fifth Volume of the Proceedings of the Kyrgyz Complex Archaeological and Ethnographical Expedition of the USSR Academy of Sciences, edited by Ivanov and Antipina; and Klavdiya Antipina's *Peculiarities of Material Culture and Applied Arts of the Southern Kyrgyz*. All are handled as priceless treasures in recent years—though all were purely academic publications with black and white illustrations. Chapter III of Antipina's book is a seminal source of information on Kyrgyz costume and embellishment. The volume we have here is the long planned development of that work, illustrated by images drawn by Temirbek Musakeev from sepia photographs taken by the early Russian travellers to Kyrgyzstan around 1900. Musakeev added colour to the scenes, drawing on both his own knowledge and the guidance of Klavdiya Antipina. This vision, delayed for almost two decades, has finally come to fruition through a series of interviews initiated by UN High Commissioner Philippe Labreveux, with the assistance of the Kyrgyz organization for supporting traditional culture, the "Talent Support Fund". Through these interviews in the last years of her life, Klavdiya Antipina gave the distillation of her accumulated years of knowledge and the final synthesis of her work has come about. Sadly she died, not living to see this fine example of her work in publication.

Now, for the newly sovereign Kyrgyzstan, this book illustrates one of the extraordinary and beautiful aspects of their traditional culture and will become a source for the new nation's interest in its traditional distinctive characteristics. Such a publication gives Kyrgyzstan hope that, despite all its recent hardships, it will find its place in modern world culture and at the same time maintain those traditions which not only enrich its own culture, raising its dignity, but also raise the dignity of all humankind. Each aspect of a traditional culture is an invaluable contribution to the present and future.

Traditional Kyrgyz Costume

Klavdiya Antipina
translated and edited by Stephanie Bunn

While ancient texts contain descriptions of Kyrgyz costume, these are not enough to give us the full picture of its early development. And unfortunately, those examples of traditional Kyrgyz costume still in existence take us back no further than the beginning of the nineteenth century. Kyrgyz clothing has been adapted over the course of history in response to the wide variety of cultural influences the Kyrgyz have been exposed to. What we see now only reflects the style of costume of the nineteenth and twentieth centuries.

The dress of Kyrgyz men and women developed to withstand the rigours of mountain climate and the needs of semi-nomadic pastoralists, moving from lowland winter pastures (*kyshto'o*) to high mountain summer pastures (*jailo'o*) with their herds. Clothes were warm, wide and roomy, suitable for long rides and frequent change of place.

In the first half of the nineteenth century, before the spread of commerce and the import of new fabrics, clothes were all made from locally produced materials. These included furs, leather, felt from wool and hand-made woven cloth. Only cotton and silk, along with jewellery made from silver and semi-precious stones, were bought, or rather, exchanged, with neighbouring peoples. Until the introduction of sewing machines (only from 1911), all clothes were cut out and sewn by hand by women.

Leather, fur and felt were the most commonly used fabrics, and this had probably been the case for centuries. There were sheepskin coats, coats and hats made from fur or felt, trousers, boots and shoes from leather.

The skins and furs came from the shepherds' own domestic animals: Bactrian camels (*tö'ö*), horses (*jylky*), yaks (*topoz*), cows (*uy*) and sheep (*koy*). Clothing made from goatskin was rare. Leather made from camel skin had a particularly high reputation for being robust, watertight and providing good insulation.

Hunting in the mountains also brought in high-quality furs. Ermine or sable were used for decorating certain items of clothing, or sold in the bazaars, along with otter, glutton, fox and wolf fur.

The soft skins of stillborn foals, or even the skin of racing horses, which is very short-haired, lustrous and shiny, were used to make the most highly prized overcoats. And embroidered goat or deerskin, which is very thin and soft, was used for good quality trousers and coats.

Footwear was traditionally made from thick leather. The poorest people had to be content with sandals made from untanned hides. Later, soft leather boots for men and women were bartered in the bazaars for sheep, or brought into the encampments (*ails*) by peddlers.

It was the women who worked tanning the skins and furs, and then colouring them with natural dyes, such as pomegranate skins, roots and berries.

CLOTHING MATERIALS AND FABRICS

Felt

Felt is one of the most ancient materials used in Central Asia. It is very dense, and is impermeable to wind, rain and snow. It provides excellent temperature insulation and is waterproof. Among the Kyrgyz, and many other Central Asian nomadic peoples, it is used for the covers of the portable nomadic home—the yurt (*boz üy*)—as well as for decorative floor coverings, carrying bags, different items of tent furniture and for various horse accoutrements, such as saddle blankets (although the latter are rarely found now). For clothing, felt was traditionally employed to make a special kind of felt overcoat, as well as the shepherd's cape. The felt cape was very large, and provided excellent protection from the cold to shepherds spending their nights in the high mountain pastures watching their flocks. The Kyrgyz felt hat, the *kalpak*, is the only item of felt clothing still worn today.

To make felt, sheep's wool (always shorn from live animals) is beaten, then spread out in the sun on a mat. The "blanket" of wool, from 4 to 6 centimetres thick is sprinkled with hot water, rolled up in the mat, and then pressed and rolled forwards and backwards for a long time in order to shrink and bind the fibres together. The woollen sheet becomes felted after several hours' work.

For yurt covers, thick, relatively coarse felt, made from second grade quality wool suffices. However, for clothing, very fine felt is needed, using wool of high quality, such as wool from the sheep's belly from the autumn shearing. The Kyrgyz used top quality felt for coats, hats or headdresses, shoes and boots.

Wool is also graded according to colour before processing, in order to make felt of a consistent tone. The natural colour of the fleece is used—white, grey, brown and black.

Only decorative floor carpets, saddle covers and bags used coloured felt designs. In this case, the patterns made from dyed wool were either incorporated into the pre-felted wool, according to the required design, and then rolled into felt, or were cut out from sheets of ready made dyed felt and then sewn together into mosaic patterns.

Woven wool

Before the introduction of Uzbek silks and Russian industrial cottons, in the second half of the nineteenth century, all woven fabric used by the Kyrgyz was made in the family home using wool from locally reared animals—camels, sheep and goats.

The animals were shorn twice a year, first in the spring, which gave the best quality wool, and secondly in the autumn. The wool was first of all picked over by hand to clean away impurities—thorns and burrs—and then washed. After dyeing, the wool fibres were carded by hand and prepared for spinning and then the women hand-spun them into thread, using a Kyrgyz drop spindle (*iyik*).

Originally, the wool was used undyed and the different natural colours of the fleece (white, grey, or various shades of brown) were juxtaposed in order to produce a decora-

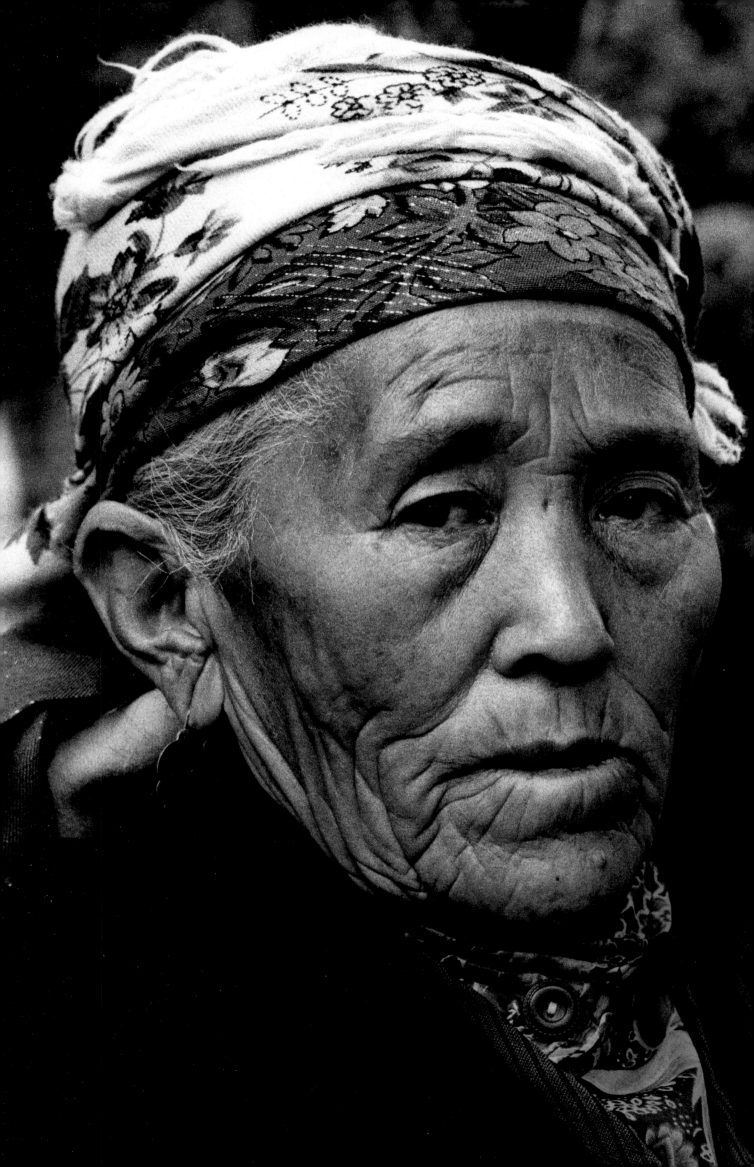

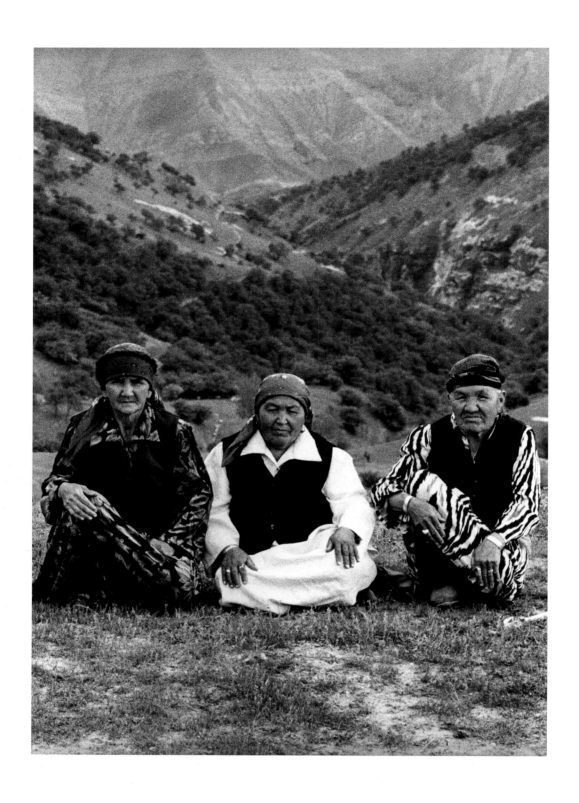

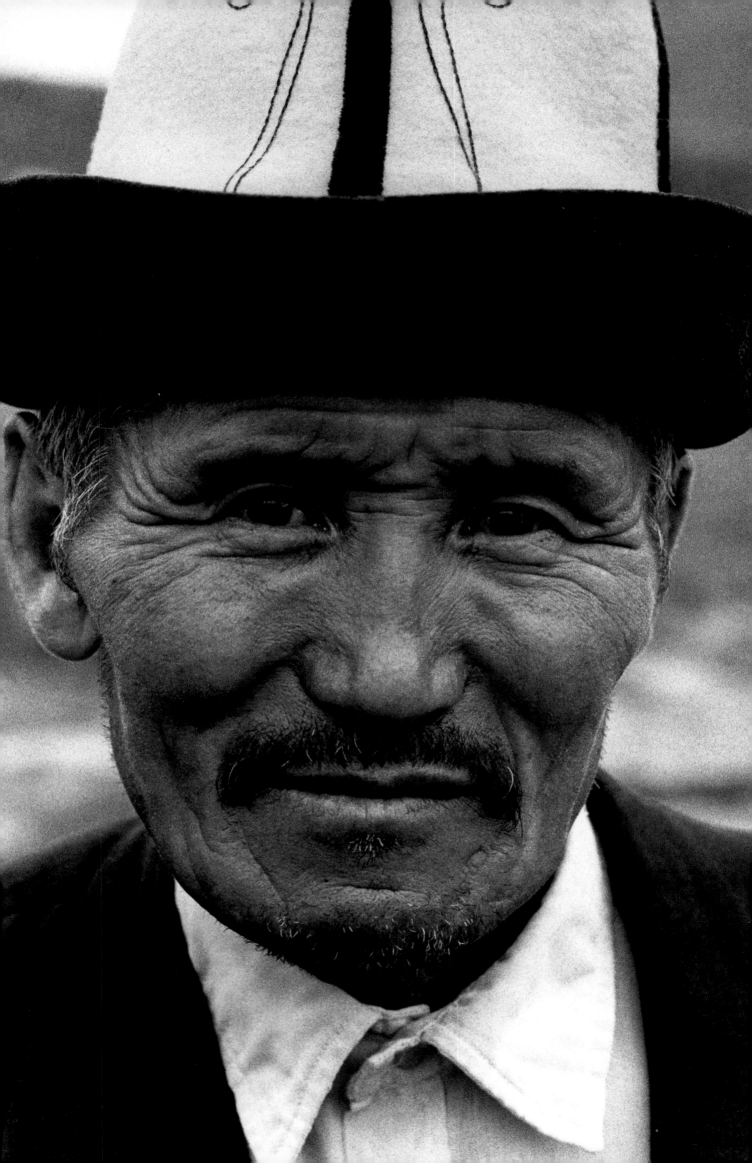

tive effect. Wool fabric was in this way woven into a main background colour, decorated with stripes of various other natural shades, or else woven into patterns, as with the *termé* bands used in yurt decoration.

In the nineteenth century, the craft of weaving was practised in every shepherd's camp. For *termé*, or ground loom weaving, the warp was lain out horizontally above the ground suspended from a tripod, and a simple heddle was used to raise the shed and let the woollen weft be passed through. These techniques did not allow women to make a band wider than 28–35 centimetres. Clothes were therefore made from these strips lined up together and sewn up.

The most sought after fabric for overcoats was woven from camel hair, either natural brown, or white which was even more valued. Exceptionally strong, this fabric (*piazy*) was very highly prized and because of this was reserved for making ceremonial overcoats.

Coats and trousers were made from closely woven brown sheep's wool, which was warm and strong, but rough. The woollen fabric underwent a light felting (or fulling) to tighten up the fibres and make the material impermeable. Such coats for everyday use lasted a long time and provided good protection against the weather.

The long turbans, which men traditionally wore in the past, were also made from woven wool cloth. These turbans, using cloth a metre and a half in length, were made from white sheep's wool or from goat's hair, and served to keep the head warm. From the middle of the nineteenth century, strong cotton cloth, woven locally in the encampments, replaced woollen fabric.

Woven bands made from white sheep's wool were used as belts for men and women. These were two metres long, decorated at one end with stripes, and were wrapped around the waist to hold the coat together.

Finally, in the south-west region of Kyrgyzstan, women wore fine woollen cloth leg-warmers made from a mixture of lamb's and goat's hair. These were warm cloth bands, 25–28 centimetres wide, wrapped around the feet and legs, and worn inside leather or felt boots.

Imported cloth

From the middle, and especially the end, of the nineteenth century, the Kyrgyz began to buy cotton cloth from the bazaars. This cloth was more comfortable and lighter than the sturdy but slightly rough wool cloth woven in the encampments. In this way, cotton began to replace wool for certain items of clothing. Cotton culture had been introduced to the area from the mid-nineteenth century through Russian influence, in imitation of that established on the rich agricultural plains of other areas of Central Asia. The Kyrgyz thus began to weave cotton for clothes for everyday use, such as blouses, under-trousers or coats. The best cotton cloth achieved a passable imitation of the material used in the much sought after *piazy* camel hair coats. These cotton fabrics were made from natural brown cotton fibre, or were dyed with vegetable dyes to imitate the different natural shades of wool, from beige to dark brown.

In the bazaars from the middle of the nineteenth century onwards, one could find cotton cloth and silk from Russia; from eastern Turkestan (now Xinjiang) including Kashgar,

Yarkand, Khotan, the Turfan oasis, Khuldja; from western Turkestan originating from Tashkent, Bukhara and Khiva; and from the Khokand Khanate, including Khokand, Namangan, Andijan, Margelan and Khodjent.

Khokand, which during this period had some 75,000 inhabitants, had the most modern bazaar of the times, with shops built from fired bricks all along the streets that crossed at right angles. Because of the commercial treaties that had been established between Russia and the Central Asian States, Russian merchants, representing the Moscow houses of commerce, had developed a presence in the region. They imported printed cottons, originally from Russian factories, for people to buy in exchange for cotton and silk. After the taking of Khokand Khanate by the Russians in 1876, this commerce intensified and a large quantity of manufactured cotton entered the Kyrgyz markets, especially in the north of the country. Smaller traders, some from Russia, some originally from other regions of Central Asia (Tajiks or Uzbeks) brought in all sorts of merchandise for import, which the peddlers took up to the summer camps (*ails*) of the pastoral nomads. Imported cotton fabric from Russian factories thus replaced the hand-made cottons by the end of the nineteenth century. Now all cotton cloth is industrially made.

Until the forced collectivization of the years 1928–33, the Kyrgyz exchanged livestock, skins and wool for cloth and other Russian articles, or they settled their purchases in cattle once a year. With collectivization, they were obliged to pay cash for purchases, for which they had formerly bartered.

The introduction of new fabrics from cotton and velvets considerably modified traditional Kyrgyz costume, which changed even more when the shepherds began to bring home ready-made clothes and rubber shoes from the bazaar.

The traditional woven thick woollen coats, for use in the high mountains, were widely replaced by double-breasted coats and quilted ones in the fashion of the Uzbeks and Tajiks. These were considerably wide with very long sleeves, made from silk or brocade for the very rich, or in less fine silk and textured cotton. Fur-lined sheepskin coats gave way to double-breasted fur coats.

Women wore the fashion of Bukhara and oriental Turkestan, wrapping themselves in huge hand-printed silk scarves. Silver jewellery decorated with coral, cornelians, mother of pearls or irregular pearls made its appearance, originating from Bukhara and Kashgar. Soon bonnets and embroidered skullcaps, silver belts and men's and women's shoes were imported. In place of their thick leather shoes, men and women adopted high boots of soft leather made by the Uzbek and Turkmen boot makers of the Bukharan Emirate. At the same time, in the bazaars of south-west Kyrgyzstan, Tajiks wool socks knitted in coloured patterns replaced felt legwarmers. After 1876, Russian colonizers settled in ever-increasing numbers in the northern plains and around Lake Issyk-kul, and introduced a great variety of knitting which became much favoured among the Kyrgyz, who knitted from fine sheep's wool for scarves, lingerie, underwear and jumpers.

The entry of the Kyrgyz territory into the regional monetary exchange circuit at the end of the nineteenth century profoundly altered the traditional Kyrgyz way of life, that passed

from an almost self-sufficient economy to an economy oriented towards exchange and selling. Goods were no longer bartered at a camp or village level, but taken to market and sold in order to buy imports. Money began to circulate, including gold pieces, *tilla* or *tanga*, pieces of silver, and above all, paper roubles printed with the head of the Russian tzars.

The owners of the herds were the first to adopt the new fashions. The shepherds in the mountains followed the new trends quite late as they appeared in the most distant summer pastures, alongside money and imported products.

These changes in Kyrgyz clothing and jewellery accelerated at the start of the twentieth century, as a result of the influence of the Russians and Kazakhs in the north, and the Uzbeks and Tajiks in the south. The different influences resulted in different styles of costume in the different regions of Kyrgyzstan. There was a southern and a south-western style in the region bordering on Ferghana Valley, which is the area most open to influence from Uzbeks and Tajiks, and a northern style which was more similar to Kazakh and south Siberian dress. These styles also reflected the ethnic makeup of the Kyrgyz, the Alai Kyrgyz from the south, for example, having long been exposed to different historical experiences from the northern Kyrgyz.

WOMEN'S CLOTHING

Among Kyrgyz nomads the beauty and the dress of the women reflected upon the honour of the group. If a Kyrgyz woman's clothes were remarkably beautiful, intricate and finely embroidered, then this would draw attention to the high status of her family. During nomadizing from pasture to pasture, following the annual round of the animals, women wore their best clothes and the young bride put on her most beautiful headdress, so that her new family could be proud of her. It is recounted by the great Kyrgyz writer Chinghiz Aitmatov, in reminiscing upon the memories of his youth, in his book *Mother Earth*, that "the nomadic journey is a solemn procession that responds to a ritual need and an economic necessity. It provides a unique occasion to show to all one's most beautiful harness, most beautiful finery, the best horses of all, one's skill in arranging bundles on the backs of camels and wrapping up the baggage in carpets" (Page 123).

At a basic level, women's traditional costume wasn't very different from that of the men. It consisted of tunic-blouses and under-trousers, waistcoats, or gilets, and overcoats, belts, shoes and boots. However, Kyrgyz women are also particularly remarked upon for the variety and beauty of their hairstyles and turbans, ornamented and highlighted with jewellery of silver and coral.

Köynök, the tunic-dress
The tunic-dress, *köynök*, was worn both in the day and at night. Its cut, in the form of a tunic, was close to that of the men's shirts. The main differences lay in its greater length (to the ankle), in it fastening on the right side at the neck, and in the fact that women's

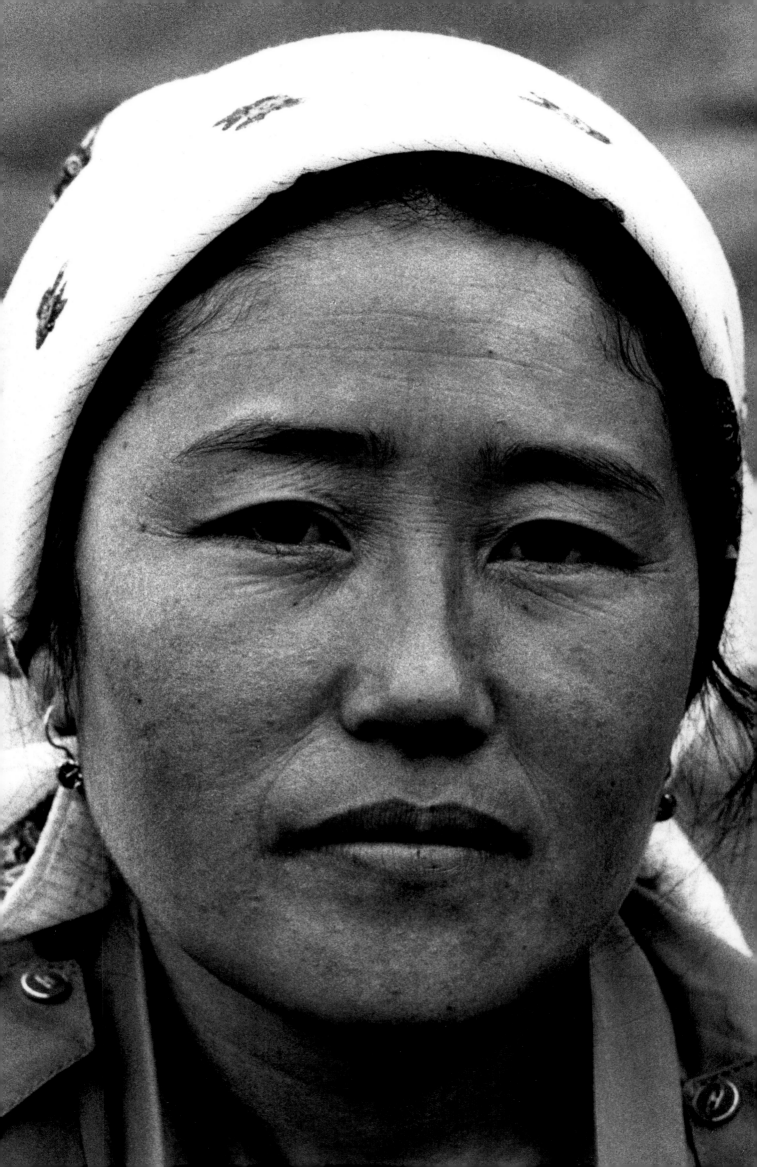

dresses were often decorated with embroidery. It was made from several strips of fabric sewn together. The sleeves were cut on the bias and fixed perpendicularly to the main body of the dress (Pages 100, 125[2], 130).

These tunic-dresses were sometimes made from hand-woven cotton, *mata*, sewn together in narrow plain or printed bands. The most beautiful dresses were tailor-made from expensive fabrics, such as satin or silk. Young women wore red tunics, the colour of fertility, while the most senior women made up their dresses from white cloth or more sombre colours. Red was obtained by dyeing cotton cloth with madder, the roots of *Rubia tinctorium*, and by dyeing silk with lac made from insects found on the branches of the mulberry tree or the ash. Synthetic dyes were introduced at the end of the nineteenth century.

The front neck opening of the tunic was on the right. It was fastened at the collar with the help of a braided tie, made by hand, the *büchülük*. In the south of the country, young girls wore the same tunics as boys, with a horizontal slit on the shoulders (Page 142).

This type of tunic-dress is, or was, found among all the people of Central Asia and Kazakhstan, with a multitude of local variations in cut, type of cloth used and ornamentation.

In northern Kyrgyzstan, the women's tunic was embellished with an additional decorative rolled yoke, all around the neck and along the opening. This extra piece was decorated with beautiful embroidery at the front.

In the south, there was no additional piece and the dress was embroidered directly onto the fabric of the collar and the neckline. The embroidery could be large and elaborate, covering the whole front of the dress.

Often, however, it was only an embroidered band or piece of cloth which embellished the collar and neckline (Page 85). The opening of the dress was often fastened by a round silver brooch or a decorative pin.

At the end of the nineteenth century, under the influence of Russians, dresses fastened by buttons began to appear. This style of dress spread progressively throughout the country as elsewhere among other Turkic peoples of Central Asia, such as the Tatars and the Bashkirs, and among the peoples of the Volga and the Altai.

In the twentieth century, women began to wear short dresses that retained the style of the traditional tunic, with skirts gathered at the waist. Dresses and skirts were then further complicated by decorative attachments, gathers and pleats (Page 134).

Trousers

Under the long tunic-dress, women wore similar trousers to those of the men—long and wide at the waist, drawn with a cord, which in past times were made from raw cotton handwoven fabric, *beyz*, 25 centimetres wide. These they wore next to the skin.

For women, these trousers (*ichtan*) are now mostly made from coloured cloth. In the south, the bottom of the trouser is gathered and decorated with a coloured sewn on band. Often, in imitation of the Uzbeks and the Tajiks, this band is woven or embroidered with tiny coloured patterns.

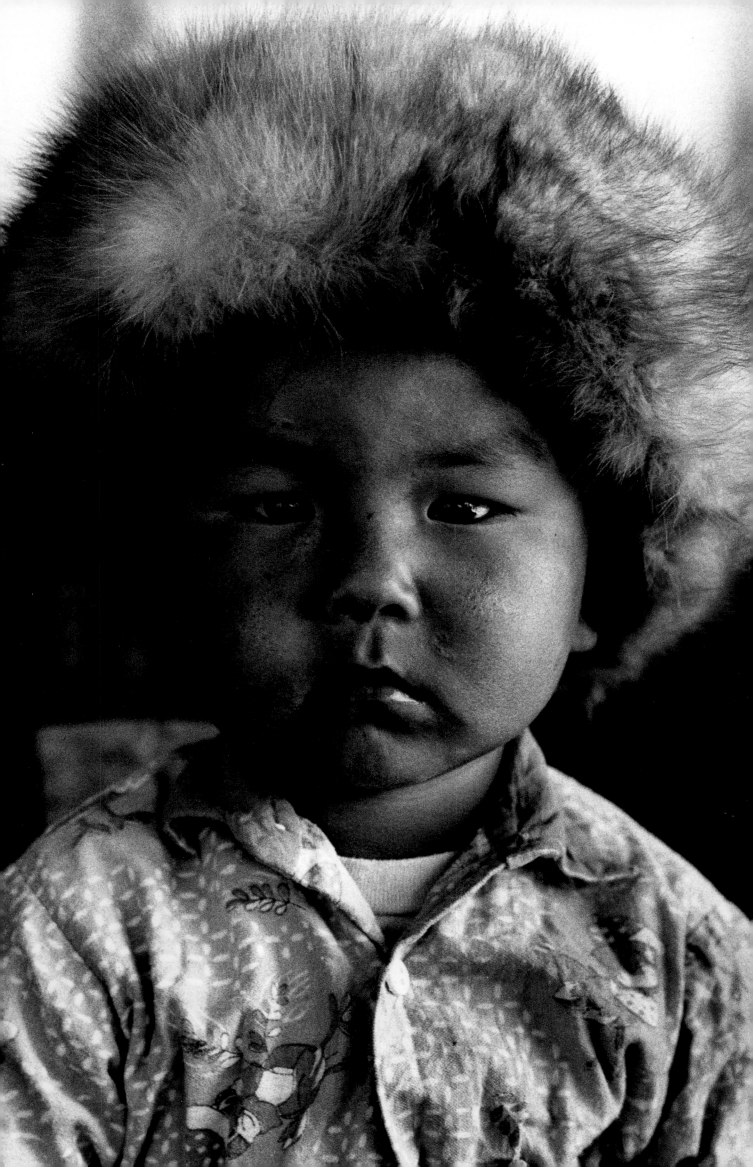

Beldemchi, the embroidered apron-skirt

The festive skirt known as the *beldemchi* made up a part of the dowry. It was presented to a young woman by her mother when she came to visit her in her parents' *ail* or camp, a year after her marriage. The wearing of the *beldemchi* marked the achievement of the status of motherhood. A year after the wedding, and especially after the birth of her first child, the daughter traditionally would make a return visit to the yurt of her parents, leaving off her tall bridal headdress and instead wearing the apron-skirt of a married woman. On this occasion, she would receive some head of livestock from her father, the *enchi*, that part of her property that comes back to her from her parents. This occasion, and the wearing of the *beldemchi*, marked the transition of the young woman who, having borne a child, was now fully integrated into the community.

The *beldemchi*, which is still occasionally worn today, is of very ancient usage among the Kyrgyz, as can be seen from the fact that the pieces of shroud used for wrapping around the hips of a deceased woman at a funeral were also called the same name, *beldemchi*. It is possible that women in the past were buried in their ceremonial skirts, to symbolize their status of married woman and mother.

This skirt, which is worn over the tunic dress and trousers, looks like an apron. It consists of a piece of embroidered cloth (*etek*) that goes part way around the body and onto which is sewn at the top a wide belt of cloth, the *bach beldemchi*. Cloth ties, fixed to the end of the belt, allow the apron-skirt to be tied on around the hips. In recent times, buttons have replaced ties.

The skirt is lined with camel wool fabric (sometimes padded with cotton wadding) and lightly stitched. The belt, 14 to 18 centimetres wide, is made from felt covered with cloth—usually black velvet.

This "open" skirt, ending at the knee, was worn at festivals and when travelling from one camp to another. The most beautiful ones are completely embroidered with brightly coloured motifs on both the apron part and on the belt. The opening and lower edge are bordered with sheepskin or precious fur, such as otter skin (Page 14).

Sometimes, nomadic women wore a *beldemchi* of sheepskin, with fur inside. It protected them from the cold in the mountain areas; women put them on for riding horses, and kept them under the yurt in winter.

There are two types of this short apron-skirt, and they are distinguished by cloth, cut and decoration, as well as the way they are worn. In the north, the *beldemchi* is embroidered and cut in such a way that the two flaps of the skirt cross over in front and overlap. And the wide fixed belt of the skirt is held in place by 3 or 5 pieces of black velvet cut slightly on the diagonal (Page 92). In the south-west region, the skirt is made from narrow bands of fabric. The flaps are edged with fur which may be precious; they do not meet in the middle or overlap as in the north, but are separated by a gap of about 15 centimetres. Thus the skirt seems to be worn over the behind, only covering the lower back, and open at the front.

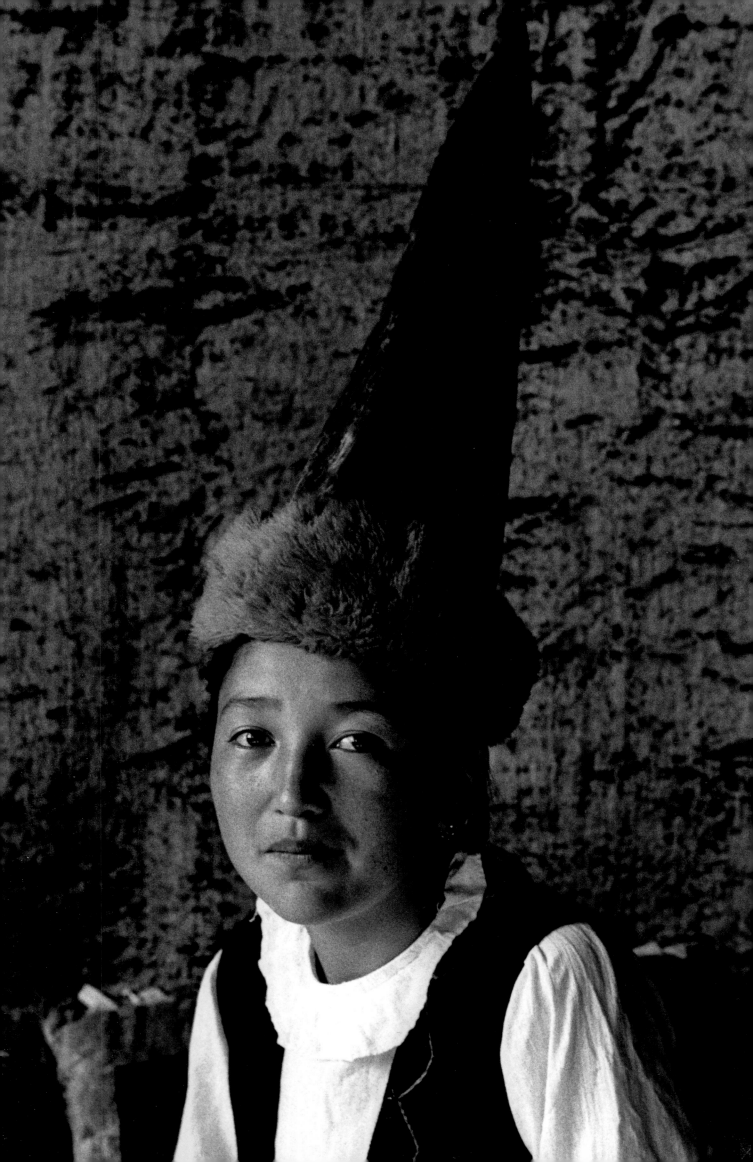

These skirts which are open in front are worn in the Pamir and Alai mountains, as well as in the Djirgatal Valley in northern Tajikistan and in the Andijan Valley in Uzbekistan (Page 101[1]).

In the regions close to Uzbekistan, where it is less cold, festive skirts are made from brightly coloured fabrics, bought from the neighbouring Uzbeks. The cloth may be red, green or blue, coloured velvet, silk, *beykasam*—striped cloth, *adrass*, or *ikat* with large flowers obtained by dyeing the thread before weaving.

Coats

Ichik, the fur coat covered in cloth

The traditional Kyrgyz women's winter fur coat was long and wide. It was called the same name everywhere—*ichik*, which means "fur" (Pages 89, 124[2]). It was made from sheepskin, or sometimes fur, worn with the skin inside, and lined with wool cloth or velvet in the north, and in the south sometimes covered with brightly coloured decorated silk imported from Ferghana Valley.

The coat was edged with a facing of fur. In the north, it was not obligatory to fasten it when one went out. In the south, on the other hand, women always had to fasten their coats with a sash or a hand-woven belt, even if they were wearing a *beldemchi*.

The chapan and other light coats

In summer and autumn, women replaced their heavy overcoats with a much lighter coat, the *chapan*, which very much resembled those worn by the men. The *chapan* is a long coat, with very long sleeves that cover the hands (Pages 92, 120). *Chapans* are made from cotton, or *beykasam*, a fabric of half-silk and half-cotton, with coloured stripes, and lined with cotton fleece and quilted. In the south, under the influence of the Uzbeks and Tajiks, women used beautiful multicoloured silks from Bukhara, *adrass* or moiré and *beykasam*, or even Uzbek and Russian brocades (Pages 100[1], 101, 174; see also Pages 123, 129).

The *kemzir*, *kamzur* or *kemsel* was a short coat that came down to the knees, with sleeves cut to the elbows and was worn over dresses. It was trimmed with a stand up collar, pockets on the sides and was made from dark coloured cloth. It was only worn in the north of the country, in Talas, Chatkal, in the Chou Valley and sometimes around Lake Issyk-kul.

The *beshmant* (Pages 95, 125) was a coat influenced by the Russian style, with a modern cut, fitting the body but leaving freedom of movement. It went down to the knee, with sleeves ending usually at the wrists and had a stand up collar. This coat was made from brightly coloured fabrics, most often velvet. It was also worn in the area around Talas, the Chou Valley and in the Issyk-kul region, in the centre of the country. For festivals, women from rich families would secure this coat with a leather belt (*kemer*) decorated with silver plated ornaments (See also Page 94).

Finally, the appearance in the 1920s of the long waistcoat without sleeves, *kelteché* (Page 130) changed the appearance of Kyrgyz women as much in the north as the south. These waistcoats were more practical than the old heavy coats. Often in dark blue, opening to the right, they were fastened with mother-of-pearl buttons or silver clasps. A shorter-style waistcoat was known as *chyptama* (Pages 86, 104, 106).

Other coats, jackets and waistcoats adopted by Kyrgyz women in modern times very much resemble those worn by the Kyrgyz men.

Shoes

The most ancient kinds of shoes were sandals (*chokoy*) made from untanned leather, and leather shoes (*charyk* or *paycheki*). These were replaced in the nineteenth century by shoes and boots of soft decorated leather, made by specialist shoe or boot makers who sold their products in the bazaars.

Low leather shoes (*kepich*) had the uppers slightly raised and were decorated with diverse ornaments, buttons, pom-poms, pieces of silver or coins.

Older women wore soft boots with light soles, known as *ichigi*, or *ma'asy* (Pages 14, 124). These were tall inner boots from black leather, which slipped into leather overshoes, *kepich* (now made from rubber), for wearing outside.

The young girls preferred boots (*ötük*), that were usually green or red with thick soles and a high leather heel. Boots worn by the young fiancée on her wedding day were especially embroidered and decorated with coloured leather appliqué or silver pieces. Small bells (*djyla'ajyn*) were often put in the hollow of the heel in order to ring during the procession.

With Russian influence, as in other parts of Central Asia, factory-made boots and shoes with rubber soles began to appear.

Hairstyles and Headwear

The different stages of life of a Kyrgyz woman were traditionally signified by her clothes and her hairstyle, which changed as she changed her status and position: first a little girl, then a young woman, then a bride, a mother and finally a mature woman.

Hairstyles

Traditionally, until six or seven years, girls had the same hairstyles as boys—shaven heads with two locks left in place at the sides. After this, the young girls let their hair grow, and they braided it into fine plaits, three to six plaits on each side (Pages 84, 116). These plaits were decorated at the ends with pieces of coral or mother of pearl buttons.

The hair plaits were sometimes joined up at the back by a silver-plated ornament, the *arkalyk*. This was especially common in the Tien Shan and Issyk-kul regions.

48

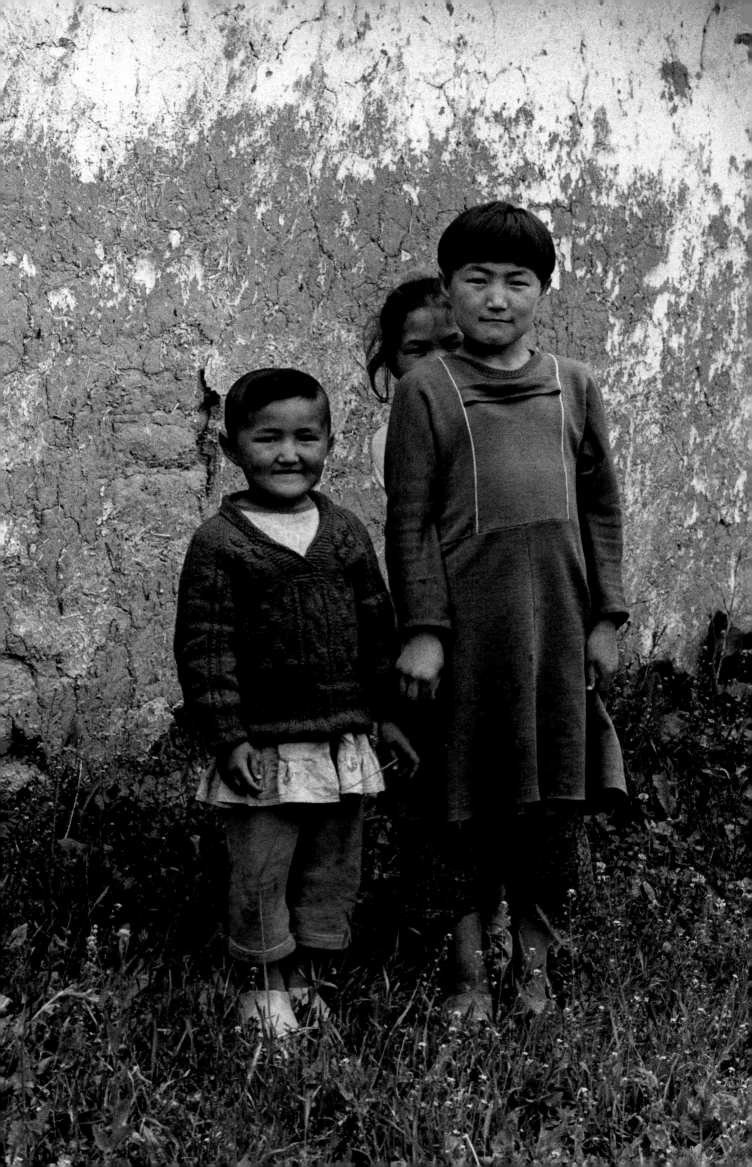

Once married, women braided their hair into two large plaits that hung down the back. These plaits were concealed in a plait holder, the *chach kap*, decorated with embroidery, silver plate and other ornaments (Page 94[2]).

Hats

The little girls wore hats on their heads, embroidered skullcaps or scarves, especially in the south (Pages 132, 142).

On special occasions in the north, young Kyrgyz girls often wore a conical cloth hat (*tebetey*) usually made from red cloth, and surrounded by a wide fur border of Astrakhan, otter, fox or mink (Pages 84, 116, 134). This typical hat was often decorated on the top of its velvet base with a cluster of owl or eagle owl feathers or a tuft of eagle's down.

The marriage headdress

Marriage represented a key moment in the life of the community. This was the celebration of the time when the young woman would leave her parents' encampment (*ail*) to go to that of her husband. She secured her welcome into her new family when she became a mother.

In the past, young Kyrgyz women were very free, and life in the mountain pastures looking after herds of sheep gave many opportunities for young people to go courting. One of the games played at big festivals, as common among the Kyrgyz as the Kazakhs, and recounted by Zalevski in 1860 referring to the Kazakhs, was *kyz ku'umay*—"catch the girl and kiss her", on horseback. A group of young men pursued the young women on horseback through the mountains. If the young woman let herself be caught laughing and allowed her arm to be touched, the happy winner could think himself chosen by the girl. The decisive gesture was for the young woman to let her right forearm be pinched.

After this, the boy's father could either himself, or through an intermediary, come to negotiate the bride-price, or the *kalym* of the girl, with her father. This would consist of a certain number of heads of cattle or sheep that the lad's family must give in stages during the marriage. Having agreed a suitable date, the young girl would begin to prepare her trousseau. This included the felts and embroideries which would decorate the yurt of the young married couple, the bedding quilts and the *ashkana chij*, a decorated screen woven from sedge and dyed wool wrapped into a pattern, which defines the kitchen space in the yurt.

She would take care not to use any knots or joins in her work lest this would "knot" the potency of her fiancé.

The boy himself put up a new yurt or *boz üy*, including the trellis walls, willow roof poles and covers of new white felt, if the family could afford it. If not, when first married, they stayed in the husband's parents' yurt, in an area screened off by an embroidered hanging—the *koshogo*. Sometimes, the marriage was accompanied by the enactment of "kidnapping", when the young man would come to take away his conquest on horseback.

After the delivery of the dowry, the wedding festival (*toy*) was organized. It was an occasion for killing a sheep, or more, for a feast.

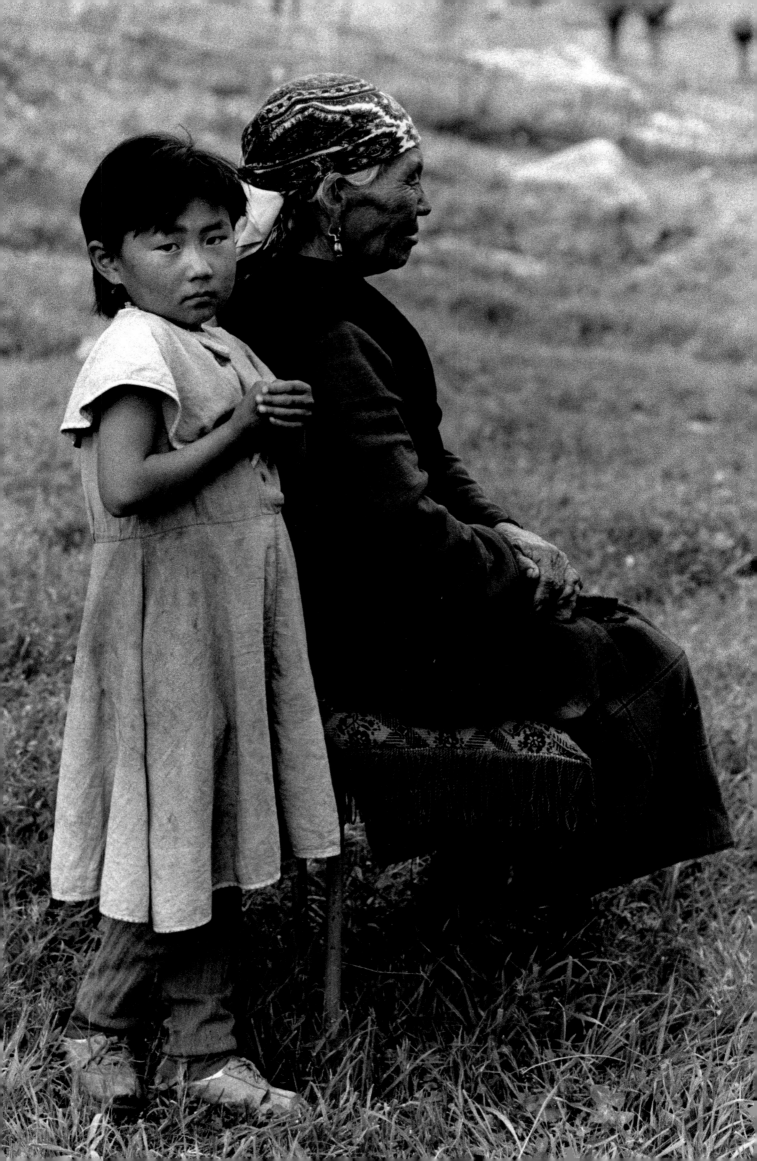

The fiancé wore a new suit, his young wife a new dress. Her hair was braided into four plaits, thickened with strands of black wool, in order to give it an even more beautiful appearance. Horse races (*bayga*) were organized for the guests. There was wrestling (*kurech*) where the wrestlers grasped each other by the belt (*kur*) in order to try and knock one another over, and archery competitions (*jamby-atmay*). Horse riders wrestled on horseback, one wearing a conical hat, the other a woman's scarf, playing the *odarych* game, that recalls an ancient form of wrestling where women wrestled equally with men.

After strong libations of *kymyss*, fermented mare's milk, there was a battle of sung words in the young woman's camp, just before her fiancé came to take her away, giving renewed opportunity for the young men (*jigits*) and girls to meet and insult each other. The young girl would cry at the moment of leaving her parents. Not to show her sadness at this time would bring bad luck to her married life. Poets accompanied this decisive moment by singing a sad nuptial song.

For the marriage ceremony, besides her best clothes, the girl wore a special and very elaborate headdress, that she kept for one year after the wedding, or until her first child was born. This headdress, decorated with elaborate embroidery and pieces of coral or worked silver, was passed down from generation to generation. In this moment of transition, when a young woman was leaving her family to join with the family of her husband, it was beautiful, and imbued with the richness and glory of her father who had to give her away.

Shökülö, the tall headdress

In the nineteenth century, in the north of the country, young girls from rich families wore a tall headdress, called the *shökülö*, from a very ancient tradition, for their wedding. This high stiff headdress had a conical form with square earflaps that covered the ears, and a long triangle of fabric hanging down the back to hold the plaits in two long braids. It was made from wool cloth or red velvet, lined and stitched with fluted lines of close seams.

At the sides, peacock feathers or crane feathers were attached. Jewels decorated this red conical headdress, including pearls, pieces of mother-of-pearl and coral, decorative pieces of silver, semi-precious stones and brocade ribbons. Sometimes, a big plaque (*kalkan*), made from silver or gilded silver, and encrusted with cornelians, was attached to the front of the headdress, above the forehead. A band covered in coral beads and pieces of silver decorated the circumference of the headdress, which was topped with peacock feathers.

A silver and coral pendant in the form of a triangular amulet could be fixed to the edge rim of the headdress to conceal the nose and mouth of the bride (Page 135).

By the middle of the nineteenth century, this ritual bridal headdress had already nearly disappeared, because its rich ornamentation made it very costly. It was only found amongst the richest families and was only worn during marriage ceremonies. Later, it was kept in the family bridal chest only to be used on the wedding day as a symbol of respect for continuity and tradition. Now they can only be found in a few museums.

This tall marriage headdress comes from an ancient tradition which extended from Mongolia and the Central Asian steppes and spread as far as Asia Minor and the Lebanon,

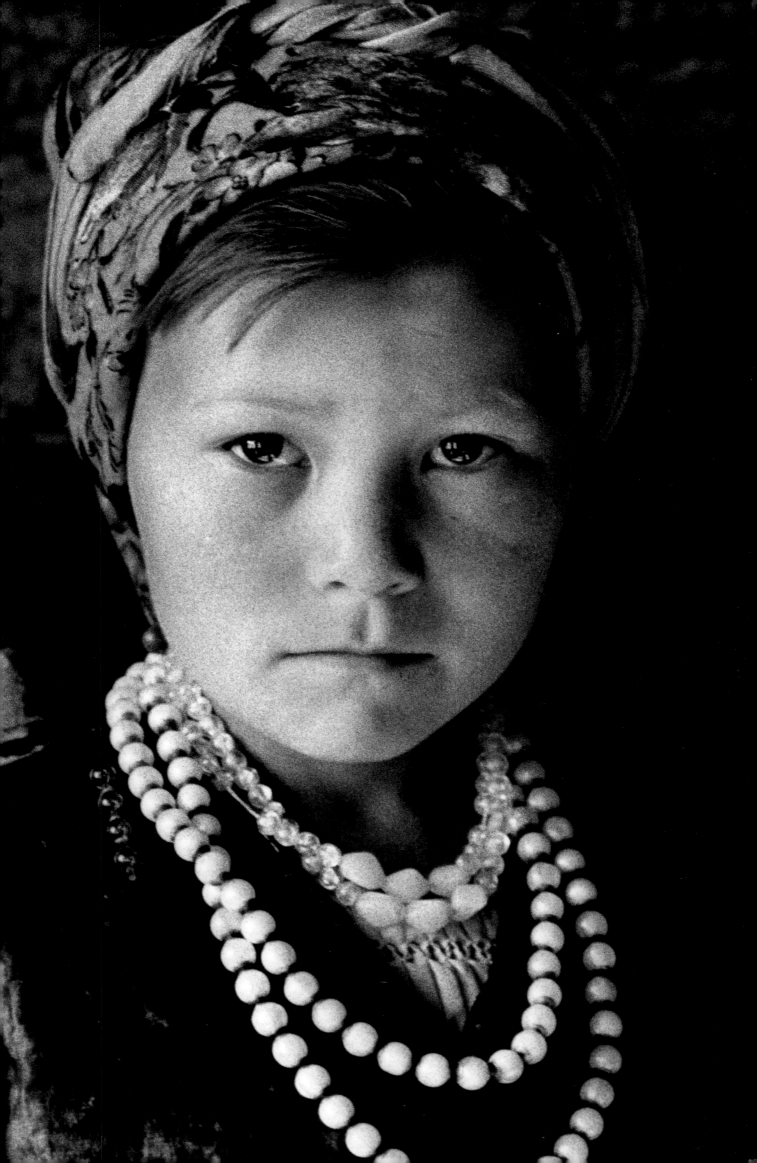

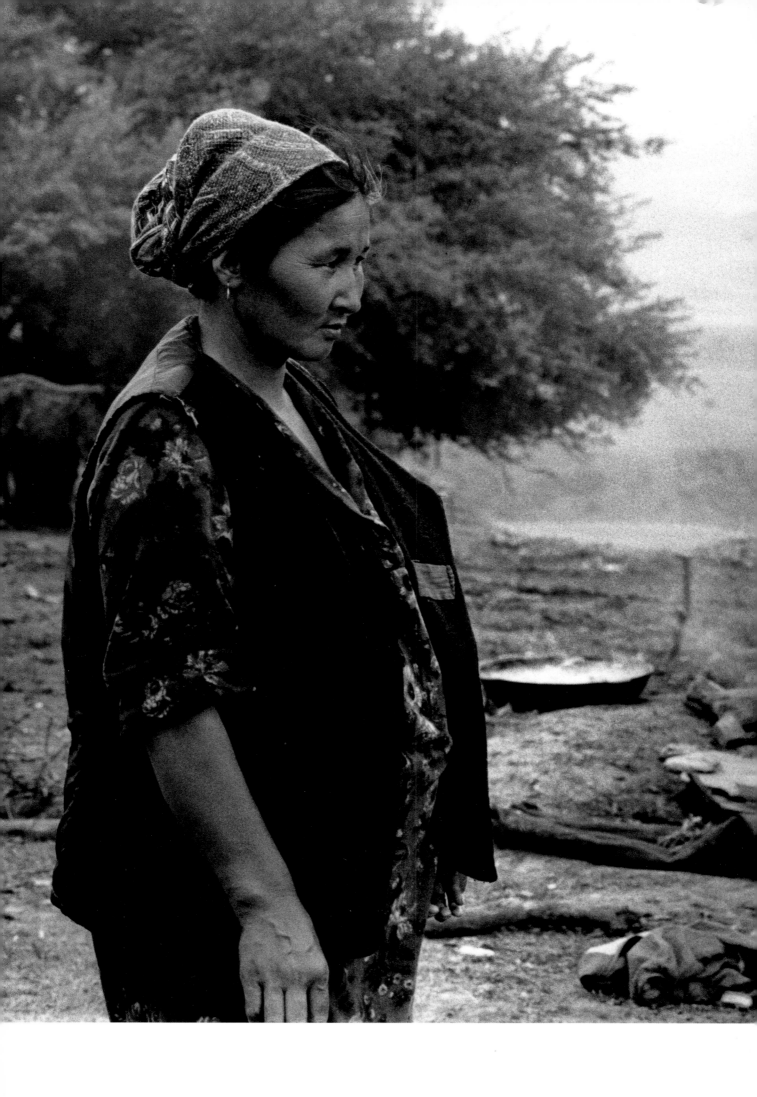

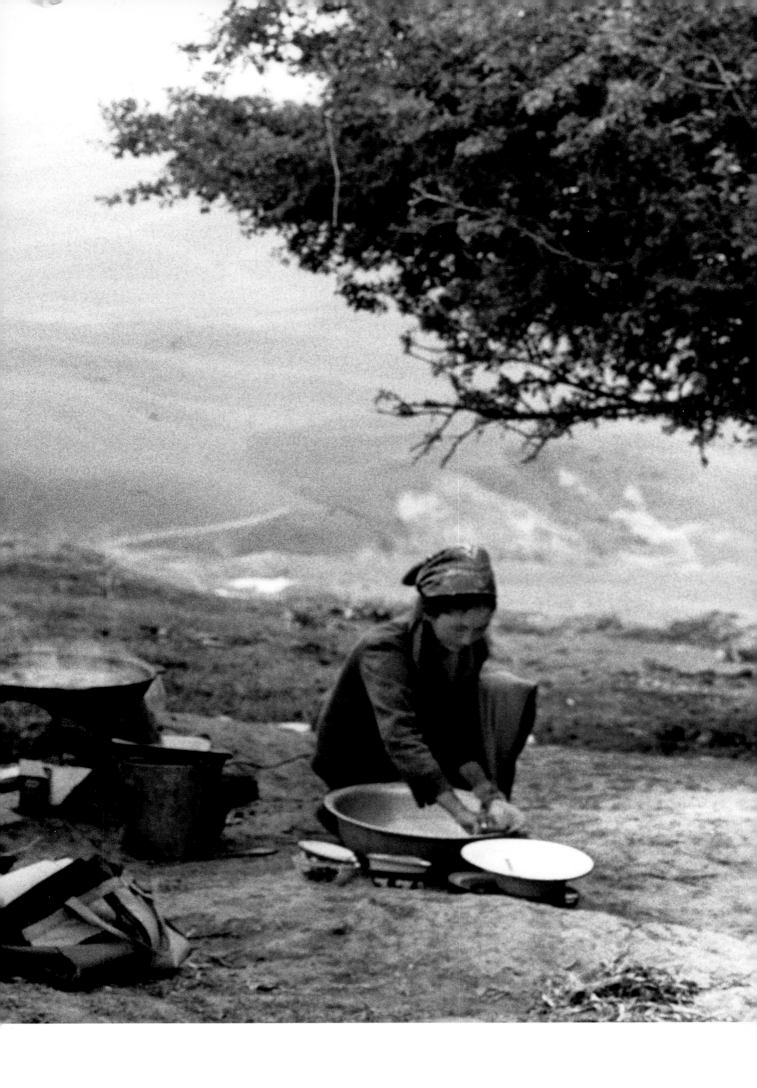

where the Crusades discovered it and imported it under the form of the *hennin* of the Middle Ages. From the eighth century BC, the Sakas populated the steppes of Turkestan and what is now Kazakhstan, to the east of the Black Sea Scythians. In the aftermath of the struggle against the Persians of Darius I (522–486 BC), the Sakas had to defend themselves against Alexander the Great. In 1969–70, archaeologists searched the Saka tumuli going back to the fifth or fourth century BC in the Issyk region, close to the present capital of Kazakhstan. They discovered the tomb of a noble wearing a tall headdress of thick felt decorated with gold ornaments. This region is now inhabited by the Kazakhs, the Karakalpaks (whose name translates as "black hats") and the Nogai. Up till the nineteenth century, local brides-to-be and young Kazakh brides wore tall conical rigid headdresses, the *saoukélé*, for ceremonies. These very much resembled the more modest Kyrgyz bridal *shökülö*.

Other similar ancient tall women's headdresses have been found in Xinjiang, and most recently at Pazyryk, in Ukok, where a tattooed woman, known as "The Ice Maiden", wearing felt including a tall headdress was found preserved in the permafrost. Paintings of women at Mongolian court also depict very tall headdresses.

The Kazakh *saoukélé* was a high conical headdress that could be more than 60 centimetres high. Its rigid form was covered in red stitched velvet and it was completely encrusted with pieces of silver and gold plate or cornelians. On each side hung cascades of coral beads separated by silver ornaments. The front of the headdress, just above the eyes, was decorated with a fur band. A long triangular flap extended down from the headdress at the back. Made of wool cloth or red velvet and covered in silk, it hung down almost to the waist to cover and contain two long plaits. From the top of the headdress a long white veil, the *djelek*, came down evenly, and hung behind the head to cover the back.

The French traveller Jules-Marie de Cuvalier de Cuverville described the *saoukélé* in a letter in 1896: "It consists of a cone a metre high covered in silver pieces, silver plate, precious stones, strange material and long bands of coral, a metre in length, ornamented in ancient silver".

The richer the family, the more decorated the headdress. The top was encircled with a metal gilded decoration mounted on a vertical gilded plaque that might have a huge cornelian in the centre. Right on the top of the headdress, a feathered plume was fixed, usually eagle owl that was considered lucky. According to Eugene Schuyler, diplomat of the American delegation to Saint Petersburg that visited Central Asia in 1873, the headdress of women in the Khokand region was decorated with the forked tail of the swallow (*karligatch*), which was said to protect from bad luck.

Monsieur de Cuverville reported in 1896 that although it was already becoming rare, this headdress was still worn for weddings. Before sitting the bride-to-be on the horse that would take her to her groom's camp, the young woman's hair was braided into the two characteristic married woman's plaits, and the tall headdress was arranged on her head.

This headdress was worn during the first year of married life, especially when there were festivals, seasonal changes of camp and whenever she found herself in the presence

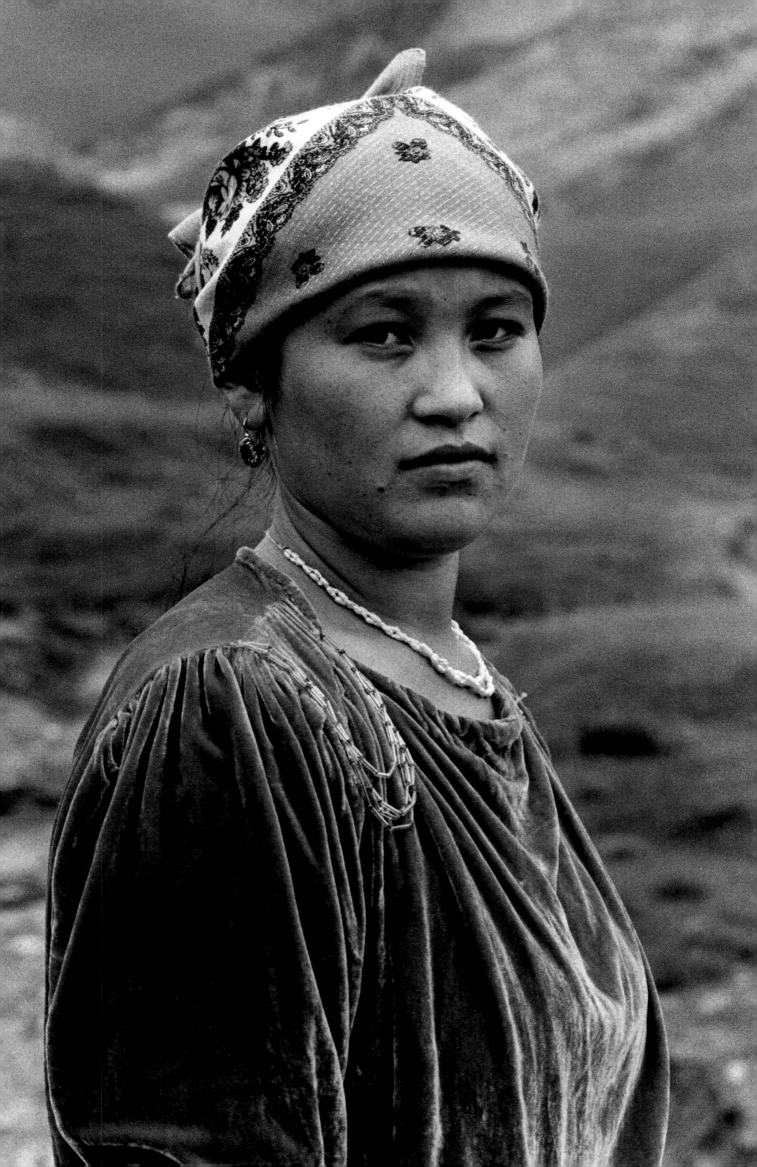

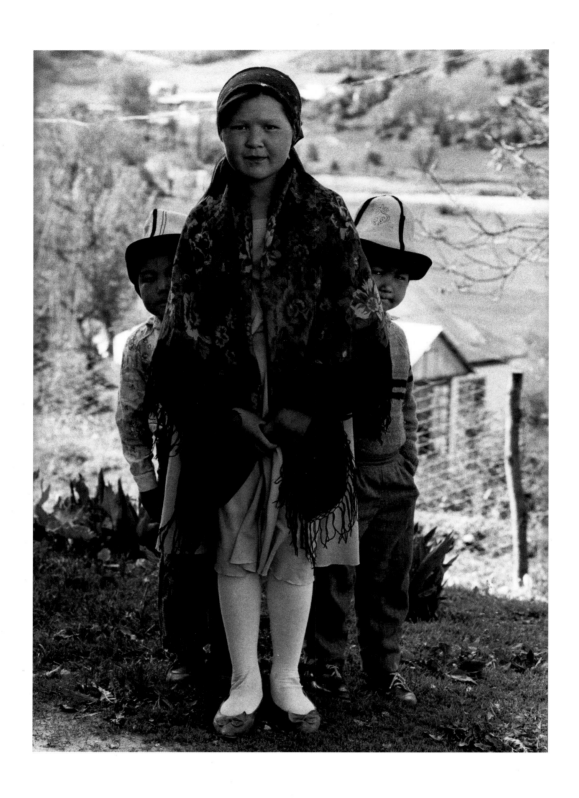

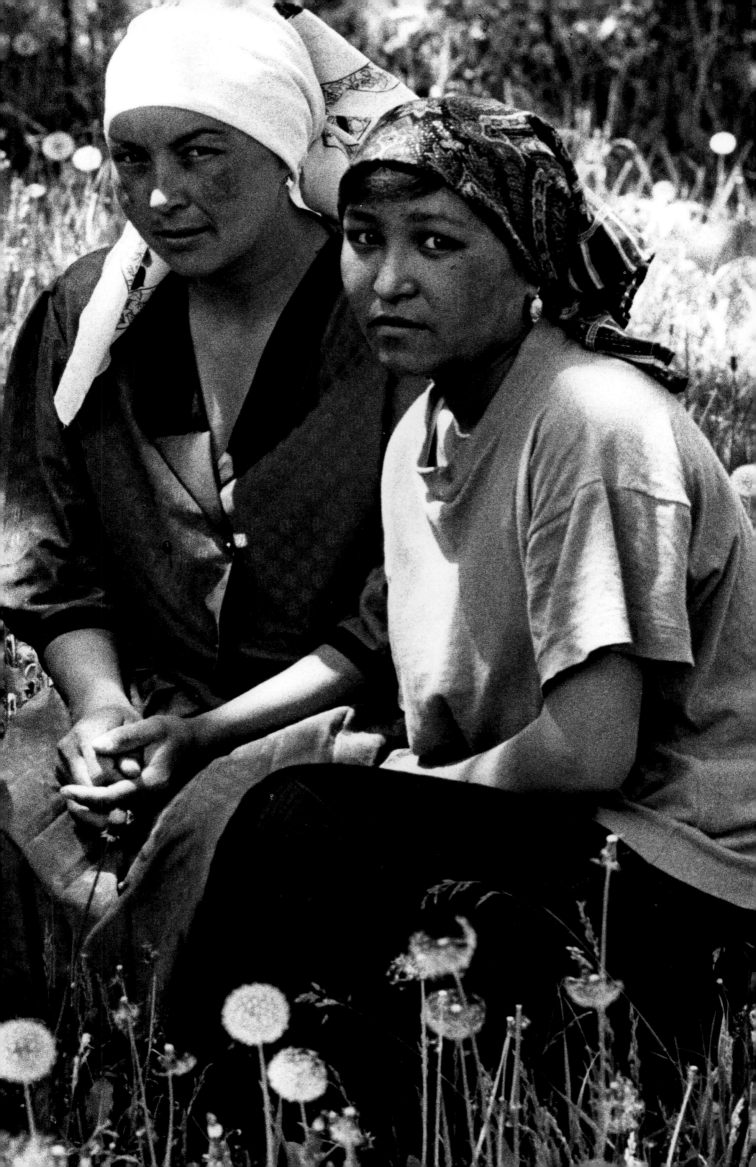

of strangers. At the end of the year, during the young bride's first visit to her parents, she ceased to wear her tall wedding headdress and from then on carefully kept it in her trunk, until passing it on, when the moment came, to her own daughter. With the Kazakhs, as with the Kyrgyz, it was handed on at the same time as the ceremonial apron-skirt, *beldem-chi*, which made up a part of her dowry. If the young woman had already had a child, she also received the *enchi*, the portion of livestock that came to her in advance of her inheritance from her father. This portion enabled the couple to be sure of making a living and to establish themselves in a separate tent.

The use of the tall *shökülö* headdress was lost among the Kyrgyz and Kazakhs by the end of the nineteenth century. The most beautiful ones, decorated with silver and precious stones, could cost up to 1000 silver roubles or one hundred horses among the Kazakhs.

Marriage veils

While in northern Kyrgyzstan, the bride to be hid only her face with a white veil when leaving her parents' camp to be led to the home of her betrothed's parents, in the south (probably due to Tajik or Uzbek influence), the young bride was concealed entirely under a rectangular piece of embroidered silk, that passed under the top of the headdress and came down to her breasts (among the Uzbeks, this veil was made from woven horse hair—*chachvan*).

In the eighteenth century, during this ceremonial journey, there was a hood (*kimechek*) which the Kazakhs and Kyrgyz wore on their wedding day. This mask was made from a tall piece of leather, which came over the headdress and was decorated on the top with peacock feathers. A fine cloth veil fixed to the hood completely hid the face and the neck.

The heavy turban of the married woman

A year after her marriage, or after the birth of her first child, the young woman who had sadly left the family camp where she had spent a free and happy childhood, was considered to be well integrated into her new environment, her new responsibilities and her new family. From then on she would plait her hair into two long black braids falling down her back and hidden in an embroidered plait holder, the *chach kap*, "hair bag"; this was long and narrow, made from black velvet, ending in fringes decorated with pieces of silver plate, silver ornaments, mother of pearl buttons and tassels or pom-poms. Hair, which had an erotic charge, potentially threatening the social order, in this way stayed hidden. The head, sacred and through which passed down the benefits of the gods, was thus specially encircled and protected.

The married women's headdress, which goes back to very ancient times, consisted of a bonnet that covered the hair at the back and around which was wound a long turban. It was embroidered to varying degrees and covered in ornamentation. It was completed with coral pendants and pieces of silver.

Each group of Kyrgyz, whether from the north or south, had (and still has) its unique version of the different heavy turbans which the women wore. This turban took several

forms and variations according to region. The manner in which it was wound, often round, characterized each different group. The turban also represented a sign of social status: the richer the family, the longer and more richly decorated with ornaments the turban was.

Turbans were usually made from 5 metres of cloth, but many used over 15 metres or even 30, which gave them enormous dimensions. The most commonly used material was a narrow band of white cloth, with a quite closely woven texture, called *istanboul*.

Elechek, the turban of the northern region

In the north, the white turban was wound around a rigid plain cap, the *kap takiya*, or *bash kap* ("head bag"). The turban was wound around the head in very fine parallel spirals. Several rounds of white fabric hid the chin, the neck and a part of the shoulders (Pages 89, 92, 122, 140). This voluminous white married woman's turban often had an austere appearance in the north and was much less decorated than in the south.

The main decoration of the northern *elechek* was a woven or embroidered band wound around the turban to fasten it (Pages 95, 110). This band (*kyrgak*, meaning "border", or also *tartma*, meaning "link", *dürüyö keshte* and *goul-e keshte*) was often made from silk, and sometimes had a net and red silk tassels or pom-poms attached (Page 96). Women from the richest families encircled their turbans with a piece of jewellery (also known as *kyrgak*)—rigid silver plaques from which hung silver and coral pendants (Page 141).

At the back, under the cloth that hid the neck and upper back, hung down the plait holder, ornamented with pieces of silver and coral beads.

Extending from this holder, that hid the hair, was a silk net, or a ribbon (called *chach monchok*, "hair ornament"), covered in decorations of glass beads or pendants, or even keys which jangled with the movements of the woman (Page 94[1–2]). There was also a beautiful silver decoration, *cholpu*, inset with stones, in which one could possibly see a stylization of the human person who was attached to the other end of the plait case.

This headdress, a voluminous white turban which also hid the neck, was characteristic of all northern Kyrgyz areas, from the Talas Valley, Chou Valley and Issyk-kul Valley and up to the mountains of Tien Shan. It was similar to that of the Kazakhs, their northern neighbours, as described by Bronislav Zalevski around 1860: "The married women shave their head, and so are forced to cover it. They wind it round with an enormous white cloth which goes very high, and at its lower edge, hides the mouth, the neck and even a part of the shoulder".

Ileki, the turban of the southern region

The turban of southern Kyrgyzstan was more intricate, varied and ornate than that of the north. It was distinguished from the northern one by the absence of any fabric covering the chin or neck, which was obligatory for the northern *elechek* (Pages 98, 118). Underneath the turban was a head covering, known as the *chach kep* or *kep chach*, that was an embroidered bonnet, so finely worked that the embroidery itself could take a month and a half to do. It was made from white cotton fabric and decorated with a great variety of multicoloured

silk patterns (Page 115). The bonnet was open at the top and had earflaps and a long em-
broidered flap at the back to cover the two plaits (Page 103). It was on these flaps that the
bulk of the embroidery was done. The bonnet's edges were decorated with pearls, mother-
of-pearl buttons and a variety of round pendants (Page 82). Some bonnets had triangular or-
naments of silver and coral, which hung either side of the face with the apex of the triangle
pointing upwards. On others, along the edge of the earflaps, long rows of coral beads, known
as *sagak*, were hung, linked by transversal plaits of engraved silver (Pages 109, 112, 120).

The turban was wrapped around the bonnet. It was long and white, and left the neck
and the ears free so that the embroidered flaps beneath could be admired. The turban was
secured by a woven band, known as the *kyrgak*, as with the northern *elechek* (Page 109).
Above the turban, at the top of the headdress, was the *kalak*. This was made from white
fabric, embroidered with multicoloured flowers and bordered by a fringe of red silk (Pages
81, 129). Sometimes the turban itself was embroidered with multicoloured floral motifs,
especially in the Pamir regions, influenced by their links with Tajikistan and was then known
as the *sayma ileki* (Page 80[1–2]) In the Pamir regions, the headdress took a slightly dif-
ferent form, and was sometimes called the *shökülö*, the same name as the ancient tall con-
ical headdress of the Kyrgyz of yesteryear. This headdress was only used after marriage
and was kept by the woman until her death.

The large dürüyö or djo'oluk headscarf
From the beginning of the twentieth century, the voluminous high turbans began to be replaced
by a large, more practical white veil or scarf, the *ak djo'oluk* (Page 100[1–2], 102), that could
be embroidered with beautiful double-sided embroidery (*sayma djo'oluk*), or decorated with
a ribbon, a fringe or silver engraved pendants (Page 107).

This scarf progressively became a required accessory for all women when they went out
and a version of it is still worn today. There are several ways of tying it around the head, each
characteristic of a particular region and also of marital status (Pages 86, 104, 106). The colours
worn now vary according to age—bright colours for young women, and white for older women.
Since the 1920s, printed and woven coloured scarves have been imported from Russia.

Clothing Adornments and Jewellery

No Kyrgyz woman in former times could imagine wearing clothing without embroidery
or other decoration. The different decorations gave a cachet to women's clothes. They in-
dicated their age, the family situation or their social position.

As much among men as among women, embroidery decorated their caps, headdress-
es, under-trousers and belts. Clothes also might be stitched with decorative seams, adorned
with appliquéd fabrics, decorated with pieces of velvet, with fur bands, fringes, pleats, tas-
sels, pom-poms, beads, coral or mother-of-pearl buttons, or with owl, eagle owl, swallow,
peacock or crane feathers.

Sewn on decorations

Clothes, caps and headdresses were often decorated with numerous pieces of worked silver, river pearls or pieces of coral. Especially in the northern regions, under Russian influence, clothes were fastened by buttons. The local jewellers began to make silver decorative buttons (*topchu*). These were big buttons, convex and round, often engraved or enamelled, and encrusted with a black paste which highlighted the whiteness of silver (Pages 86, 95, 104, 106). All these buttons, that appeared in the middle of the nineteenth century, featured similar decorative patterns to those used on men's belts and women's plait decorations.

The same patterns were also found on horses' harnesses and metal kitchen utensils. This is probably because the jeweller or silversmith made all these different artifacts.

Other decorations known as *tumar* were fixed to women's headdresses and to clothes, and acted as amulets for protection against evil spirits.

They were often triangular, very varied, of different sizes and could be hollow, concave or tasselled. They were also sewn onto jackets and dresses, often on each side of the opening that was seen as a particularly vulnerable place (Pages 125[1], 132).

It is important to distinguish those buttons and ornaments which were made using traditional motifs from those imported from the bazaars of Khokand and Bukhara, and other regions of Russia. These small decorative items were easily transported. They help one to appreciate the diverse links and exchanges that have always existed between the Kyrgyz regions and neighbouring centres.

Plait ornaments

Plait ornaments were very varied, especially in the north of the country, where the sheath of the plait holder extended down the back, under the heavy turban.

The *cholpu* was made up of an arrangement of silver plates or silver roubles, joined into a triangle linked by three chains (Page 94[1]).

The two plaits could also be extended by a *zirye*, a linked chain of coins and silver roubles. In the valley of Zetmen Tyubyé, a plait decoration, *gudmuk*, was made of coins held together with little straps of leather.

Around Issyk-kul, in the Talas Valley and in the Tien Shan, could be found decorations which hung off the ends of the plaits. These were *chach papik*, imported from the Uzbeks and the Tajiks, and were "pom-poms of hair" bound by black silk and extended by silver conical ornaments. They could be adorned with coral beads and silver domes containing braids of black silk. There was also the *chach üchtük*, rows of silver pieces interspersed with coral beads.

All these plait ornaments, like "cascades" of silver with rings, coins, baubles and delicate stones, were also familiar to the Kazakhs and the Tatars, who had possibly introduced them to the Kyrgyz in the second half of the nineteenth century.

Jewellery

All over Kyrgyzstan, as with other items of dress, there were some variations in style of jewellery from region to region. In the north, most common were heavy coral bead necklaces set out in several rows held in place by worked metal silver plates (Page 106). In the south, jewellery was more varied. The same coral necklace, *shuru*, existed, but with some different features. The rows of coral beads, cylindrical in shape, were often interlinked with rows of semi-transparent cornelian beads, imported from Badakhshan. The red colour of the coral brought health and fertility; the cornelian, luck and abundance. River pearls, which were also sometimes used, gave protection against illness and misfortune.

Necklaces could also be made up of silver spheres interspersed with coral beads. The *boy tumar*, a large amulet carrier, was one of the most valuable pieces of jewellery, usually made by the artisans of Bukhara in Uzbekistan. It was suspended from the neck by a chain decorated with silver coins. Women also wore frontal jewellery known as *silsila*.

Young girls loved to adorn themselves with coral necklaces, pearls, coins or silver pieces. From infancy, they wore earrings in a variety of shapes and sizes (Page 86). The *sagak söyköy* were earrings linked together by a silver chain that passed under the chin. They could be found all over the country. Other earrings were in conical form, linked by chains of silver and coral beads.

They were connected by a triangular or rectangular chest plate in enamelled silver or encrusted with coral beads.

These *söyköy djeburöch*, characteristic of the north of the country, were part of a fiancee's dowry. Young women wore them at their wedding ceremony and during the journey to a new encampment, when they showed off their best attire. Bracelets (*bilerik*) and rings (*shakek*) were made from engraved, inlaid or stamped silver. Rigid bracelets, opened by a hinge, were linked by chains to three rings worn on the three centre fingers of the hand.

Jewellery from the north and the south of the country was also differentiated by style of decoration. To the north, Kyrgyz jewellery was often made from engraved or inlaid silver, decorated with black paste (a mixture of copper and lead often worked with sulphur and borax) in which simple, high-quality patterns were designed which stood out well in black against the silver base. Jewellery from the south was again more influenced by the Uzbek and Tajik style, when it was not directly imported from the jewellery centres of Khokand, Tashkent and Bukhara.

Silver was decorated with stamped motifs on its surface, in rosette forms, palmettes, clovers, stars, circles or circles inscribed on a point. Other techniques used by the jewellers included carving, engraving, filigree, applying silver threads and milling. The jewellers from both north and south also decorated pieces of horses' harnesses with inlaid or engraved silver, and other objects such as metal kitchen utensils.

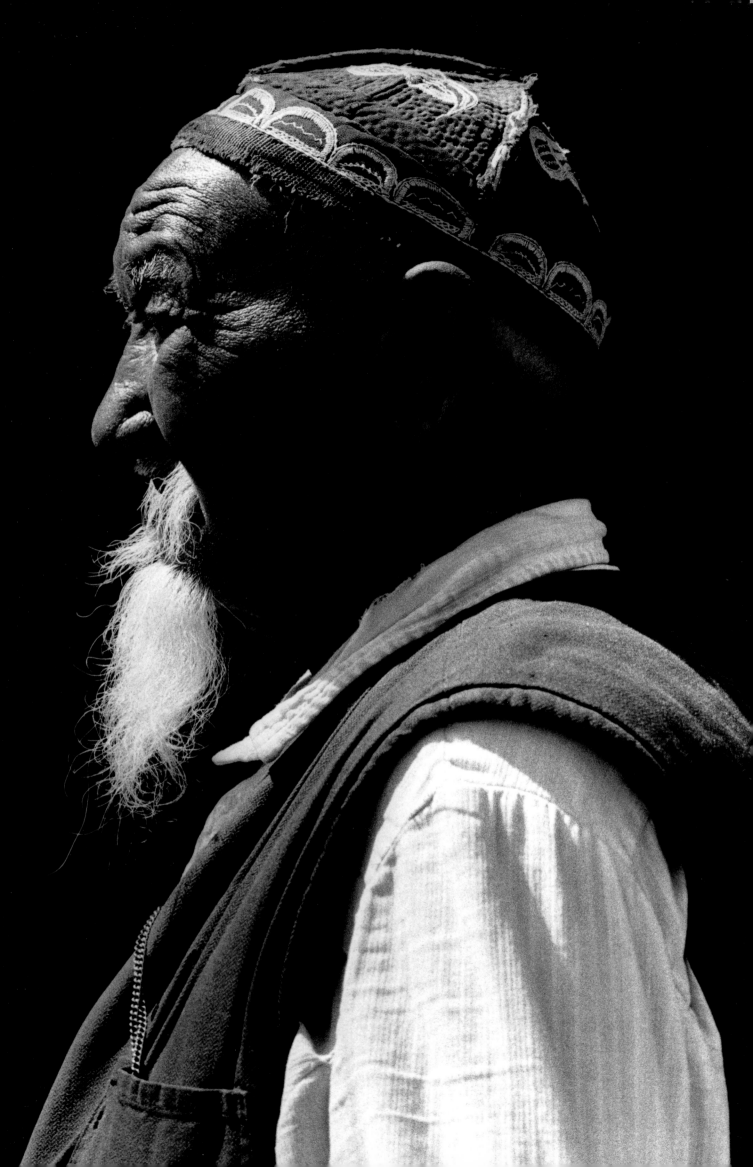

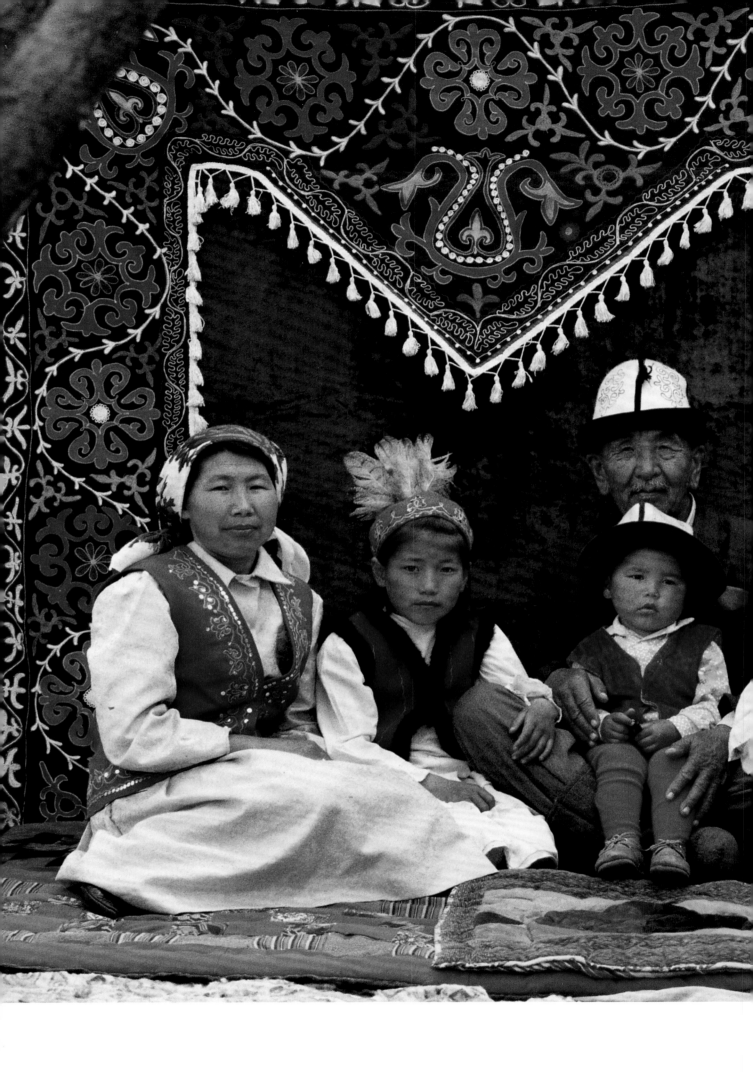

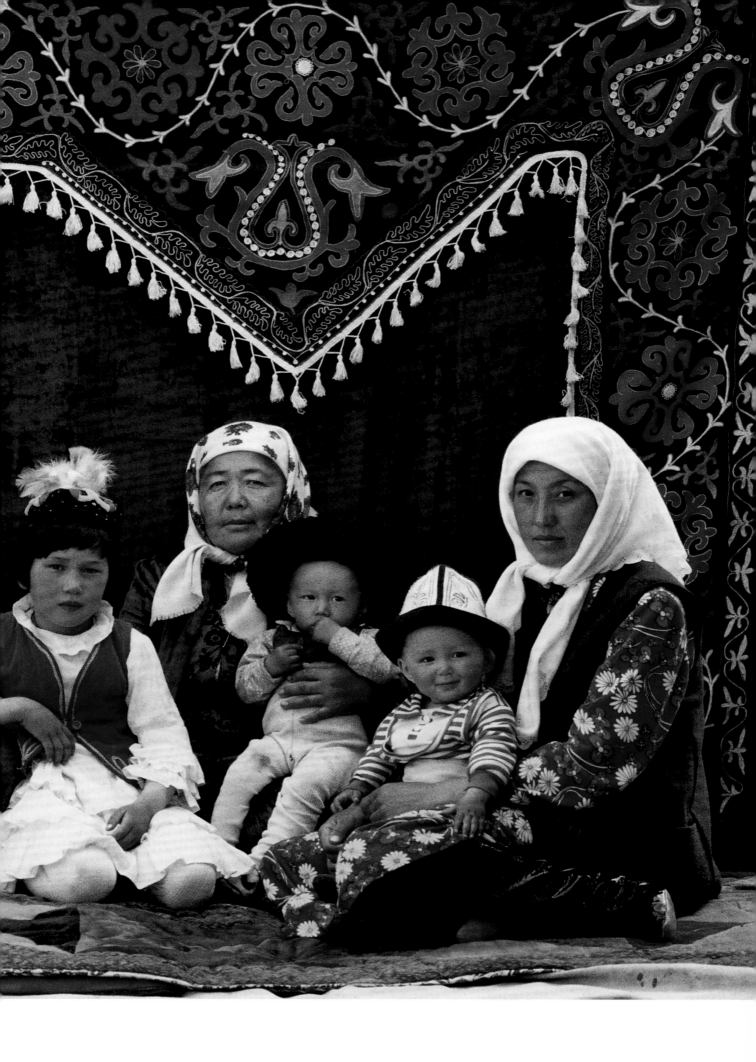

TRADITIONAL MEN'S COSTUME

Until the middle of the nineteenth century, Kyrgyz men dressed in a fashion which must have closely resembled that worn by their distant ancestors. Their usual attire consisted of shirt, trousers, woollen cloak or fur-lined coat, leather or woven belt, leather shoes or boots, with a fur hat or embroidered felt cap.

Shirts and under-trousers

Like the other inhabitants of Central Asia, from Kazakhstan and South Siberia, Kyrgyz boys from about six to eight years old wore a long loose shirt of white cotton (formerly of wool) next to the skin. This fashion continued into manhood. In the south, the long *djegde* shirt had no collar and was open to the waist. In the north, the shirt, which was called *achyk köynök*, meaning "open shirt", was often trimmed with a little turned-down collar and a cotton stay-lace to fasten it at the top.

By the end of the nineteenth century, the long shirt had been shortened so that the opening no longer reached the waist. In the north of the country, under Russian influence, mother-of-pearl buttons for fastening shirts made their appearance.

Under-trousers (*ich shym*) were made from white cotton. They were very large at the top, wide between the legs to allow for easy movement and narrowed towards the ankles. They were tied at the waist by a belt of plaited wool (*ichkir*), decorated at each end with embroidery, or by the marriage belt, with tassels of golden threads and coloured silks.

Trousers

Winter trousers were cut out from sheepskins or goatskins, the fur being worn inside. Others were made of a thick wool fabric woven locally by hand, or of the wonderful brown *piasy* cloth, made from camel's wool, which was very warm and strong.

The most ancient kinds of trousers were made of leather (*djargak shym* or *teke shym*, or wild goatskin) and dyed with natural brown colours to imitate reindeer (*bugu*) skin. In the past, the Kyrgyz called trousers made from elk skin *kandagai shym*, and these were referred to in the Manas epic as being worn by the heroes of old. These elk skin trousers reflected the time of the epic when the Kyrgyz lived in the forests of south Siberia, to the north of their current home.

In the north of the country, the rich *beys* and traditional chiefs, the *manaps*, wore deerskin trousers at festivals and games. These were *sayma shym*, embroidered with large multicoloured silk flowers on the sides and at the bottom of the legs (Page 170). They were ceremonial trousers and, by their cut and the embroidery that decorated them resembled the embroidered Kazakh buckskin trousers, or those made by urban craftsmen in Samarkand and Bukhara.

During journeys on horseback, coat-flaps were slipped inside these skin trousers.

From the end of the nineteenth century, industrial fabrics, velvet or cotton cloth, had

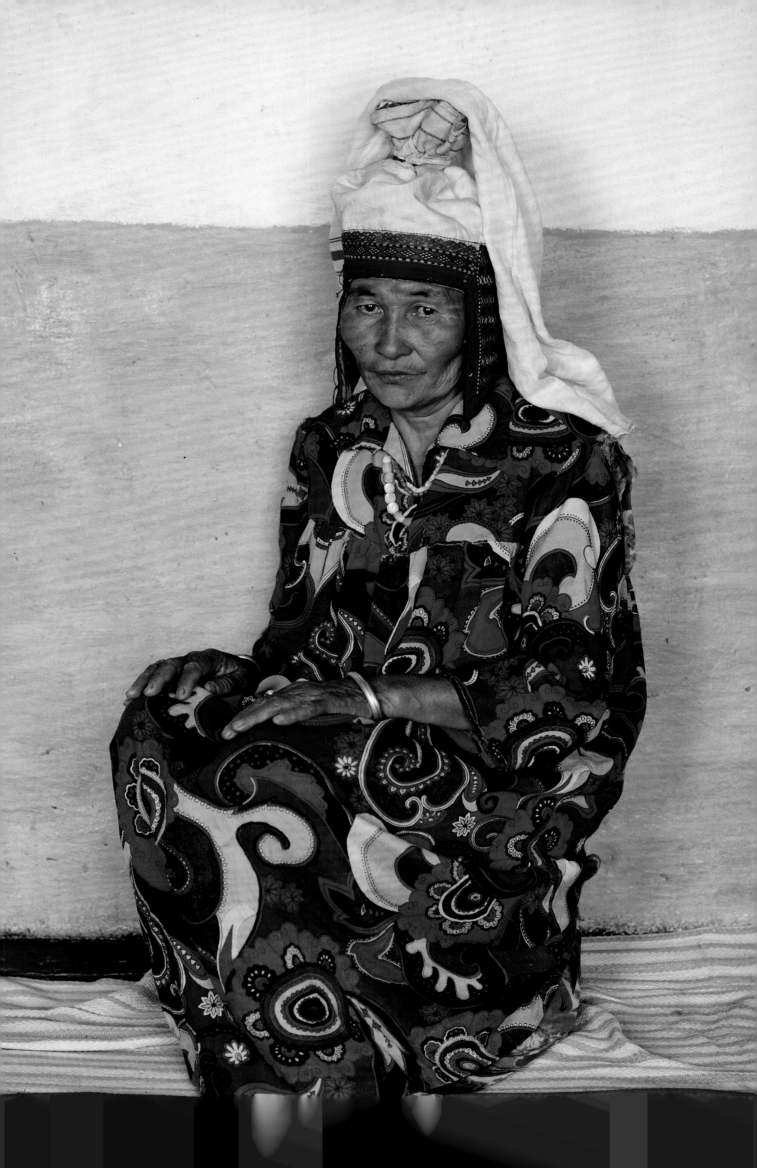

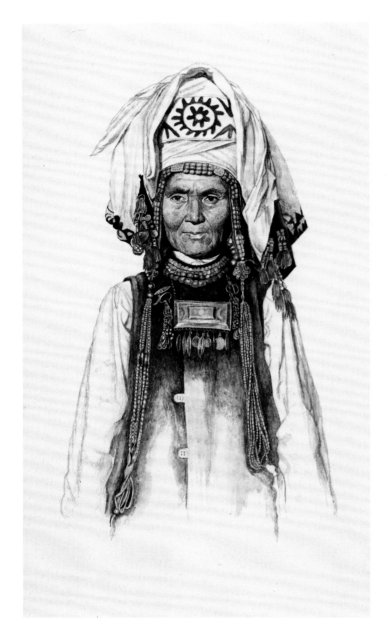

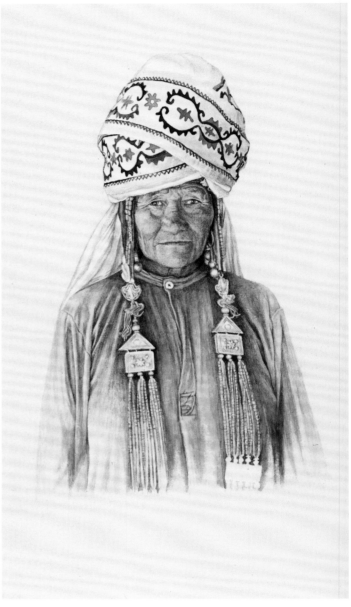

Sayma ileki (embroidered ileki) and chach kep
with silver and coral decorations.
Southern Kyrgyzstan, second half of the
nineteenth century

Woman wearing sayma ileki and chach kep
with silver and coral decorations.
Pamir, southern Kyrgyzstan, late nineteenth
century

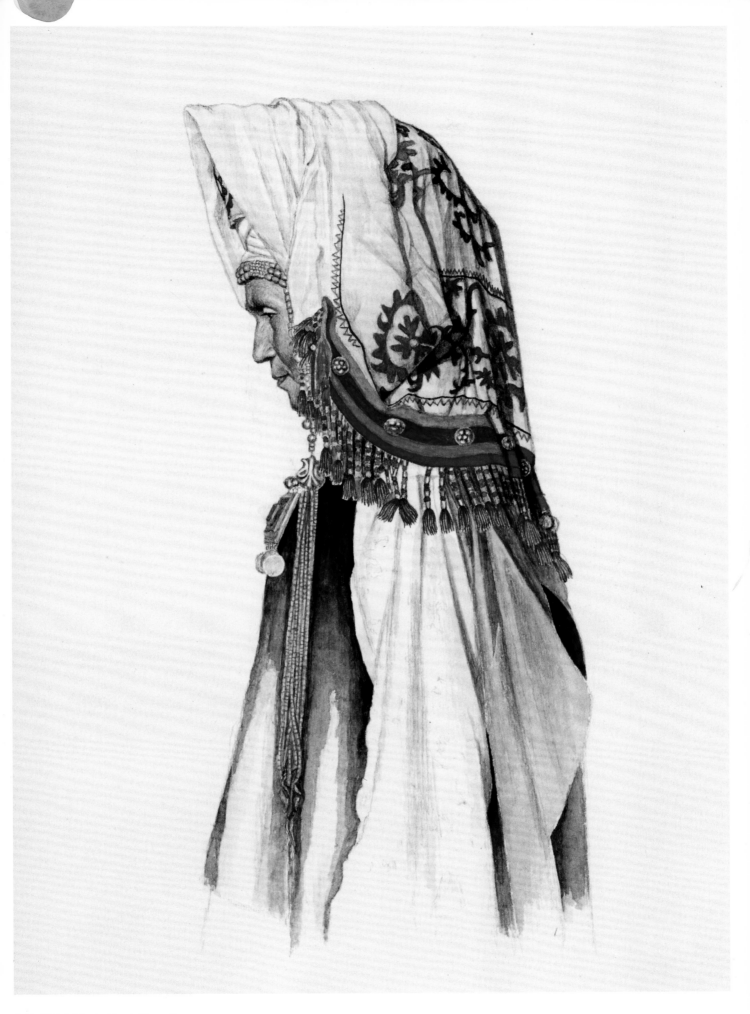

Ileki with *kalak* (embroidered silk scarf)
on top and *chach kep* with silver and coral.
Late nineteenth–early twentieth century

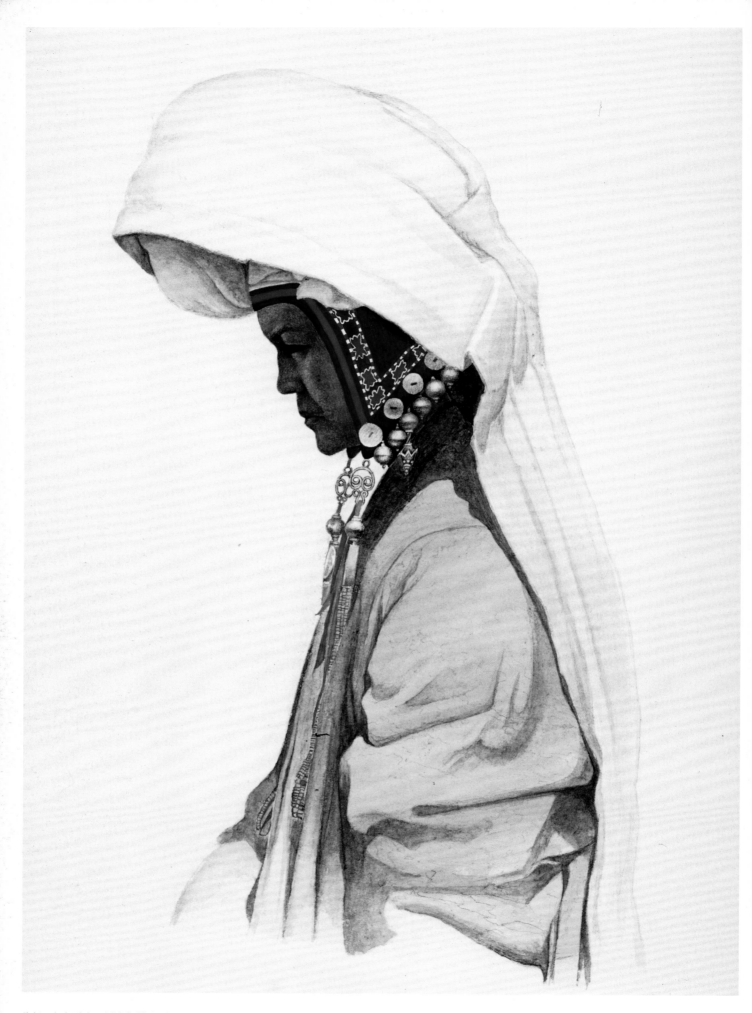

Ileki and *chach kap* (plait holder) with
mother of pearl buttons, round silver pendants
and coral ornaments.
Southern Kyrgyzstan, early twentieth century

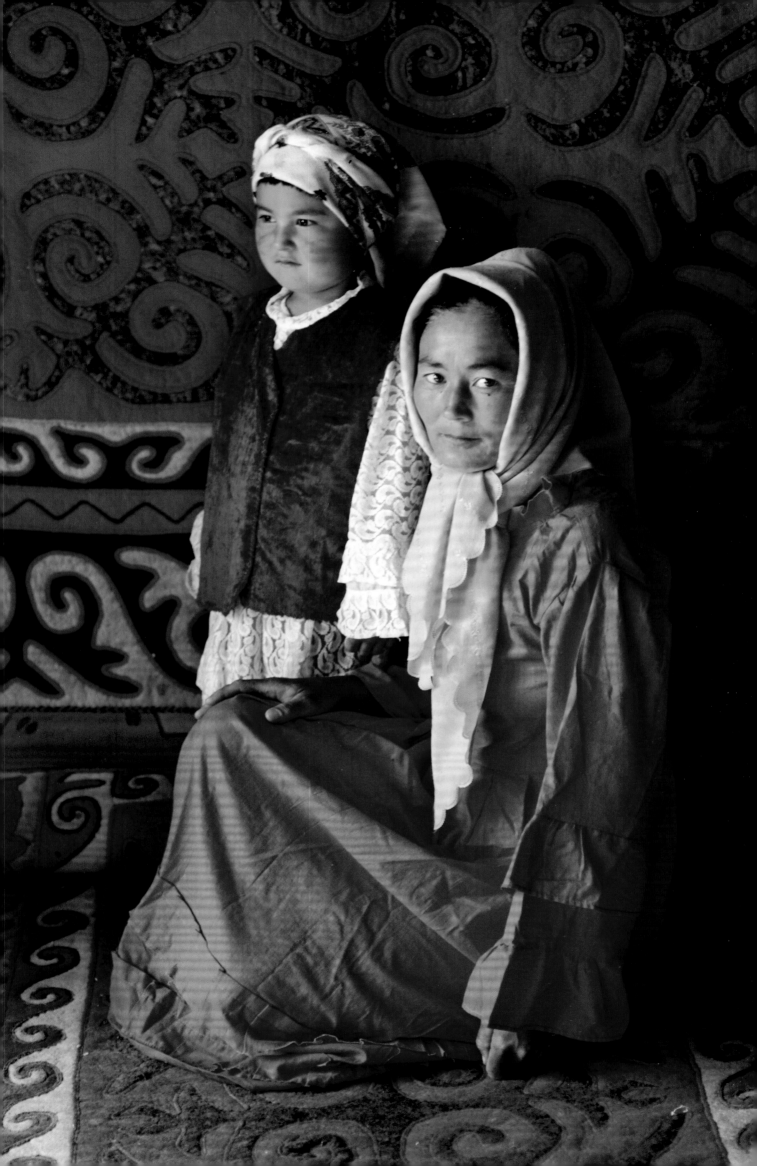

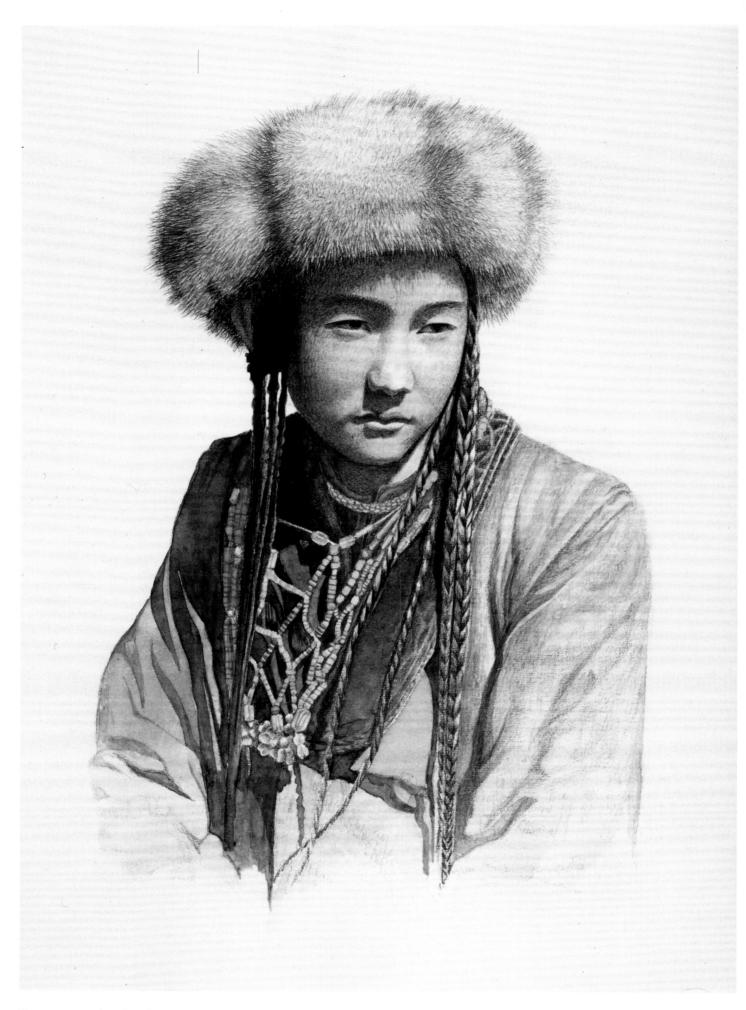

Young woman wearing *tebetey* from fox
fur, *boocy* (beads) and plaits on each side
of her face.
Northern Kyrgyzstan, early twentieth century

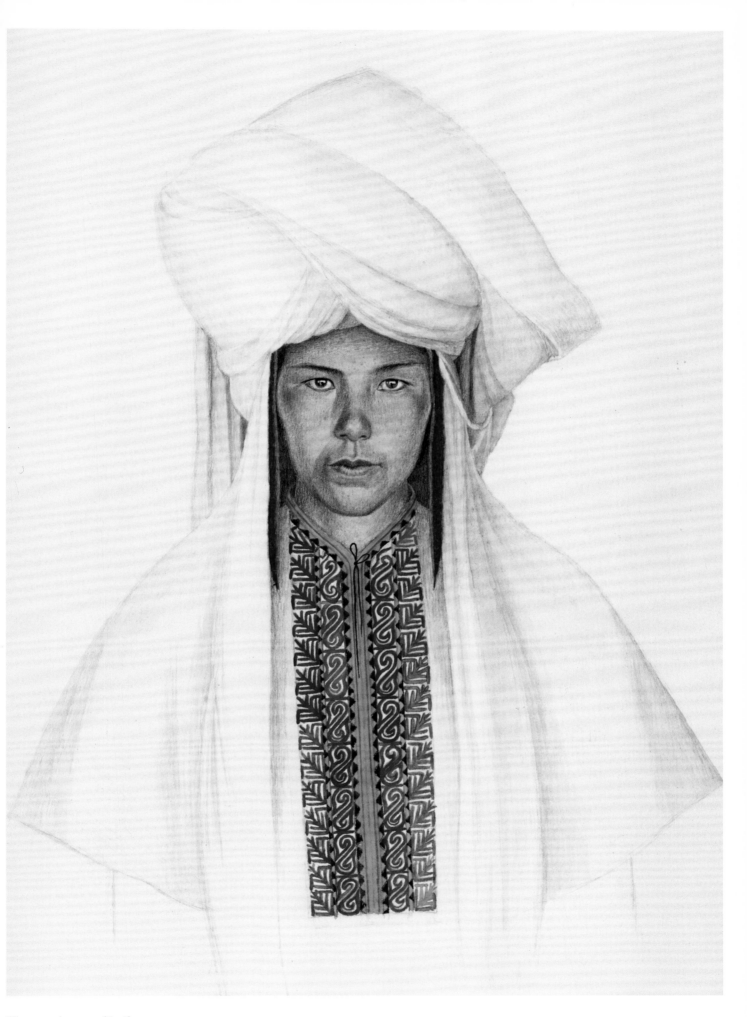

Woman wearing *sayma köynök*
(embroidered dress) with embroidery
onto a separate band around the neckline,
and *ileki* (southern turban).
Southern Kyrgyzstan, 1920–30

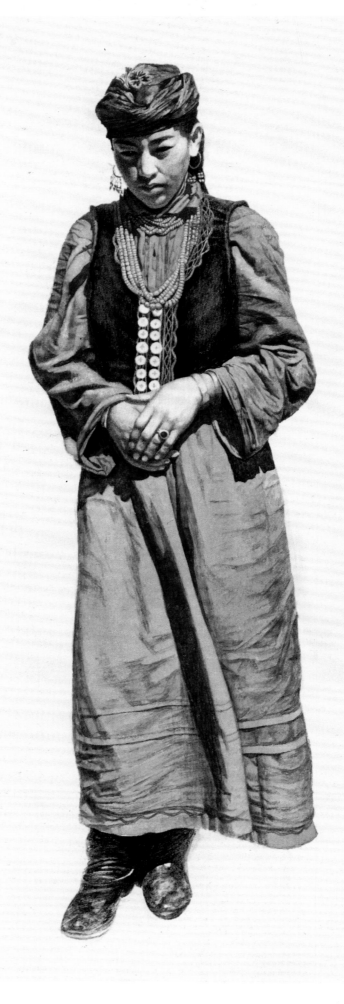

Woman wearing *chyptama* (short-style
waistcoat) with *topchu* (silver buttons), *shuru*
(coral necklace), earrings, *shakek* (rings)
and *bilerik* (bracelets). Also *djo'oluk*
(headscarf) and *köynök* (dress).
Southern Kyrgyzstan, 1950

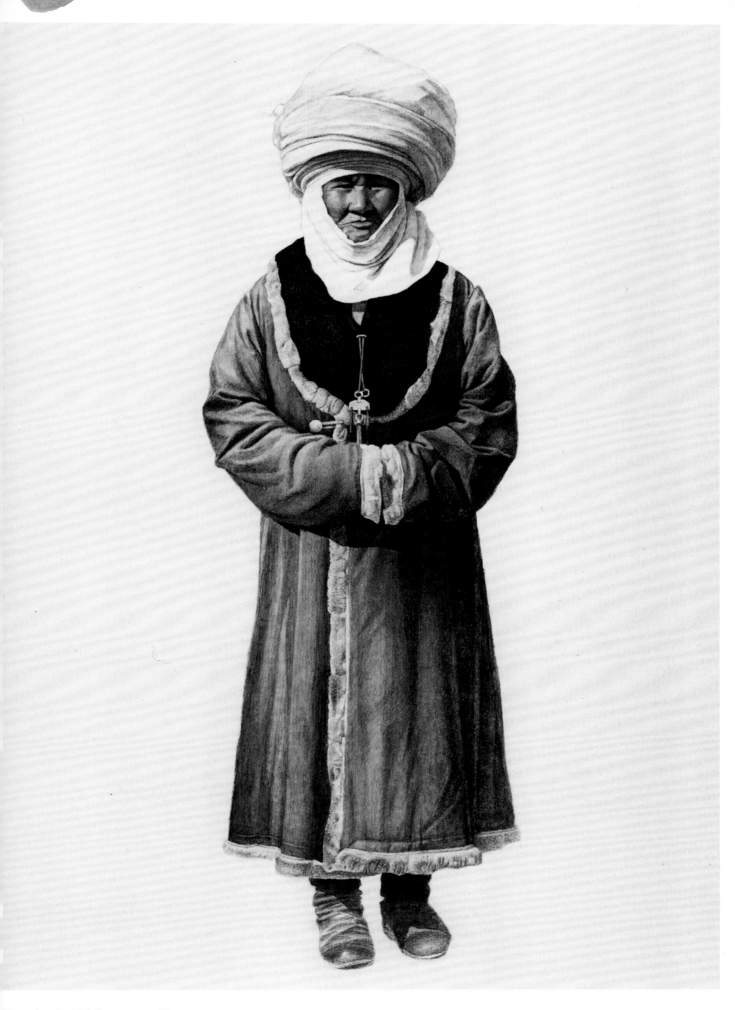

Woman wearing *ichik* (fur coat covered in
fabric) and *elechek* (northern turban).
Northern Kyrgyzstan, 1950

largely replaced the old woollen, leather or fur trousers, which are no longer worn except by hunters and cattle breeders (Page 171).

Winter Coats

In this mountainous country, with its severe climate, winter coats had to be warm and waterproof. There were numerous different kinds, made from felt, fur or wool. These coats were always big and all-enveloping, with long sleeves to keep the hands warm, and had a front opening with no buttons.

The left side always covered the right, which is characteristic of traditional Kyrgyz men's coats, and it was held in place with a leather or fabric belt.

Felt coats

In the expanse of the Central Asian steppes and the high pastures of the Tien Shan mountains, where the shepherds often slept out in the open near their flocks, a large overcoat of heavy warm felt, usually perfectly rain- wind- and snow-proof, was used. Such coats were found all over Central Asia, and are still in use in Afghanistan, Iran and in Turkey where they are known as *kepeneks*.

The large Kyrgyz felt coat is called *kementai*, but also *kebenek* or *kebanak*. The thick sheep's wool felt, with its natural white colour, was made into a long coat, open at the front, with long sleeves, and decorated with coloured patterns made by lines of stitching. The most beautiful were made of a fine felt, picked out carefully with lines of stitching around the edges. The ends of the sleeves, the flaps and the neck could be decorated with black leather on white appliquéd patterns (Pages 10, 159[2]).

Felt could also be used as a lining for farmers' clothes, such as the *chi'idan* and *doldai chepken*, coats made from hand-woven thick sheep's wool.

Fur and sheepskin coats

The high mountain semi-nomads, even nowadays, occasionally wear heavy sheepskin coats (*ton*) with the fur worn inside (Pages 153[2], 159[1], 168[2], 169[1]). These furs are used, not only outside for protection against the extreme climate, but inside the yurt, which, despite the thick covering of felt, can often be very cold in winter. The most refined of these coats are made from fox skin or *börü*, the mountain wolf skin (*Canis lupus*). These fur coats go back to remote antiquity. Their name *ton* is found on the Orkhon runes, the most ancient Central Asian Turkish language inscriptions from the eighth century. They are still also worn (very occasionally these days) among the Kazakhs, the Bashkirs, in the Altai and in the Tuva basin. In the north of Kyrgyzstan, these fur coats are called *postune*, as in Tajikistan and Afghanistan.

They are made of bands of fur, assembled and sewn, often with a large fur collar to protect the neck. They give good protection against the winter cold. At night, the high mountain shepherds spread them out over themselves like a blanket.

Another overcoat of very ancient origin was the *da'aky*, sometimes found in the northern regions of Kyrgyzstan until the end of the nineteenth century.

This was fashioned from colt skin (*kulun ton*), with the fur this time worn on the outside (Page 154). Tufts of colt's hair decorated the back and the sleeves. It was generally young people who wore this coat. In the same area, in very exceptional circumstances, you could come across a superb coat made from snow leopard fur, also with the fur on the outside. Only the richest herdsmen could afford such luxurious coats.

At the beginning of the twentieth century, in the Issyk-kul region, a new kind of sheepskin coat appeared. It was lighter, with a more modern cut, and imitated the Russian style, being fitted in at the waist with pleats at the back and a little turned down collar. It was known as a Russian *ton* (*orus ton*) or pleated *ton* (*büyürmö ton*).

Fur overcoats covered with cloth

By the end of the nineteenth century, when fabric manufactured in Russia was available all over Kyrgyzstan, it began to be used to cover over the outside skin of the fur-lined coats. These coats could also be trimmed with sheep or fox skin, or for the rich, with precious furs from animals such as the sable or marten, hunted in the mountains, the steppe or in the northern forests. These were the "going out" clothes for men and could form part of the marriage dowry. At festivals, the flock owners, with an ostentatious gesture intended to attract prestige, showed off their very best such coats, made of furs, rich cloth and adorned with costly decorations. These coats were called *kaptama ton* (covered coat) or *ichik*. They were cut smaller in comparison with the older shepherds' fur coats. They were shorter, ending at the ankles, with a more "city style", and were fitted, with short sleeves revealing the hands and a small turned-down collar (Page 166).

Woven Cloth Coats

Thick woollen coats

The most ancient traditional woven coat is the *chepken* or *chekmen*, an overcoat worn over a shirt or a light cotton or silk *chapan* coat. It is made of a thick woven sheep's wool or camel's hair (*termé*, *piazy*), undyed beige or natural brown in colour. It is warm, wind- and waterproof, and is worn especially in winter (Page 153[1]). Large and roomy, reaching down below the ankles, the *chepken* is open at the front, without buttons, cut so that the right side goes over the left side. The sleeves are long to protect the hands and it has no collar. Like the other traditional coats, it is held closed with a sash, a cloth belt (*kushak*) or a *kemer*, or decorated leather belt (Page 150).

The chapan

The *chapan* is the traditional quilted fabric coat of the peoples of Central Asia and of Kazakhstan. It is long and wide, open at the front, with the left going over the right (Page 158[1–2]).

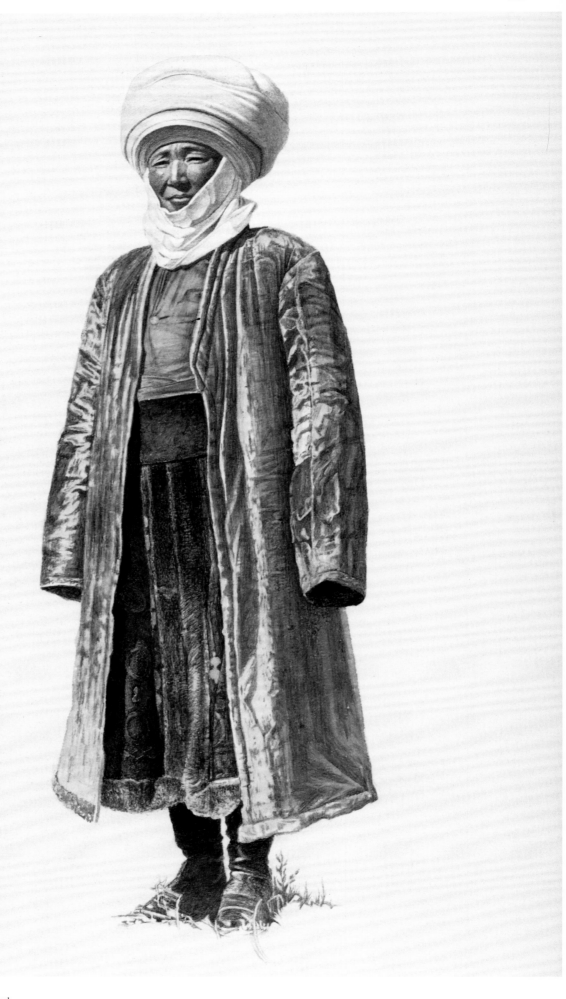

Woman wearing *chapan* (padded Central
Asian overcoat), *elechek* (northern turban)
and *beldemchi* (warm winter overskirt,
open at the front) with *bach beldemchi*
(cloth belt) clearly visible.
Northern Kyrgyzstan, late nineteenth century

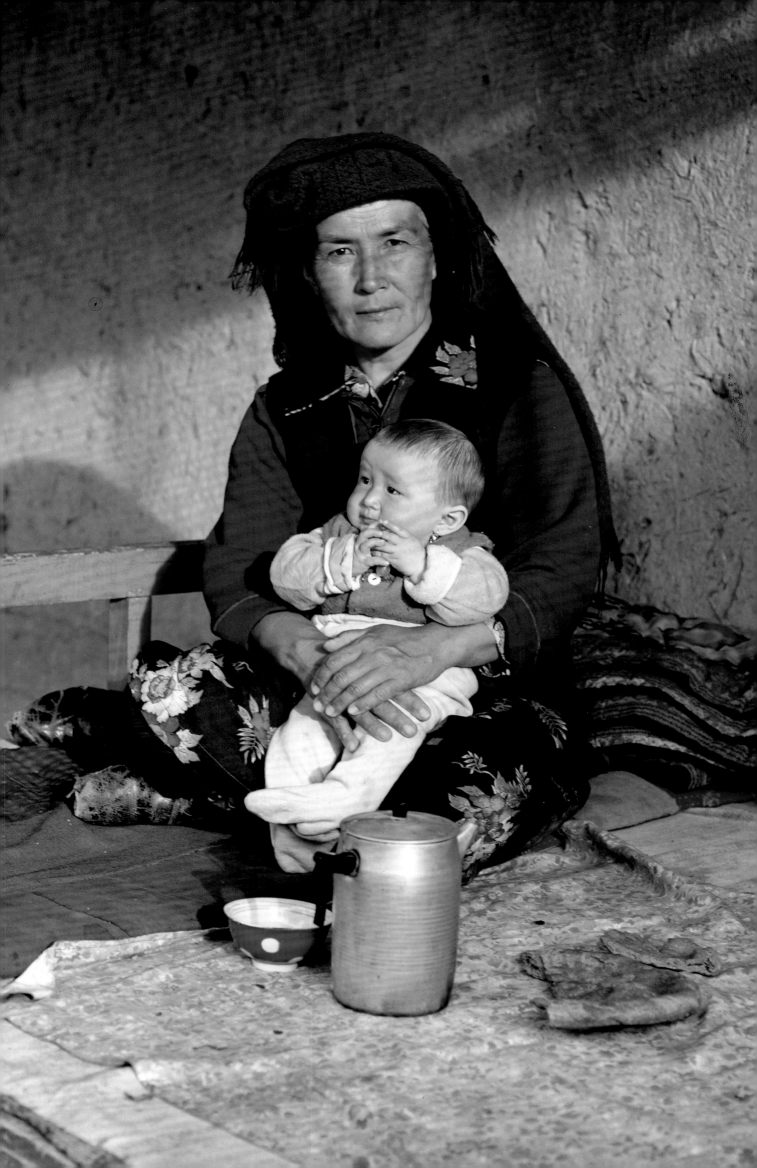

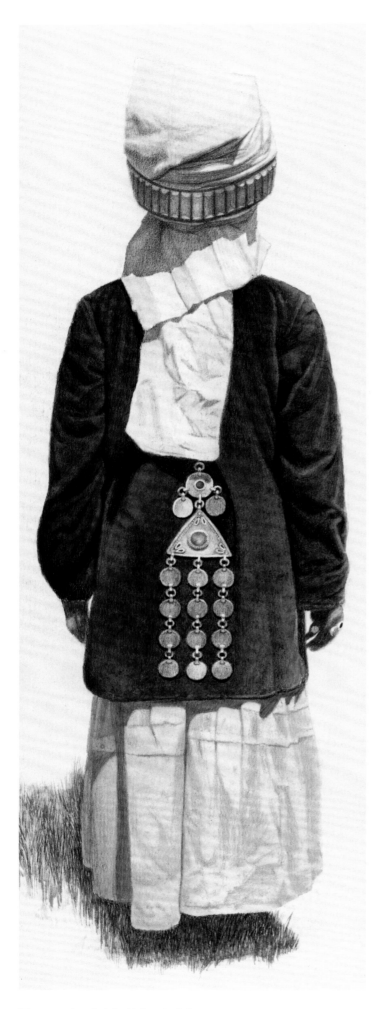

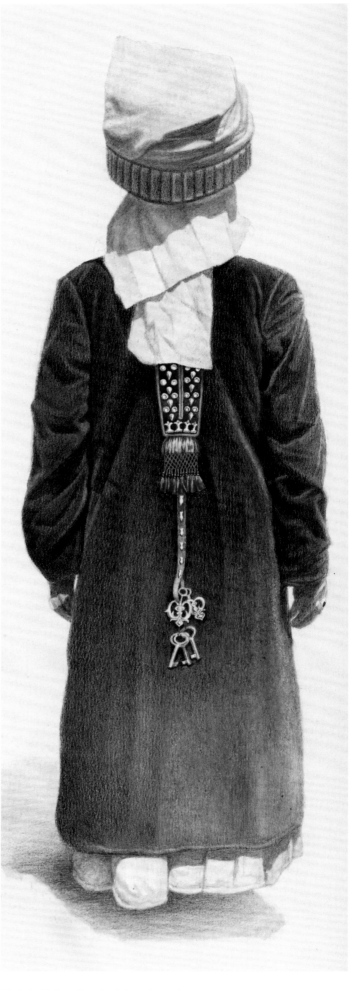

Woman wearing *elechek* with *kyrgak*, *cholpu*
(silver plait decoration), *köynök* (dress)
and *beshmant* (fitted overcoat).
Tien Shan, northern Kyrgyzstan, 1930–40

Elechek with *kyrgak* made of silver plates with
chach kap (plait holder) and *chach monchok*,
a fringe hanging from the *chach kap* with
metal pendants, including keys which jangle
as the woman walks.
Northern Kyrgyzstan, second half of the
nineteenth century

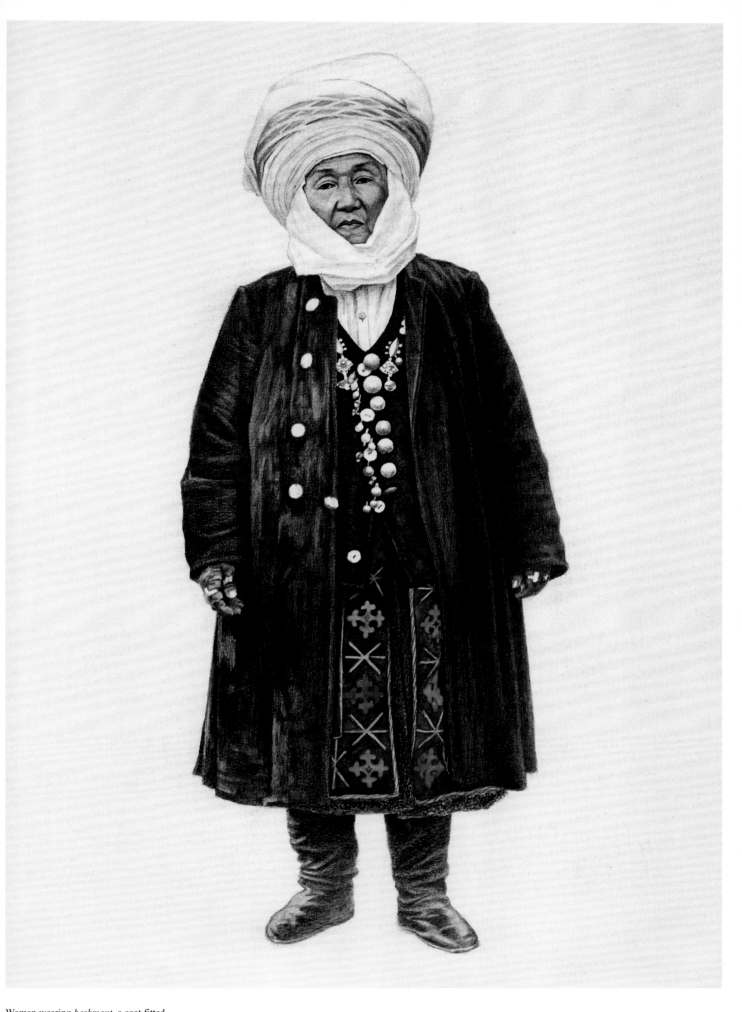

Woman wearing *beshmant*, a coat fitted
to the body, without padding or quilting, with
a stand-up collar, *beldemchi*, *elechek* and scarf
round her neck with *kyrgak* (a band of
beautiful decorated fabric which sometimes
encircles the *elechek*).
Northern Kyrgyzstan, late nineteenth century

95

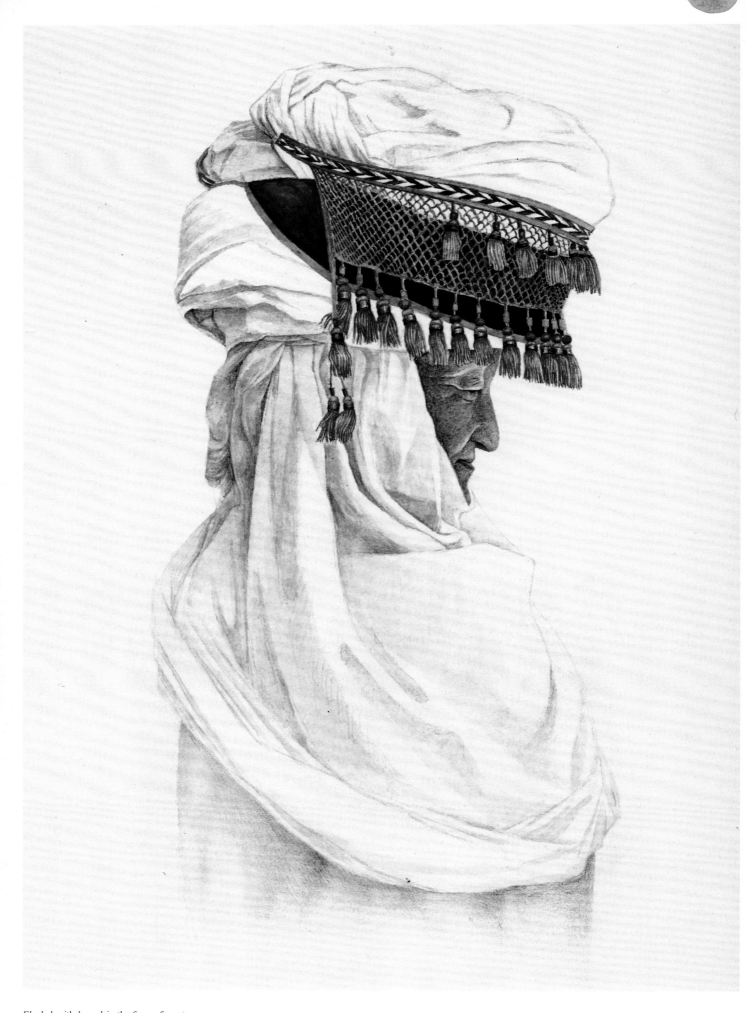

Elechek with *kyrgak* in the form of a net
and red silk tassels.
Talas Valley, late nineteenth century

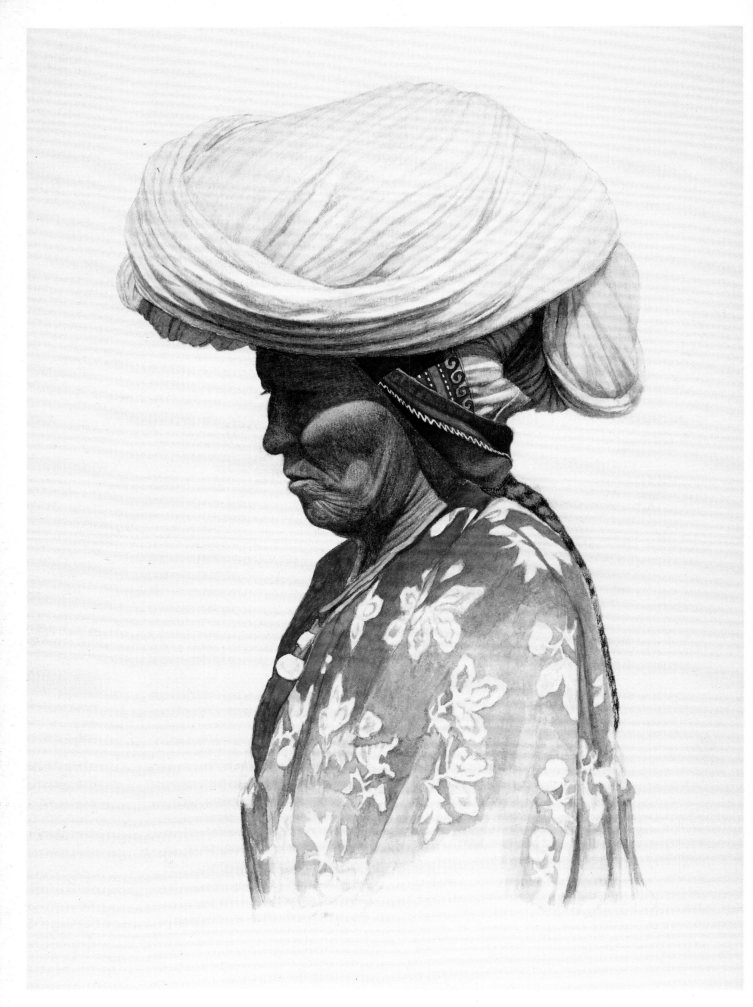

Ileki with *chach kep*.
Southern Kyrgyzstan, late nineteenth century

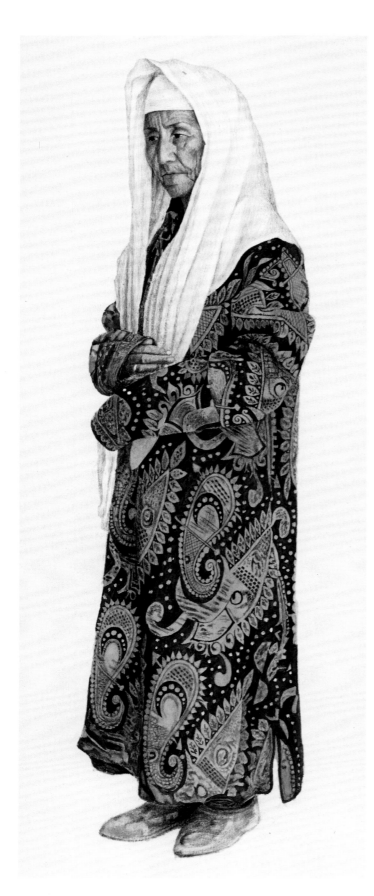

Woman wearing *chapan* from coloured cloth
and *djo'oluk* (scarf).
Southern Kyrgyzstan, early twentieth century.

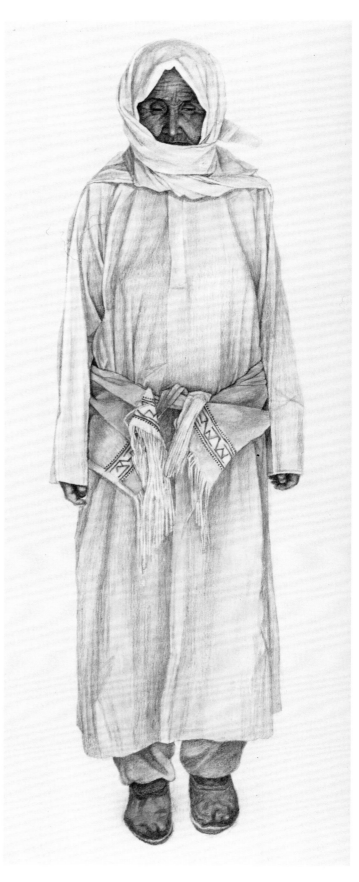

Woman wearing *djo'oluk* (scarf) and *köynök*
(dress) tied with a *belbo'o* (sash).
Southern Kyrgyzstan, early twentieth century

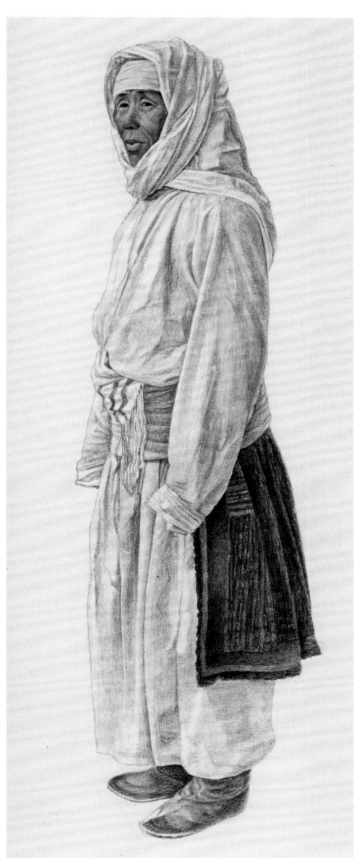

Woman wearing southern-style *beldemchi*
with wide front opening, *köynök* (dress),
and *djo'oluk* (scarf).
Southern Kyrgyzstan, 1900–20

Woman wearing *chapan* from *beykasam*,
and *elechek* (northern-style turban with scarf
around neck).
Southern Kyrgyzstan, second half of the
nineteenth century

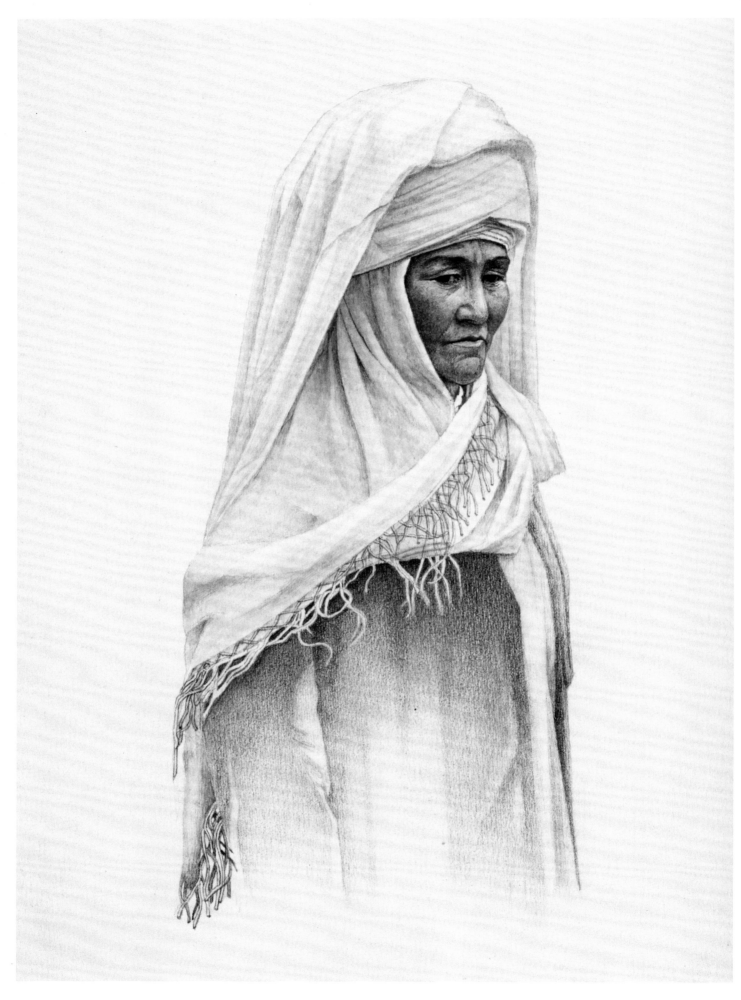

Elechek and scarf.
Talas Valley, second half of the nineteenth
century

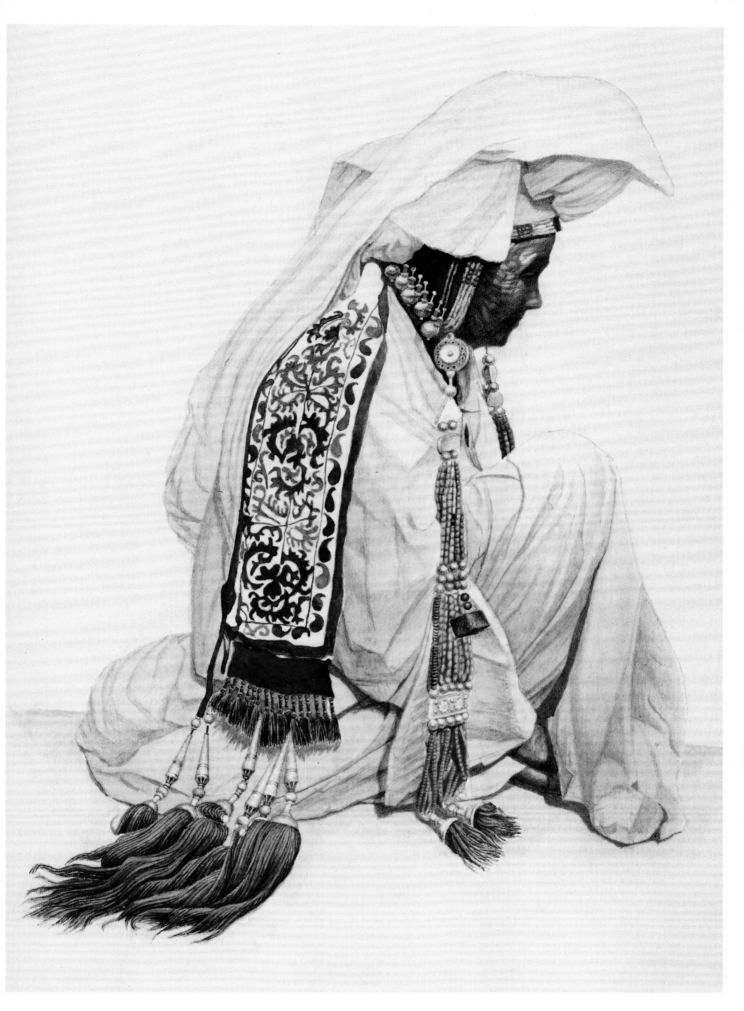

Ileki and *chach kep* with silver and coral
decorations. The embroidered flap and *chach
monchok* hang from the bonnet.
Northern Kyrgyzstan, late nineteenth century

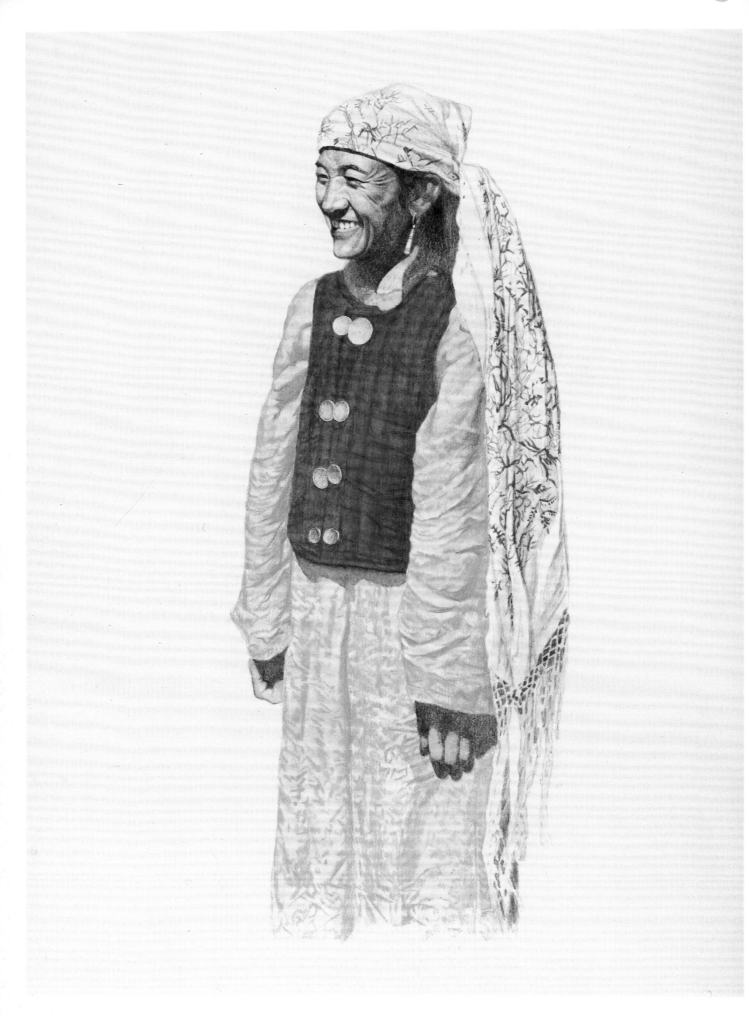

Woman wearing *chyptama* (short-style
waistcoat) with *topchu* (silver buttons),
djo'oluk (headscarf) and *köynök* (dress).
Southern Kyrgyzstan, 1950

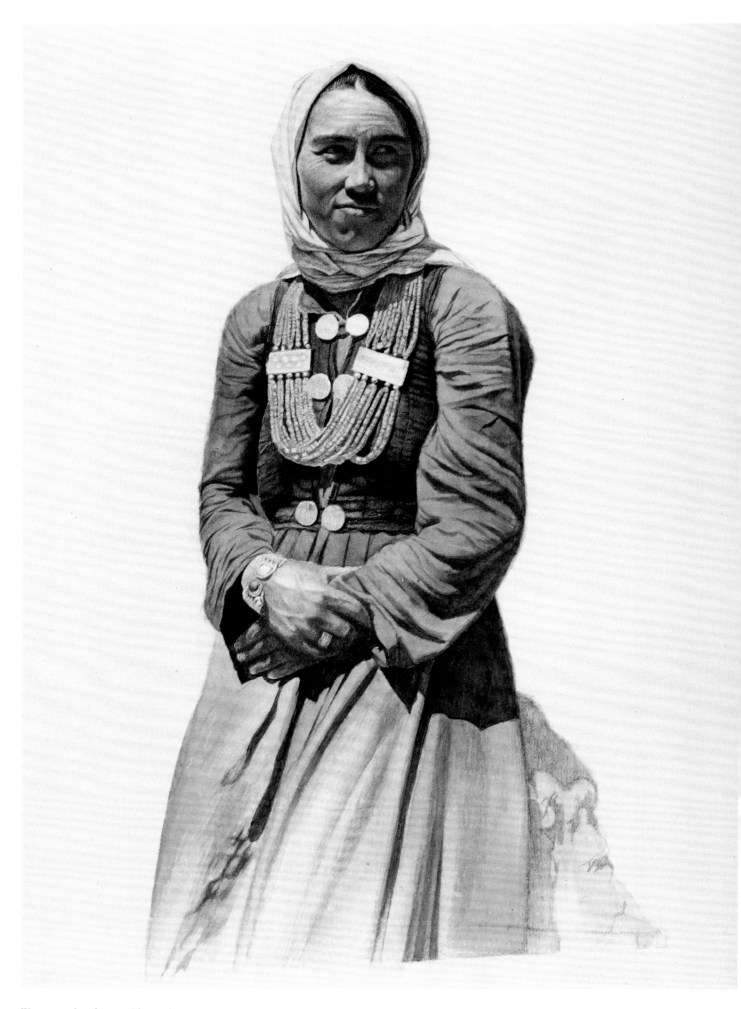

Woman wearing *chyptama* (short-style
waistcoat) with *topchu* (silver buttons), *shuru*
(coral and silver necklace), *shakek* (rings),
bilerik (bracelets) and *djo'oluk* (headscarf).
Northern Kyrgyzstan, 1920–50

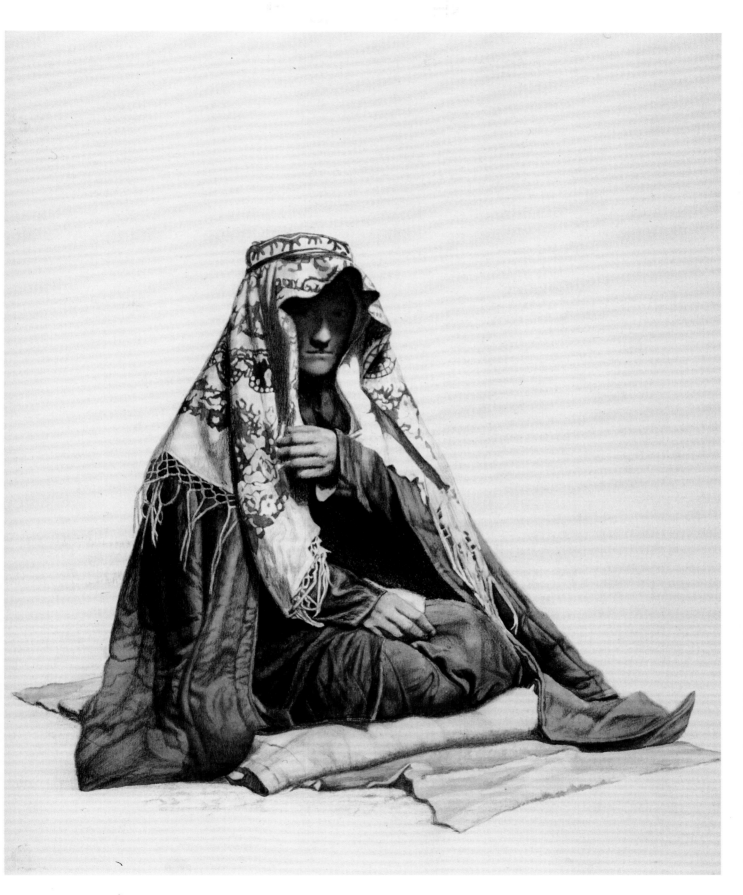

A *djesir* (widow), wearing *sayma djo'oluk*
(embroidered scarf) and *chapan*.
Southern Kyrgyzstan, early twentieth century

Formerly the sleeves were very long, passing the hands by 15 to 20 centimetres. Little by little, during the second half of the nineteenth century, the sleeves became shortened so that they were more practical. These sleeves were attached at right angles to the main body of the coat, with a gusset under the arms allowing for ease of movement. A piece of fabric cut diagonally, the *chalgai*, was sewn on the right flap of the opening to close the right side of the *chapan* under the left when it is fastened.

This coat was worn in winter and summer over a shirt and trousers. It was made of narrow bands of cloth, hand-woven on a horizontal loom, either in wool, cotton or in the half-cotton and half-silk striped fabric, *beykasam*. It was lined with hand-printed patterned fabric, or else with Russian-made cotton wadding, printed with large floral coloured patterns. It was trimmed with cotton wadding and completely quilted in longitudinal bands, 3 or 4 centimetres wide, which held the lining in place. A decorative stitching highlighted the neckline and the front coat-flaps. When riding, the coat tails were often slipped inside the trousers (Page 170).

In the past, the *chapan* was made from dark-coloured cotton fabric or, more rarely, from woollen cloth, or striped fabric (*illassa, na'npty, no'otu, trinké* or *lampuk*), known as *beykasam* or *alacha* in Uzbekistan. In the northern regions, old people liked to wear *chapans* made from printed Russian fabric in dark colours, whereas the young preferred craftsman's fabrics with brightly coloured stripes.

Until the end of the nineteenth century, you could come across luxury *chapans*, sewn from buckskin and embroidered with large roses and multicoloured floral patterns. These were in a similar style to the ceremonial deerskin trousers, and were mainly found in northern Kyrgyzstan and, sometimes, among their Uzbek and Kazakh neighbours.

The *tu'ura chapan*, a coat with straight flaps, spread over most of the country except to the west. This coat was often found in the Lake Issyk-kul region, in the mountains of Tien Shan, in the Alai and Pamir mountains and in Chou Valley. It did not have a flap added, it was amply cut, with round sleeve holes and a flared base. It was padded with a cotton-wool quilted lining.

Until the end of the nineteenth century, *chapans* were always made by local tailors. But, from the start of the twentieth century, the Kyrgyz began to buy more and more readymade Kazakh and Russian coats from the north, and in the southern and western markets, striped fabric *chapans* were imported from the neighbouring Tajik and Uzbek regions.

Also frequently worn in the south was the *djelek*, a traditional summer coat that was a kind of striped cloth *chapan*, unlined and not padded or quilted.

Armenius Vambery, the Hungarian traveller who in 1863 crossed the then forbidden Central Asia disguised as a pious Muslim, noticed in Bukhara bazaar, that the Kyrgyz, Kipchaks and Kalmuks came there to buy these *chapans* made from "the most striking colours".

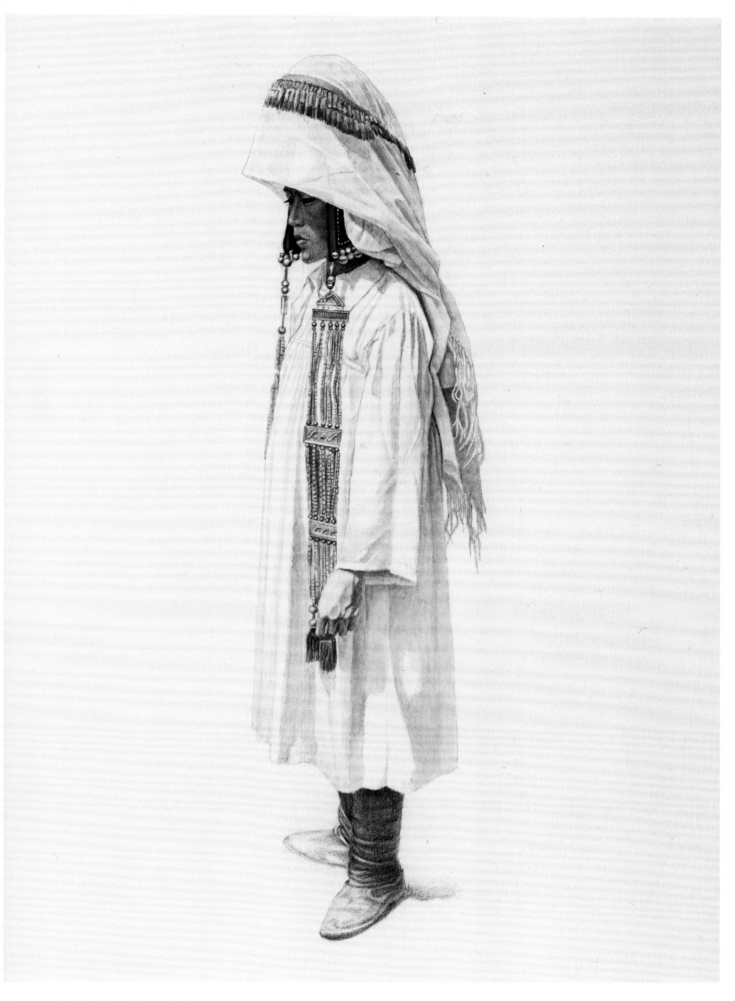

Woman wearing *ileki* and *kyrgak* (woven band
fastening with tassels) and *chach kep* with
coral beads linked with silver plates.
Ferghana Valley, southern Kyrgyzstan,
1930–40

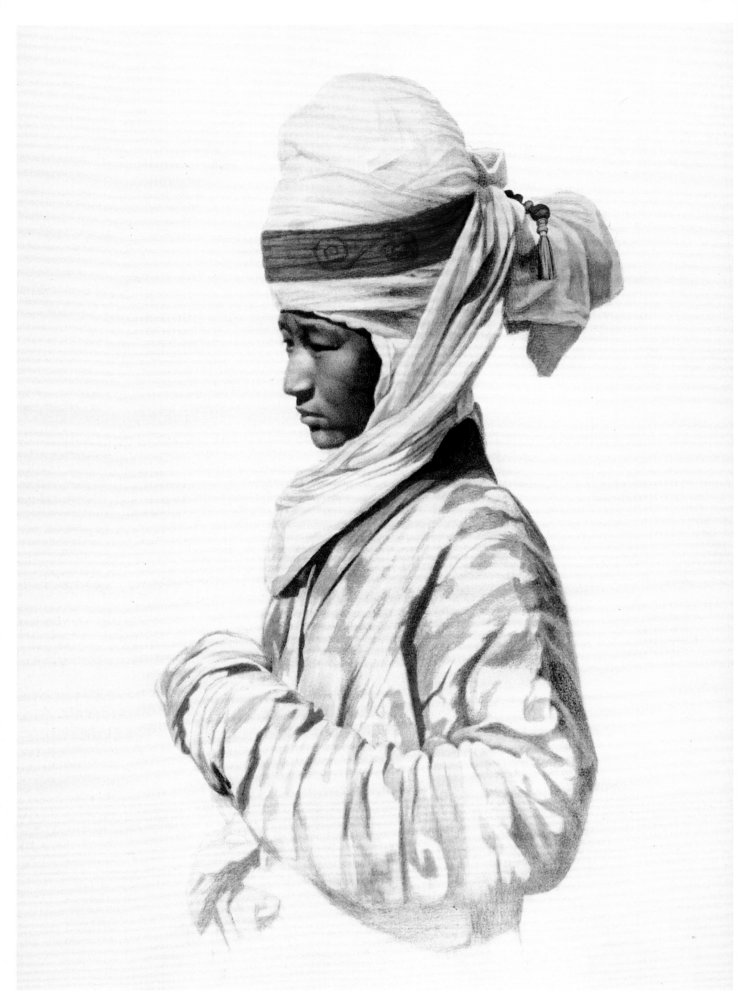

Woman wearing Talas style *elechek*
with *kyrgak* (band of decorated fabric that
encircles the *elechek*).
Talas Valley, late nineteenth century

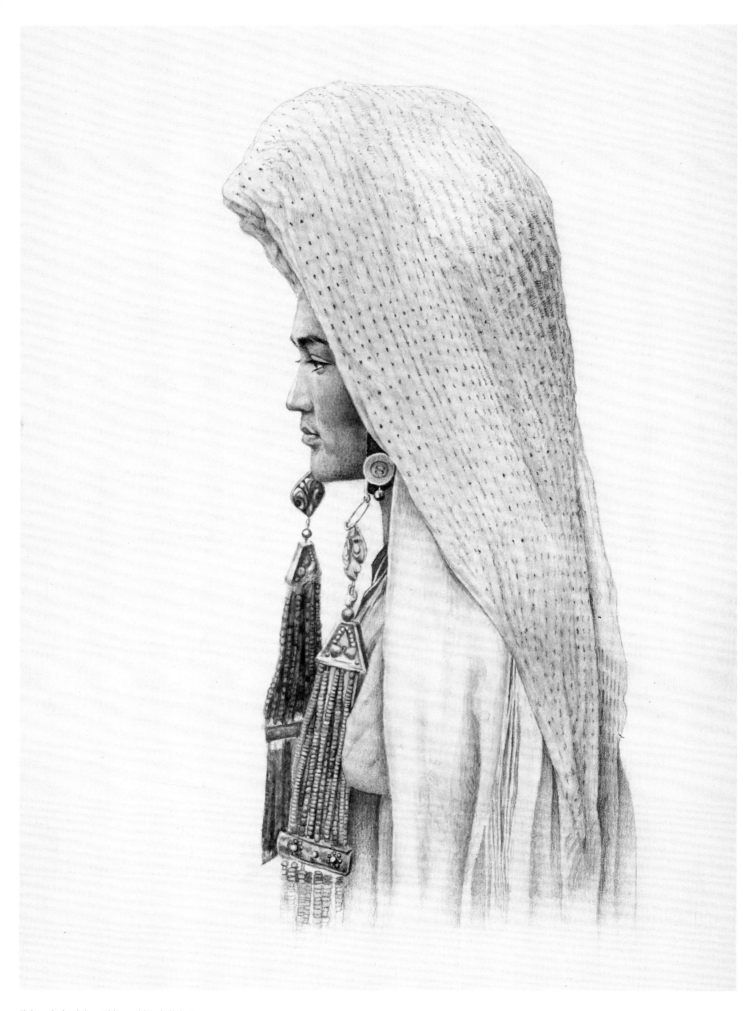

Ileki and *chach kap* with coral beads linked
with silver plates.
Southern Kyrgyzstan, late nineteenth century

Other light coats

From the end of the nineteenth century, lighter coats, more fitted than the wide *chapan*, began to make their appearance. As with women's clothes, there was the *beshmant*, a coat fitted around the body, lined but not quilted, with a high collar; the *kemsel* or *kemzir* coat, with short sleeves only reaching to the top of the elbows and the *kelteché*, a waistcoat without sleeves.

The *beshmant* was a fitted coat with a modern cut. It had horizontal pockets, and was fastened with buttons. It was very practical, more like a long jacket than a coat, and was adopted by men as well as women in northern Kyrgyzstan. It was used by city dwellers, mountain shepherds and, indeed, anyone who needed a coat which was easy to carry and didn't interfere with movement. It was lined with cloth, had either a high or an open neck, and the sleeves ranged from full-length to being cut at the elbows. It was fashioned from beautiful woollen fabric as well as from coloured velvets. Young people especially liked bright colours such as yellow, green, red or violet. Although fitted, it was widened at the waist for comfort on horseback (Page 169[2]).

The *kemsel* was a short coat, cut to the knees, with the sleeves reaching to the elbows. The *kelteché* was a kind of sleeveless jacket, coming down to above the knee. By the end of the nineteenth century, it had become the everyday costume for women and old men. The *kemsel*, like the *kelteché*, could be lined and was sometimes quilted. These two short coats must have been borrowed from the Bashkirs and the Tatars who wore similar clothes in the nineteenth century.

Belts

Kyrgyz men and women have always traditionally worn cloth bands or leather belts around the waist. These are fixed around sheepskin overcoats, waistcoats, jackets and even shirts.

Fabric belts, *bel kur* ("fabric belt around the waist"), and sashes, *belbo'o* ("waist band"), *boto kur* or *keshenyé* were formerly woven by hand and were very long, from 1.5 to 2 metres (Page 150). By the beginning of the twentieth century, they had been replaced nearly all over the country by factory-made cloth belts.

Older people secured their clothes with a white belt, the young chose coloured belts, often with a red background. In the Pamir region, in the south of the country, the Kyrgyz, following the Uzbek and Tajik example, used silk or cotton sashes, *charkchi* or *oromol*, which were sometimes embroidered. Often a leather belt or strap was put over a fabric belt (Page 158[2]).

Some southern Kyrgyz imitated the rich Uzbeks of Bukhara by sporting a silk velvet sash decorated with silver plates engraved in black, or else with silver decorations in relief, encrusted with gold, coral or semiprecious coloured stones.

In the ancient Kyrgyz epic Manas, a leather belt was known as *djekene*; now it is called *kemer* as in contemporary Turkish. This leather belt, worn by Turkic people across Central Asia, was reserved for the richest Kyrgyz. They decorated them abundantly with rings,

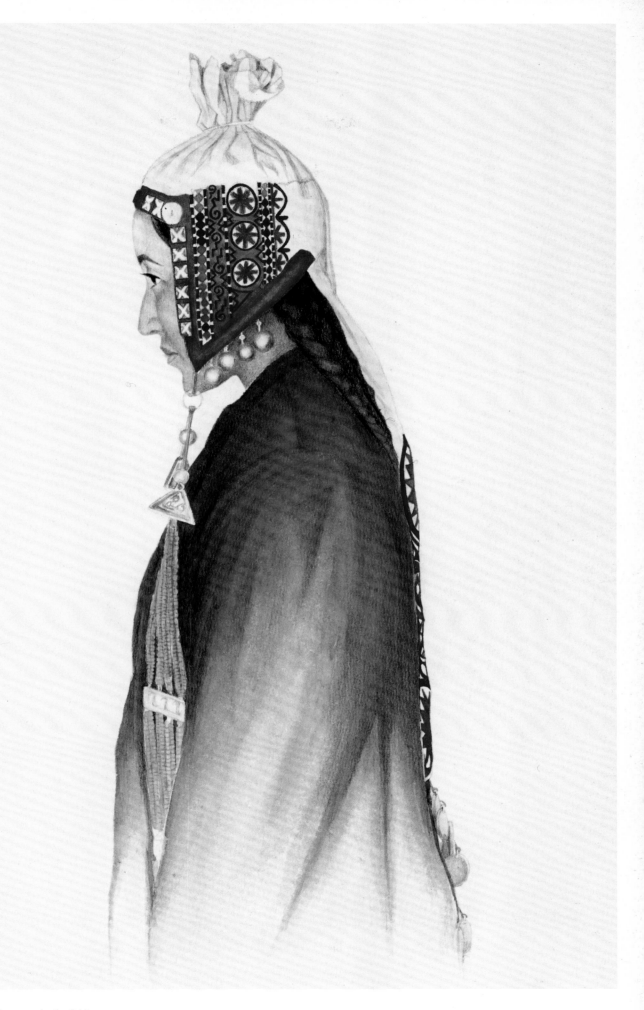

Chach kep (bonnet which goes under the *ileki*)
with silver and coral decorations. In the north
this bonnet is undecorated and is known as the
kep takiya.
Northern and southern Kyrgyzstan,
end of the nineteenth century

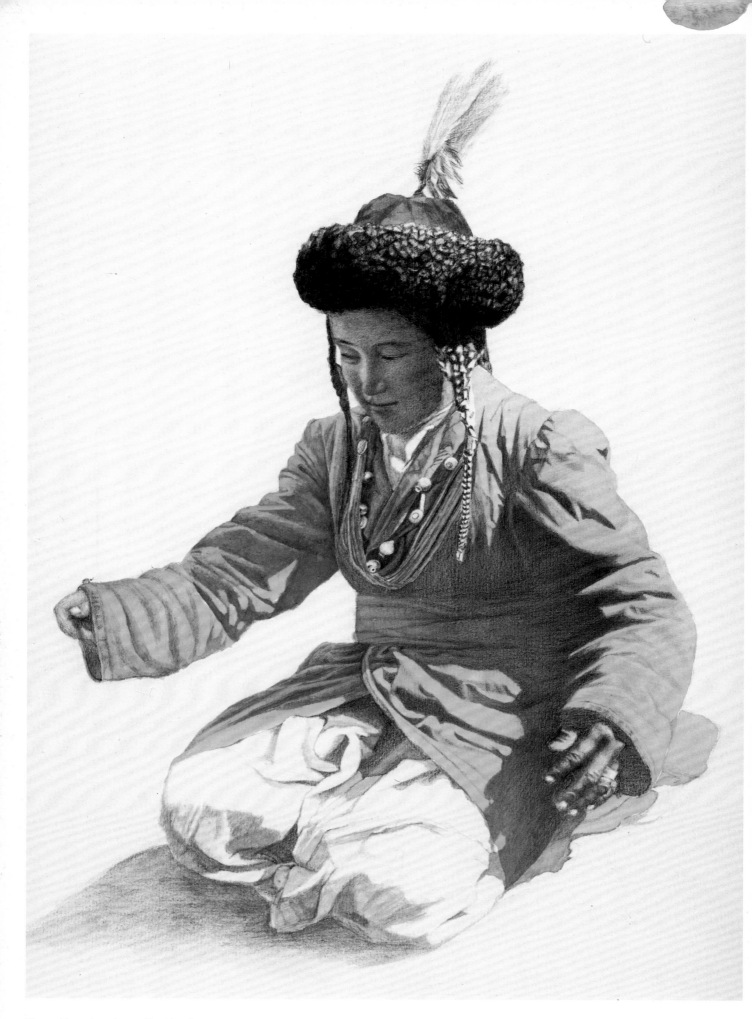

Young girl wearing *tebetey* with a trimming
of Astrakhan fur and owl feathers, *chapan*
and *shuru* (coral necklace).
Northern Kyrgyzstan, early twentieth century

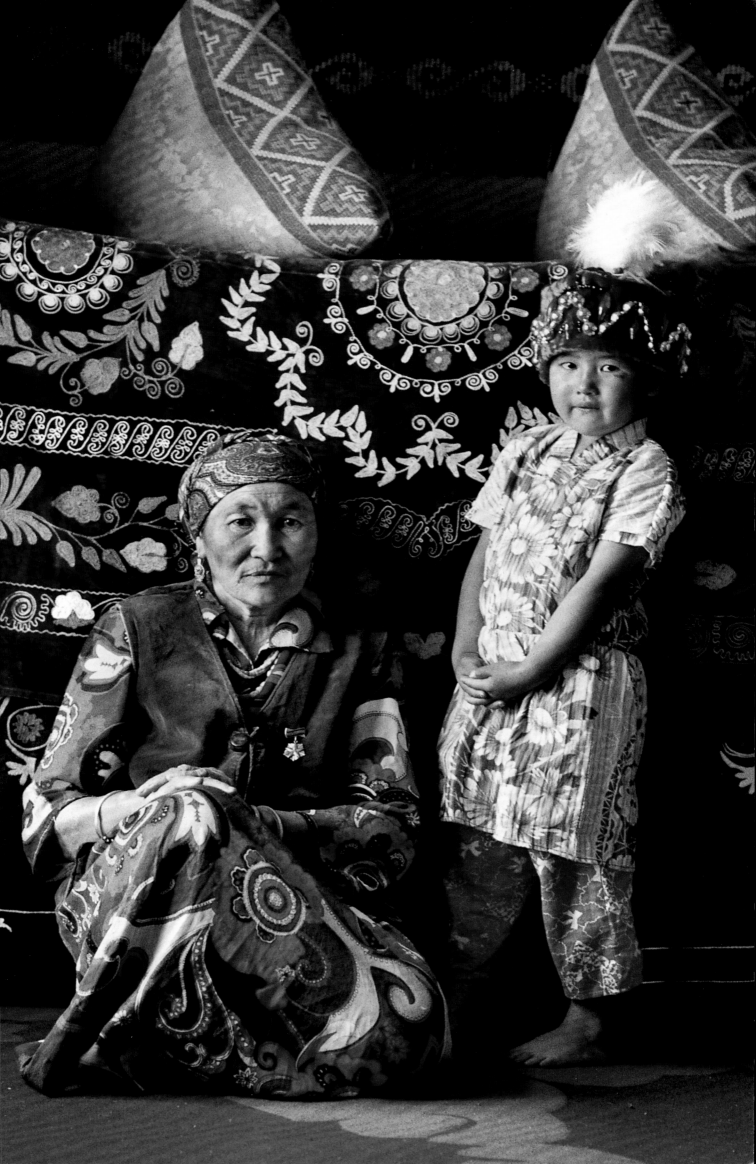

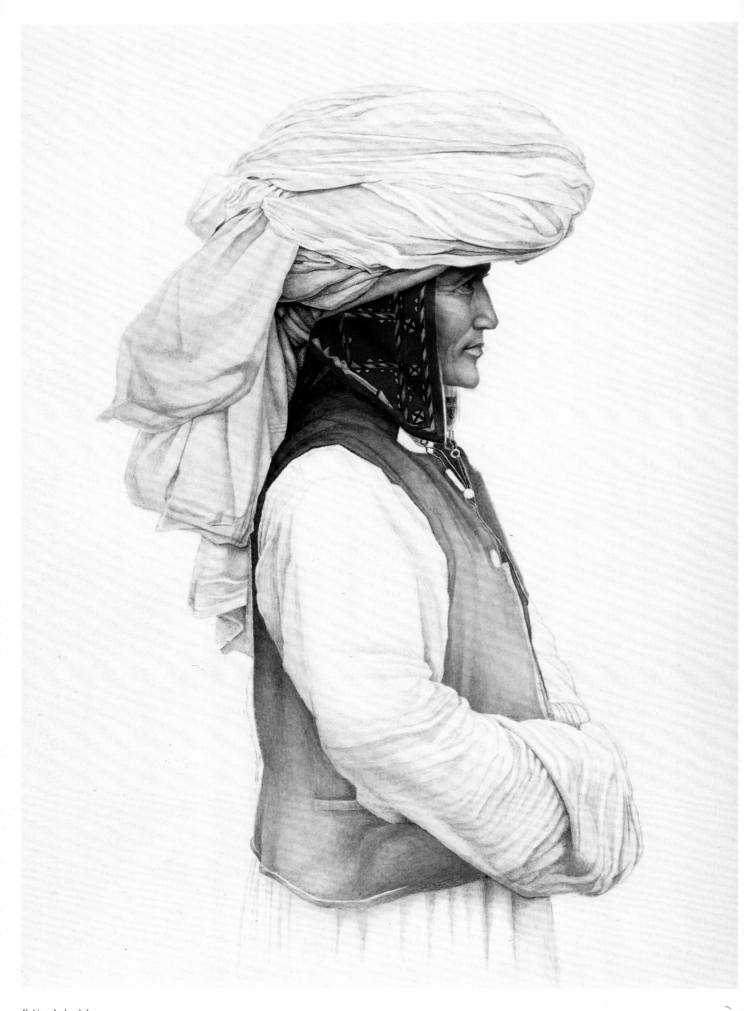

Ileki and *chach kep*.
Southern Kyrgyzstan, second half of the
nineteenth century

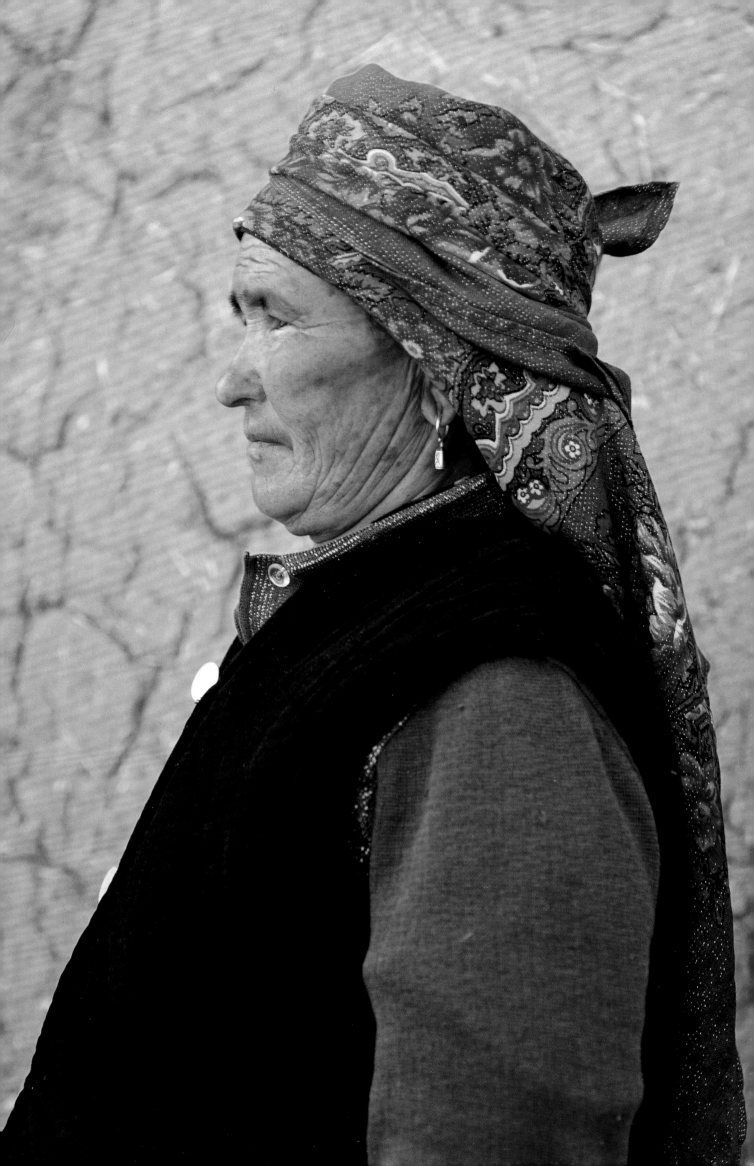

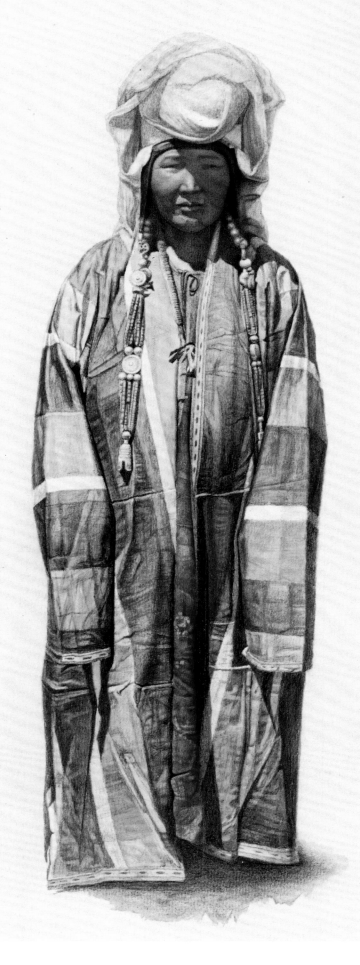

Woman wearing *chapan* (quilted Central
Asian overcoat), *ileki* (southern turban) and
chach kep with silver and coral decorations.
Southern Kyrgyzstan, 1930–50

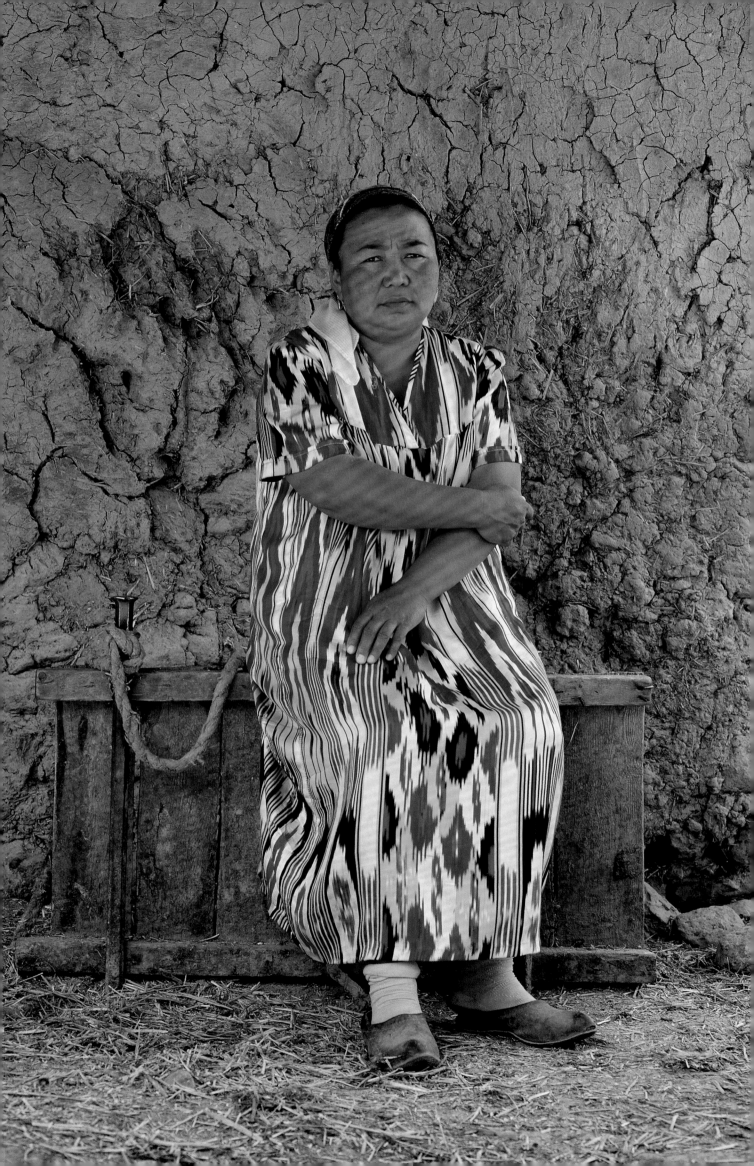

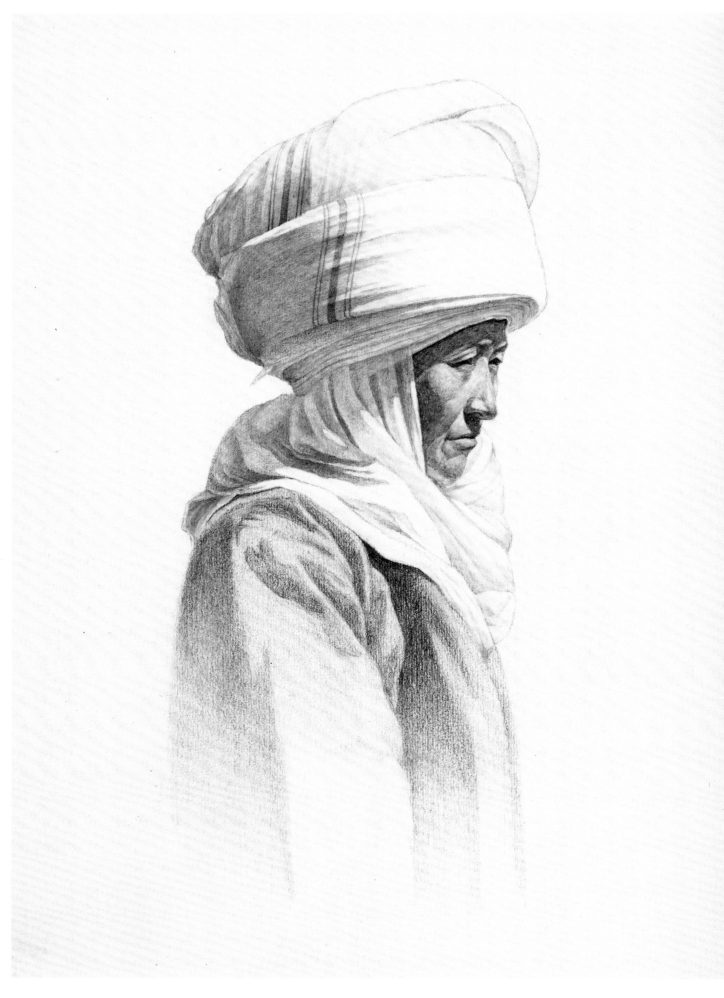

Elechek.
Northern Kyrgyzstan, mid-twentieth century

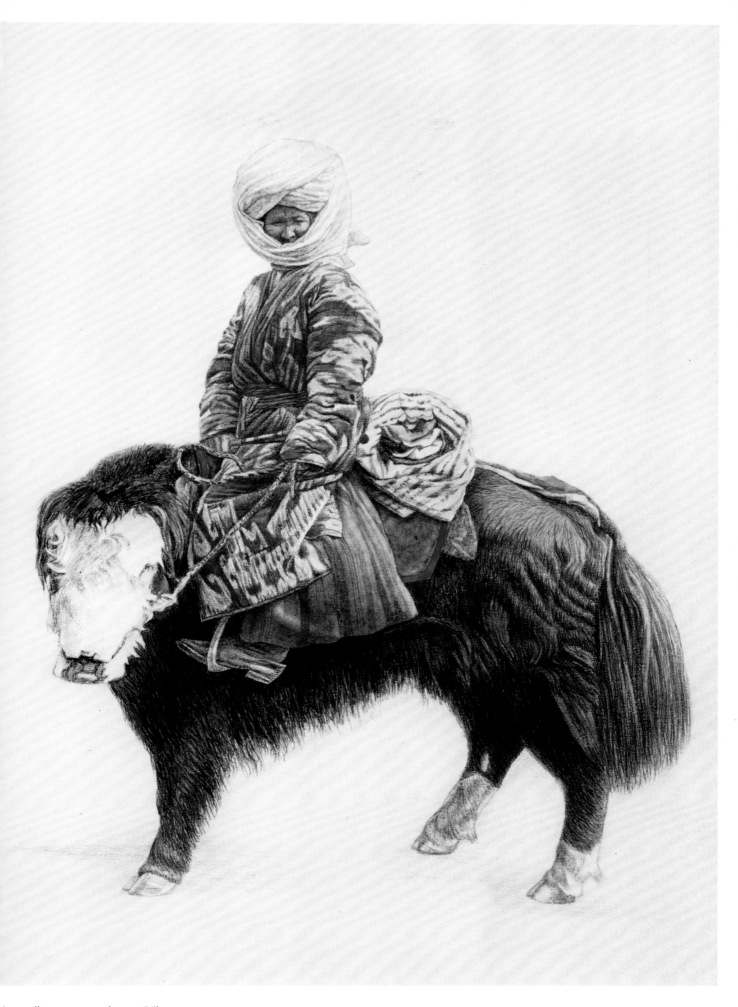

A nomadic woman on a yak wears *ötük*
(boots), *elechek* and *chapan* of *beykasam*.
Pamir, southern Kyrgyzstan, late nineteenth
century

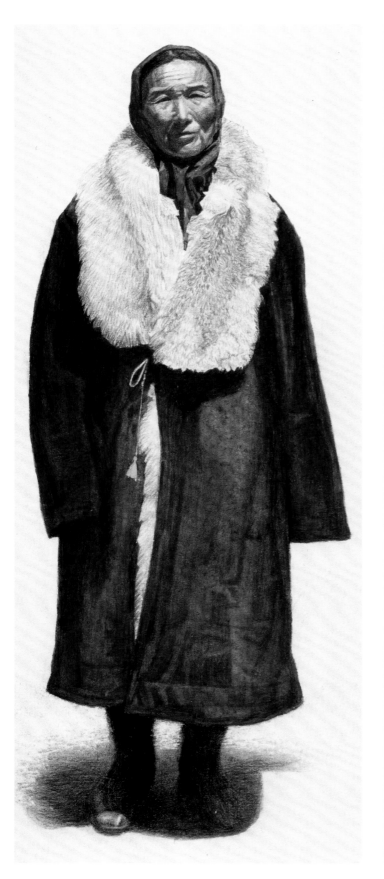

Woman wearing *djakalu'u ichik* (sheepskin
coat covered in cloth) with collar and *djo'oluk*
(scarf).
Tien Shan, northern Kyrgyzstan, 1920–40

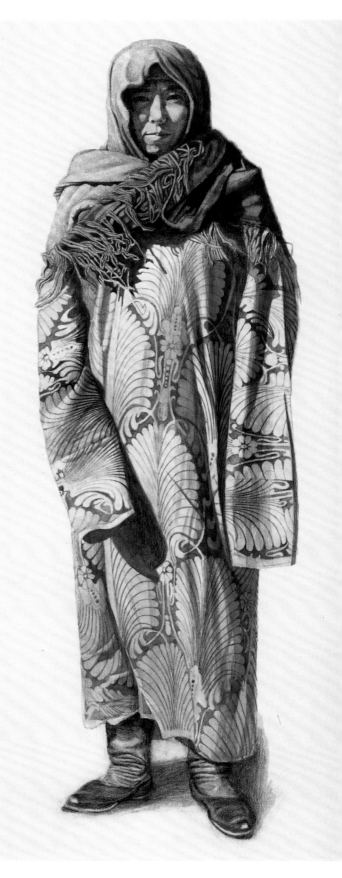

Woman wearing *ma'asy* (soft leather
boots with light soles) and *kepich*
(leather overshoes), *köynök* and *djo'oluk*
(large headscarf).
Southern Kyrgyzstan, 1950

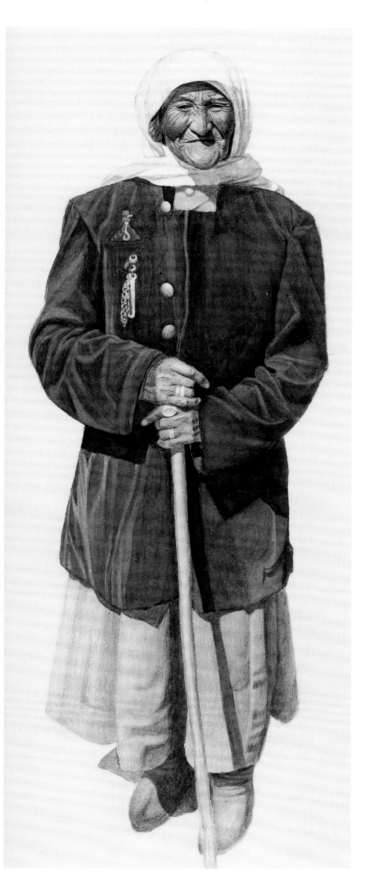

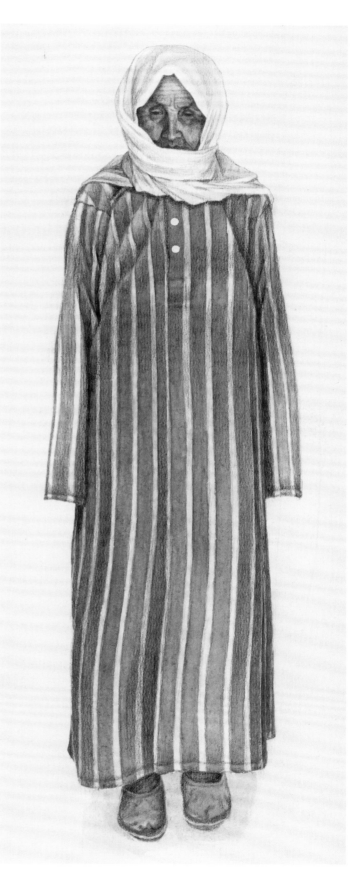

Woman wearing *beshmant*, with talismans and
evil eye protectors attached.
Northern Kyrgyzstan, first half of the
twentieth century

Woman wearing striped *köynök* (dress)
with buttons and *djo'oluk* (scarf).
Southern Kyrgyzstan, late nineteenth century

Child wearing an Astrakhan *tebetey*
and a quilted *chapan*.
Southern Kyrgyzstan, early twentieth century

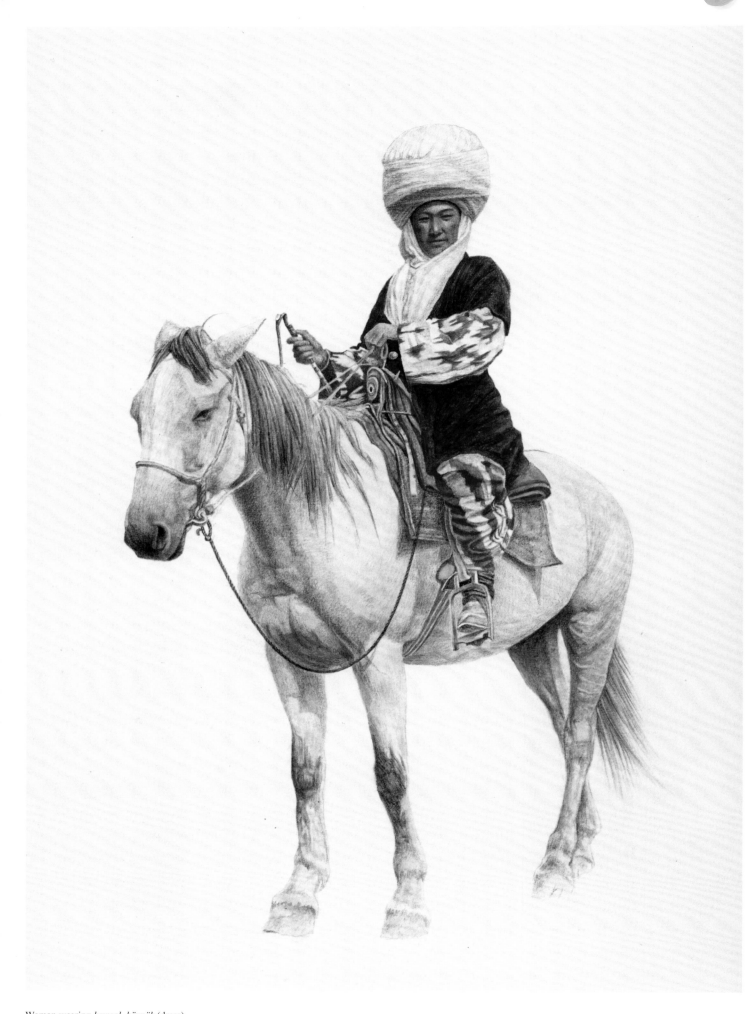

Woman wearing *kemsel*, *köynök* (dress)
from Uzbek silk and *elechek*.
Northern Kyrgyzstan, late nineteenth century

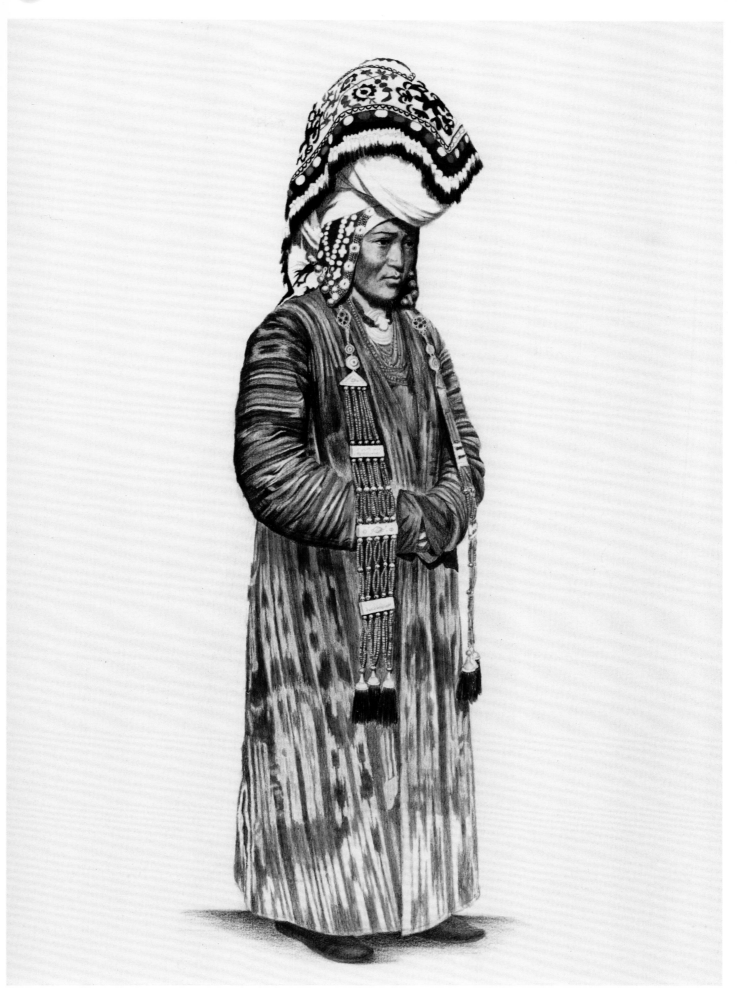

Woman wearing the *ileki* and *chach kep*
with silver, mother-of-pearl and coral
decorations, and featuring a *kalak* (silk
embroidered scarf over the *ileki*). The woman
is also wearing a *shuru* (coral necklace)
and overcoat or *chapan* of Uzbek *adrass*.
Ferghana Valley, southern Kyrgyzstan,
early twentieth century

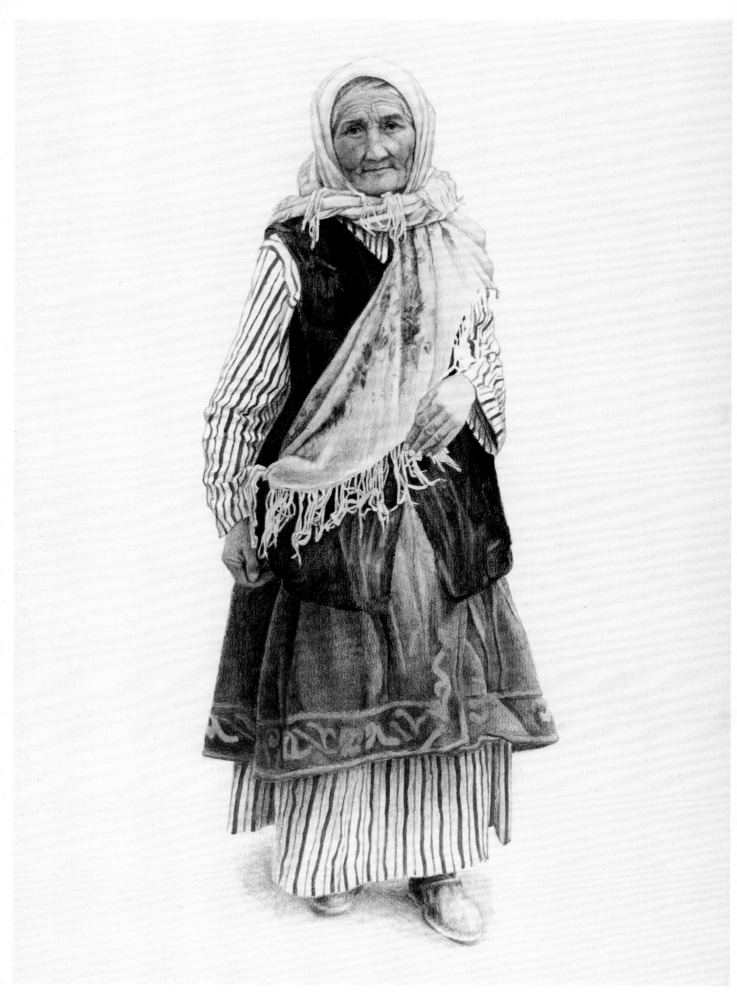

Woman wearing *kelteché* (waistcoat),
köynök (dress), *beldemchi* and *djo'oluk*
(big head scarf).
Northern Kyrgyzstan, 1950

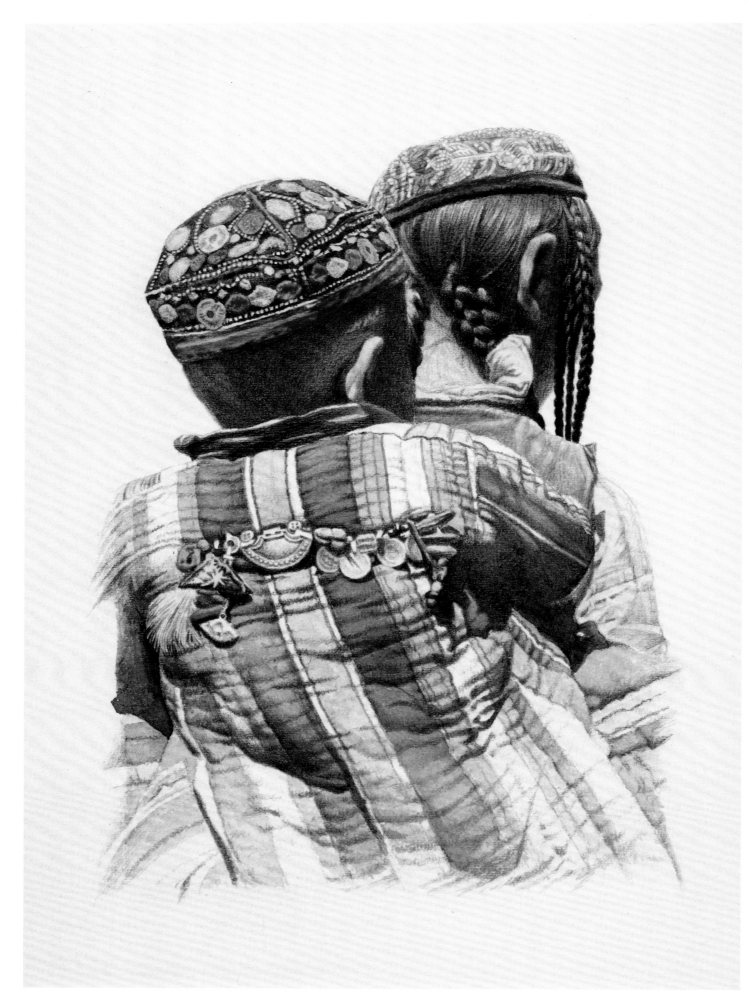

Child wearing *chapan* with *tumar* (amulets)
of silver and coral sewn onto the back.
Both children are wearing *sayma topu*
(embroidered skullcaps). Older girl wearing
side plaits.
Southern Kyrgyzstan, 1930–40

buttons or ornate plates of silver. Also known as *bedene kemer* ("chrome belt"), these belts added a touch of elegance and solemnity to an outfit (Pages 166, 170).

The belt was an essential element of men's and women's wear. A Kyrgyz man would never go out of his yurt without a belt around his waist. In the epic songs, wrapping round a belt signifies the undertaking of a glorious action. It is the belt that confers invulnerability to the hero, because it is seen as "impenetrable". As with many Asian peoples, not wearing a belt means one is not dressed, and to undo the belt is to abandon oneself, to recognize defeat or else to undress oneself.

Until the beginning of the twentieth century, Kyrgyz men kept the ancient tradition of carrying a fire lighting kit of the Mongol type on the left hand side of the belt. This was a plate of iron on which to strike a flint to set light to a piece of cotton. Also carried on the belt were a razor, a long awl for sewing leather, a purse, a pipe and a pouch of tobacco. All these accessories were attached to the belt, protected by a special embroidered leather pouch. Hunters added powder flasks and bullet cases (See also Page 150 for knife on belt).

Caps and Hats

Kalpak

In summer, the Kyrgyz still very often today wear a white embroidered felt hat, which has black highlighted seams (Pages 10, 164, 169[2]). This *kalpak* hat very closely resembles the equivalent headgear of the Kazakhs and the Karakalpaks.

Formerly, the region of the steppes and mountains south of Lake Balkash, now occupied by the Kazakhs and the Kyrgyz, was traversed by Saka nomad pastoralists. Herodotus, the fifth century BC Greek historian, described the Saka and their western neighbours, the Scythians, who lived in the regions to the north of the Black Sea from the eighth to the third century BC.

The Sakas were horse-riders who knew how to work in bronze and iron and produced objects decorated with felt, wool, copper, wood and bone. They are famous for their "animal-style" art, also known as Scytho-Siberian art.

According to Herodotus, they wore tall straight pointed headdresses in thick black felt. A bas-relief at Persepolis (the east staircase of Apadana) shows Scythians wearing tall pointed caps, as well as fabric trousers tucked into supple leather boots, such as Herodotus had described. It is probably a relic of this Saka hat that is still found today in the Kazakh and Kyrgyz *kalpak*.

The conical *kalpak*, which could be up to 40 centimetres high in the nineteenth century, is made of four pieces of felt sewn together to join them. It has a wide brim, slit at the front and the back, which is worn turned up. The turned-up sides of the hat are lined with satin or black velvet, which makes the white of the felt stand out. The top of the hat is sometimes trimmed with a tassel.

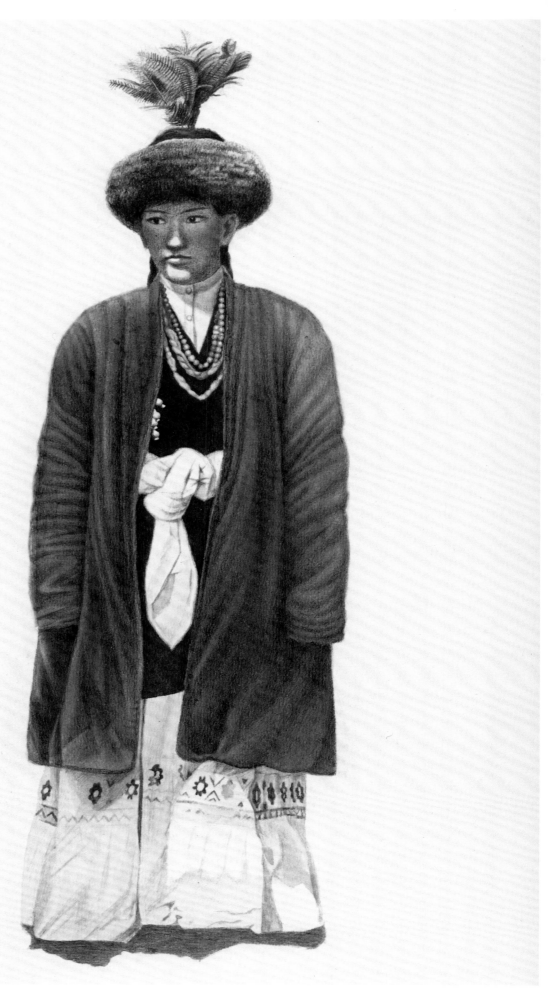

Woman wearing *sayma köynök* (embroidered
dress) tied with a *belbo'o* (sash), *beshmant*
(overcoat), *tebetey* (hat edged in fox fur
and decorated with eagle owl feathers)
and *shuru* (coral necklace).
Northern Kyrgyzstan, 1920–30

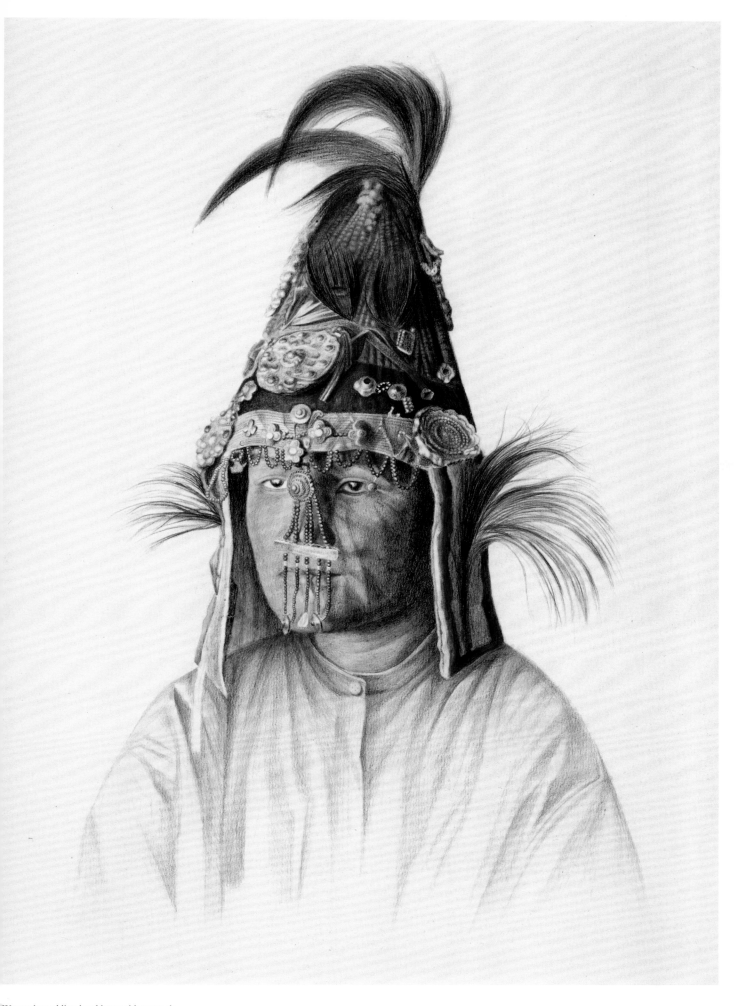

Woman's wedding headdress with peacock
feathers, coral, silver and velvet decorations.
Northern Kyrgyzstan, late nineteenth century

The most beautiful *kalpaks* are decorated with embroidery sewn in wool or coloured silk, or else with black leather decorations (Page 8). *Kalpaks* of the ancient noble Kyrgyz were decorated with costly furs and elaborate embroidery. From the nineteenth century, craftsmen specialized in fashioning *kalpaks* and began to sell them in the bazaars.

Thus, the *kalpak* is an icon of Kyrgyz dress, and is still worn today especially at festivals, by men and young people across the whole country. Often made and embroidered by hand, it features different styles and decorations according to the regions and local particularities. It is still very widely worn among the Kyrgyz of Chinese Turkestan (Xinjiang), and is found everywhere on the bazaars of Kashgar.

The tebetey or conical hat

The other characteristic Kyrgyz hat is the conical *tebetey*, made of velvet, wool cloth or any other thick, warm fabric. It is lined with felt, wool or cotton padding. In the nineteenth century, it was tall and round, like a sugar loaf, made up of four joined-up pieces of fabric (Page 158[1]). In the twentieth century, it became less tall and had a rectangular base.

This conical hat was decorated around the base with a fur border 10 to 12 centimetres wide. The furs used were those of the grey or black Astrakhan lamb (*körpö tebetey*) or the fox (*tülkü tebetey*) (Pages 169[1], 166).

The most expensive were those hemmed with marmot fur from the Tien Shan mountains or with otter fur (*kunduz tebetey*). Hats edged in fox were found all over the country, while those edged with Astrakhan border were more characteristic of the northern regions (See also Page 159[1]).

The so-called *Kashgar tebetey* was also made of four pieces of fabric assembled into a tall round cap. It was decorated with a fur border, 4 to 5 centimetres wide, sometimes of two different coloured furs. It was widespread in the south and south-east of the country in the regions closest to Kashgar and also in the Talas Valley and Djumgal Valley.

The telpek

The *telpek* was a typical sheepskin cap, made of four pieces, assembled into a conical form. It is also adorned with a fur border 4 to 6 centimetres wide (Page 160). This conical *telpek*, used chiefly by shepherds, was worn with the fur inside, and could sometimes be decorated on the outside (Page 168[2]).

Malakay, the fur hat

Shepherds and hunters sometimes still protect themselves from cold in winter with a kind of bonnet with ear-flaps which resembles the Russian *shapka*. This is made from fur with leather on the outside, covering the head and ears well. Kazakhs and Kyrgyz both wear this fur bonnet, the *malakay*.

The Pamir Kyrgyz have a round hat with ear-flaps made from sheepskin and lined with stitched cotton, which is known as a *tumak*.

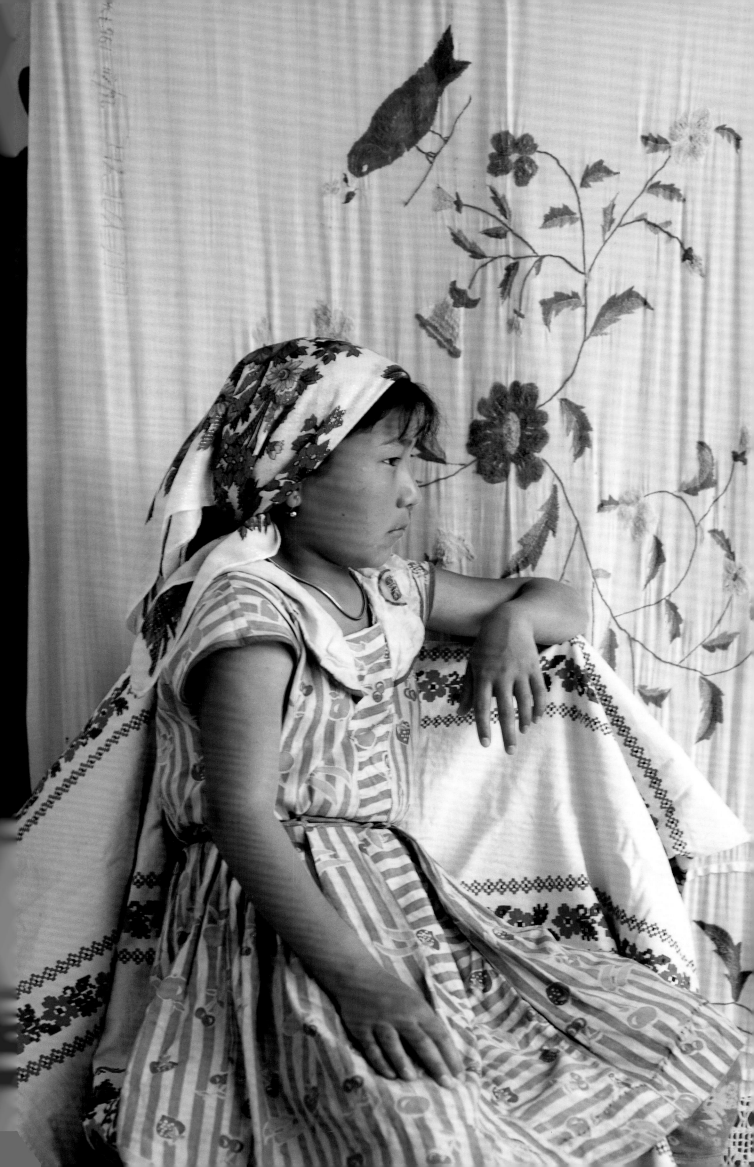

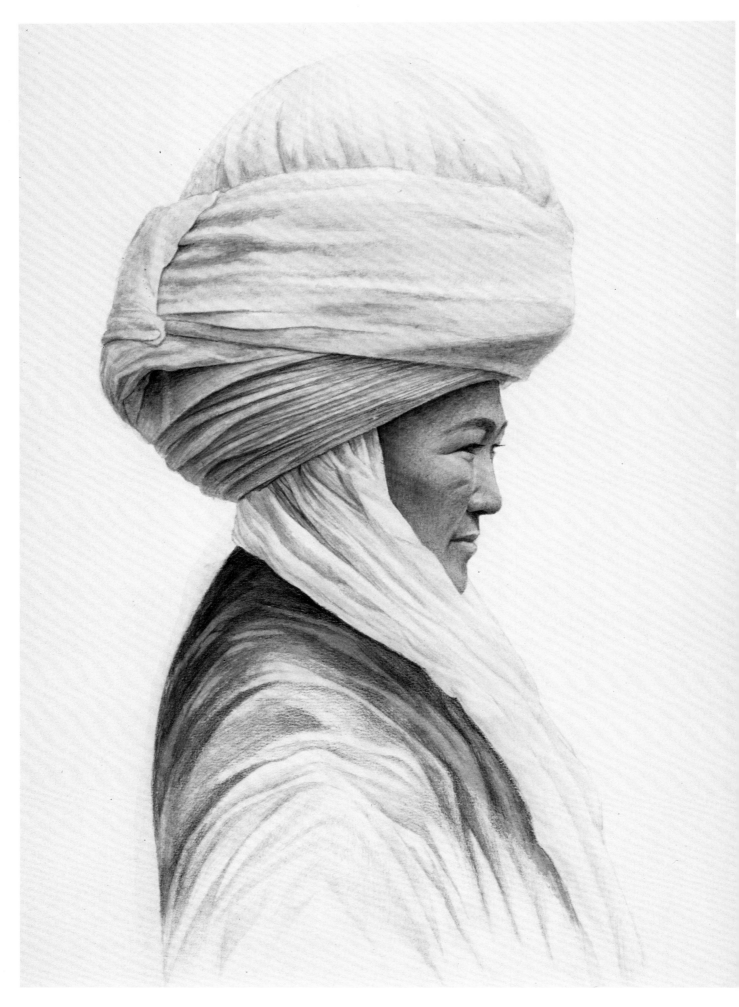

Elechek.
Northern Kyrgyzstan, early nineteenth century

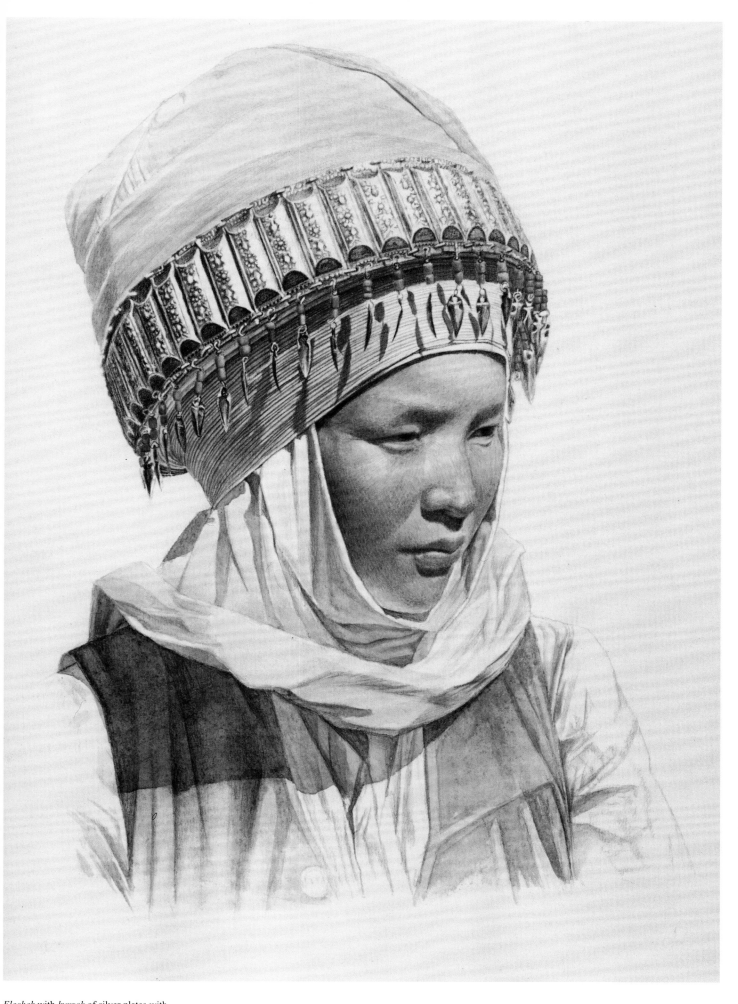

Elechek with *kyrgak* of silver plates with
coral decoration.
Northern Kyrgyzstan, secon half of the
nineteenth century

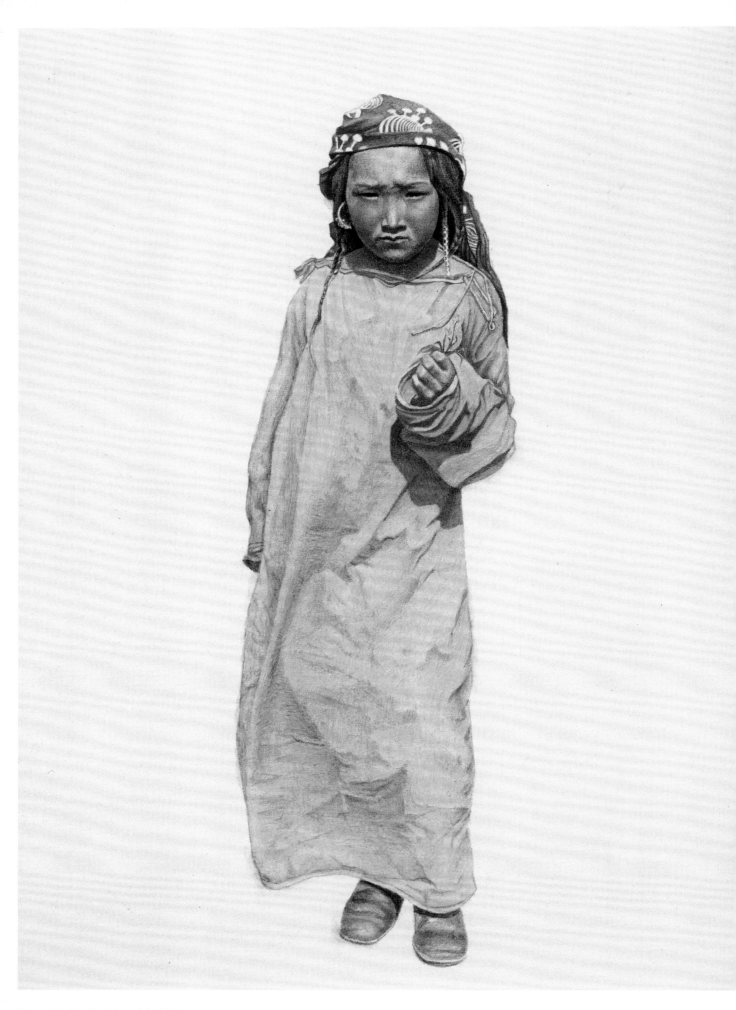

Young girl with side plaits and *djo'oluk*
(scarf), wearing simple *köynök*.
Southern Kyrgyzstan, early twentieth century

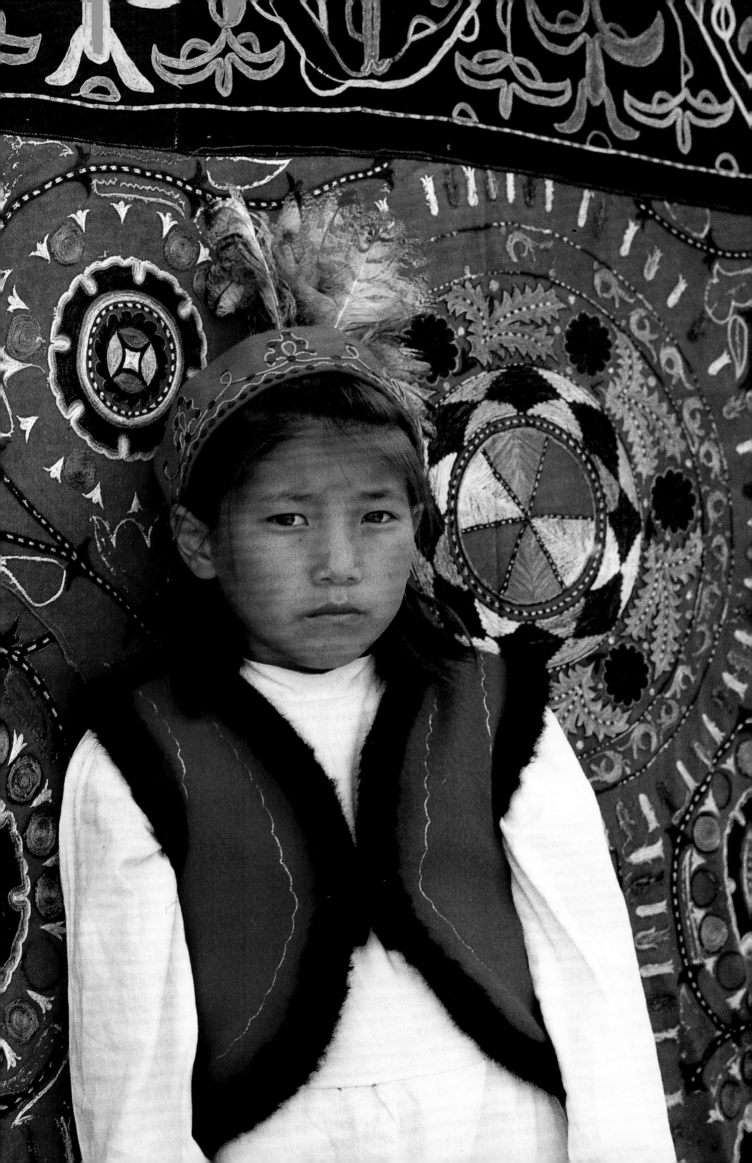

Topu, the skullcap

Under their hats, men had shaven heads and normally wore a skullcap, *topu*, so as never to expose their bare heads, not even in their homes. The Kyrgyz, although late converts to Islam had adopted this Islamic rule (especially in the south with contacts with Ferghana), believed that the head is the part of the body closest to God and must stay protected and covered.

The skullcaps were made from white unlined cotton fabric at home by women. Their top was often pointed. They were made of four cloth triangles joined at the top and padded slightly round the rim to grip the head. They were stitched all over their surface with lines of needlework and embroidery. In the Alai region, skullcaps were taller than in other areas and they were lined (Pages 149, 162).

From the second half of the nineteenth century, skullcaps were bought more and more at bazaars. In the north, they often exhibited a Tatar influence. In the south and south-west skullcaps were often imported from Tashkent or from Ferghana Valley, which was also populated by Uzbeks and Tajiks. Stitched and embroidered at the crossing point, decorated at the top and around the edge with multicoloured floral patterns, these skullcaps are characteristic of other Muslim Central Asian peoples—Tatars, Uzbeks and Tajiks. They are still worn today in parts of south Kyrgyzstan.

Children wore coloured velvet skullcaps, often embroidered with patterns considered to be protection against the evil eye (Page 132). These often depicted birds, held in belief to be "heavenly birds", such as the *bürküt*, eagle (*Aquila chrysaetos*), the royal eagle, the falcon (*chumkar*) and the owl. On children's skullcaps there might be a row of triangular cloth amulets, tip pointing upwards, hanging from the back or the front.

Selde or sallya turbans

In south-west Kyrgyzstan, men, especially those over the age of 40, followed the Uzbek and Tajik custom of wrapping their fur bonnets, *tebetey* or their embroidered skullcaps, *topu* with a long turban (Pages 148, 152[1], 158[2], 163). The older men wore white turbans.

Shoes

Shoes represent a good indicator of the wealth and social position of the wearers. In the past in Kyrgyzstan, the poor and shepherds only had sandals of thick leather that they often made themselves. The rich wore shoes made by specialist craftsmen, or imported from Tashkent or Bukhara. Hard boots were used for horse-riding and soft boots for wearing inside. In the nineteenth century, the majority of Kyrgyz only wore untanned hide shoes. These include *chokoy*, or shepherds' sandals, made of a piece of hide curved up around the foot and knotted above the ankles with a leather lace, and *charyk*, wide soled shoes, with a leather base often untanned, turned up lightly at their end towards the anklebone. There is also the *paycheki*, made of untanned leather (from the Persian *pay*, or foot).

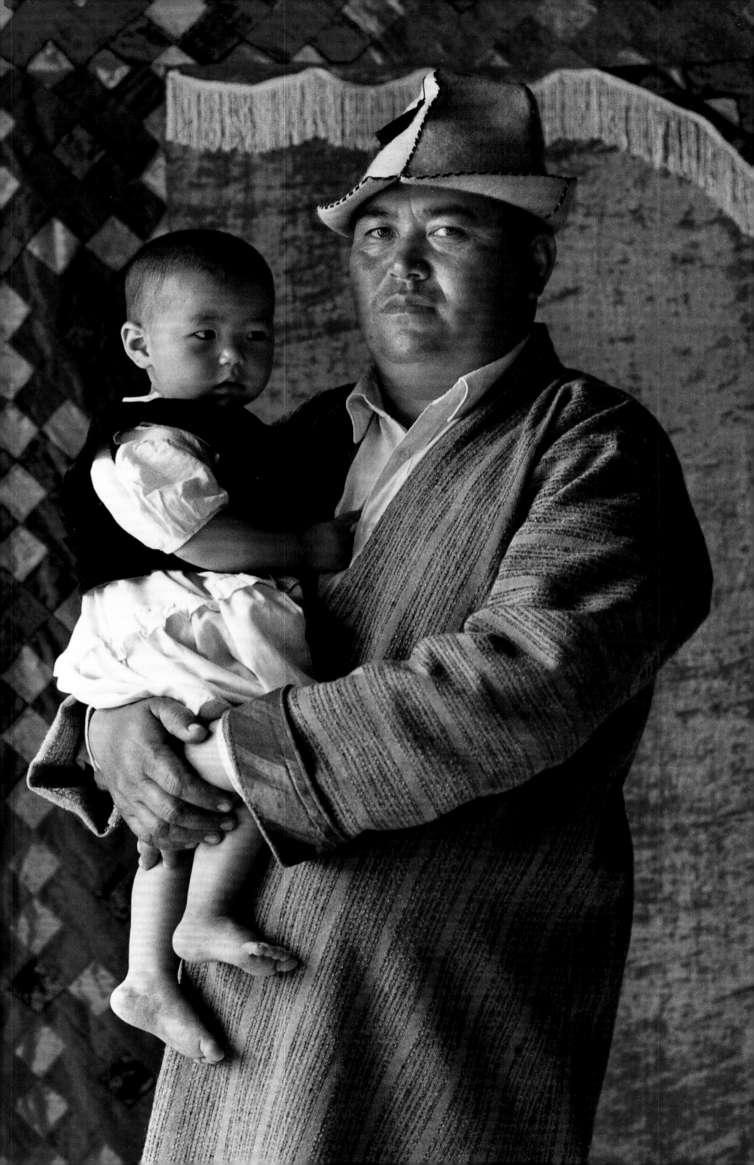

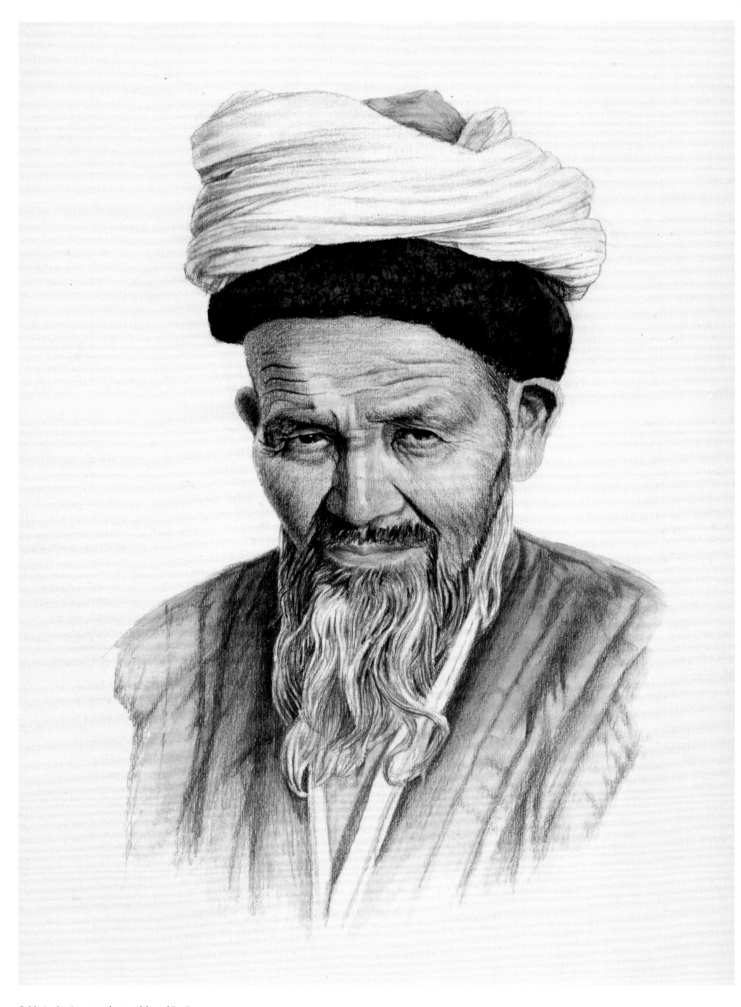

Selde (turban) wrapped around *kara körpö
tebetey* (black Astrakhan hat).
Southern Kyrgyzstan, 1920–50

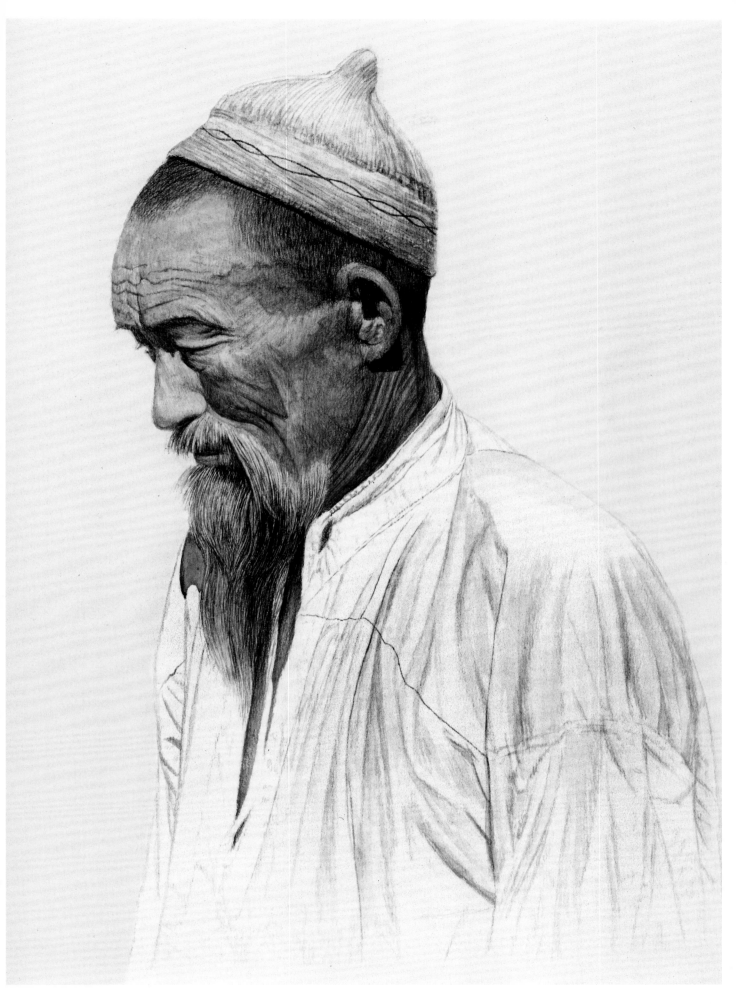

Man wearing *topu* (skullcap) with stitching,
and shirt.
Southern Kyrgyzstan, 1930–40

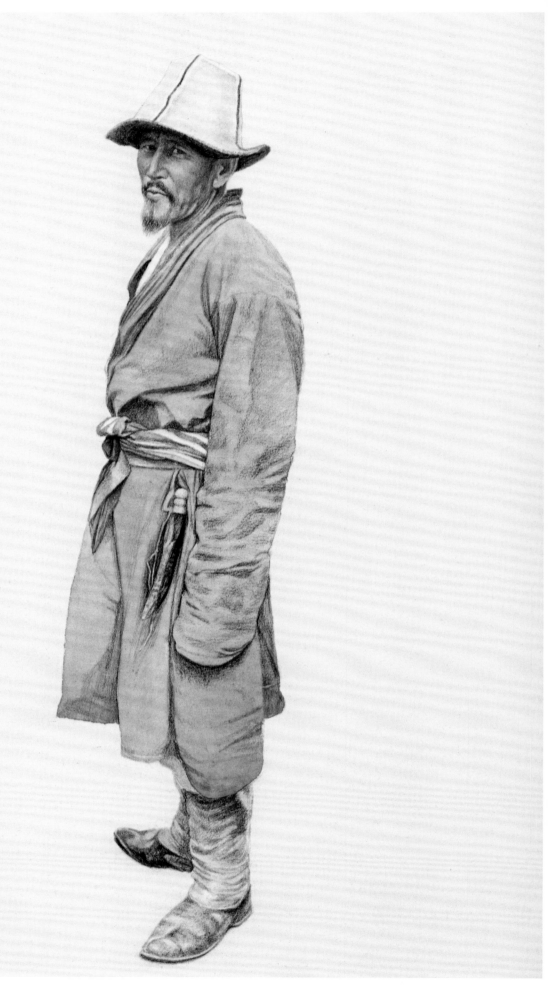

Man wearing *chepken*, woven overcoat
fastened with *keshenyé* (sash), with a knife
in a leather holder, white felt *kalpak*
and *ma'asy* (boots with rubber galoshes).
Southern Kyrgyzstan, early twentieth century

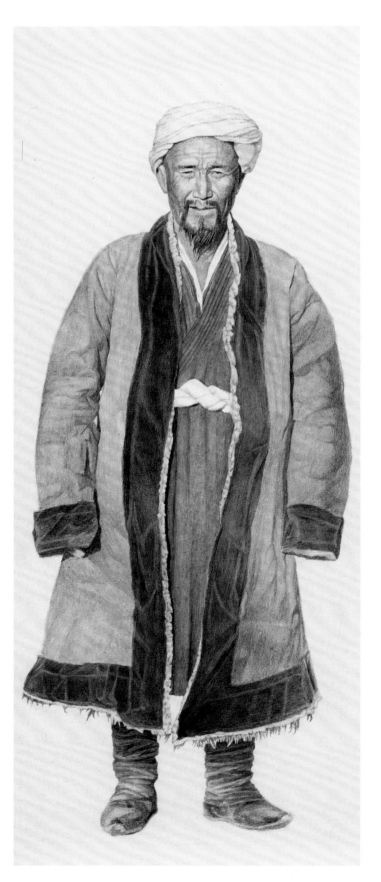

Man wearing *ton* (sheepskin coat), *chapan*
fastened with *keshenyé* (sash), white *selde*
(turban) and *ma'asy* (light boots with
galoshes).
Osh Kyrgyzstan, 1910–30

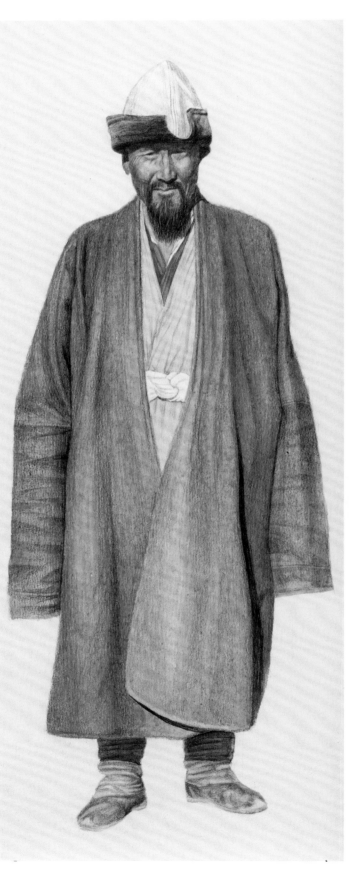

Man wearing *chepken* over *chapan* fastened
with *keshenyé* (sash), *kalpak* edged in black
velvet and *ma'asy* (light boots with galoshes).
Southern Kyrgyzstan, early twentieth century

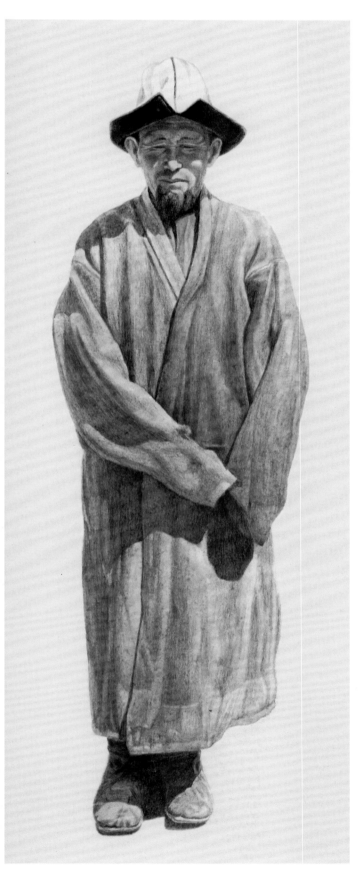

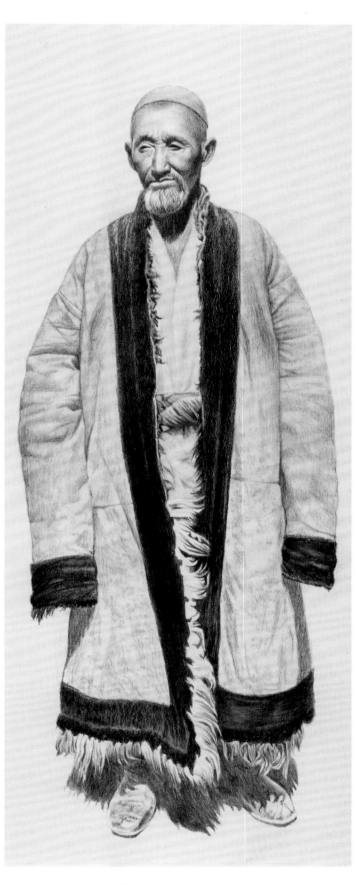

Man wearing *chepken* down to his ankles, felt *kalpak*, edged in black velvet, and *ötük* (boots).
Southern Kyrgyzstan, 1930–40

Man wearing *djakalu'u ton* (sheepskin coat) with long sleeves covering his hands, and a *topu* (skullcap).
Southern Kyrgyzstan

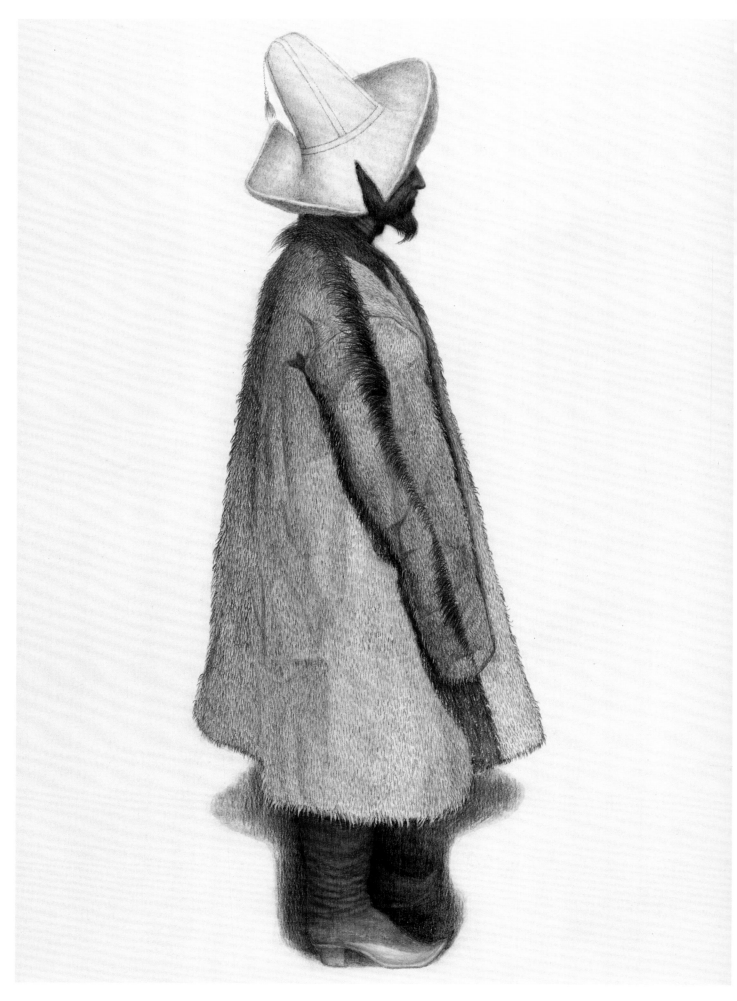

Man wearing *kulun ton* or *da'aki* (coat
made from foal skin) and traditional old-style
felt *kalpak*.
Northern Kyrgyzstan, second half of the
nineteenth century

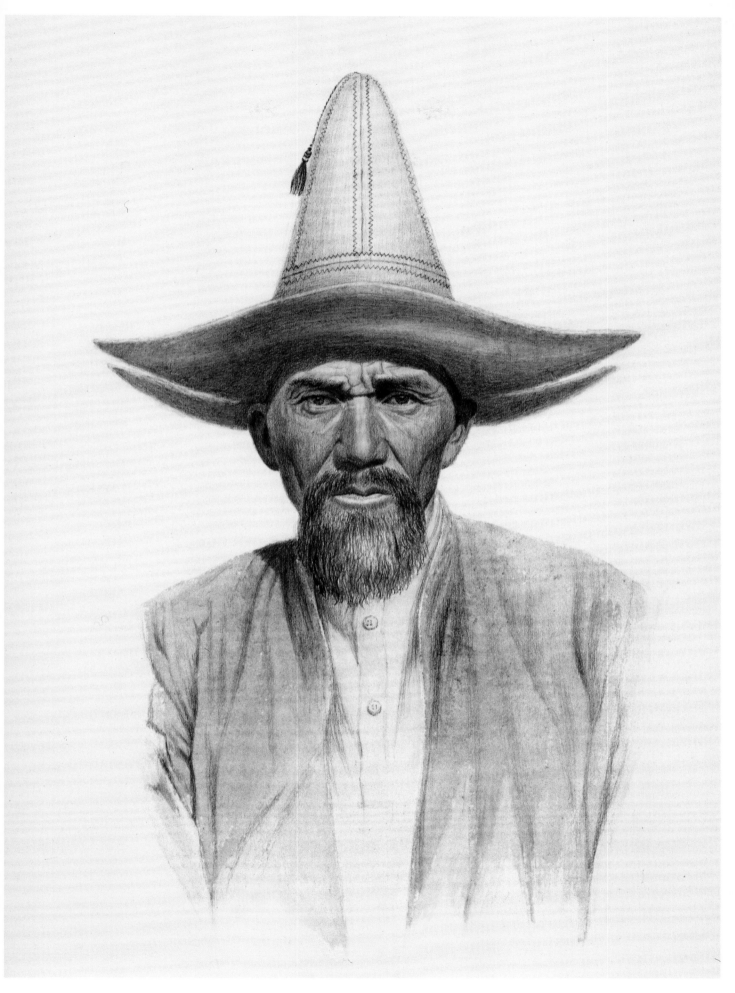

Man wearing an *ak kalpak*

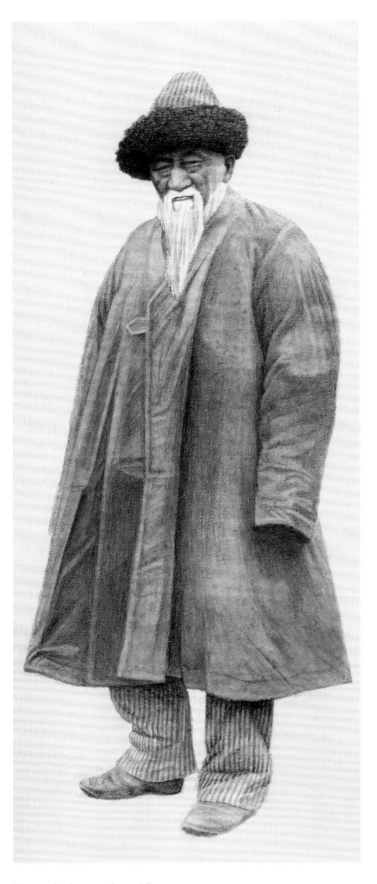

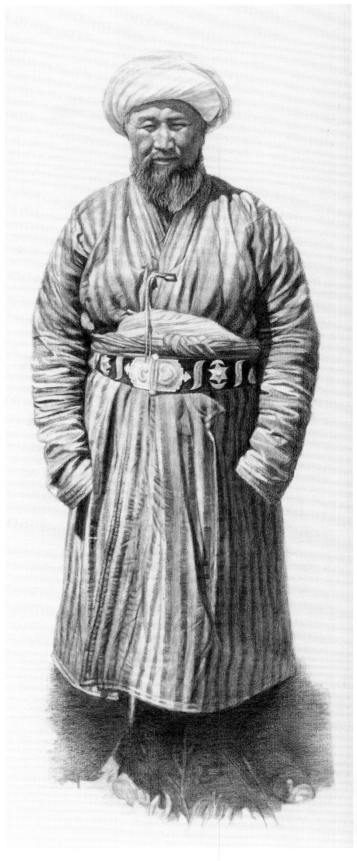

Man wearing *kaptama chapan* (*chapan*
covered with cloth), *tebetey* (hat) bordered
with black Astrakhan, trousers and *ma'asy*
(soft boots with galoshes).
Northern Kyrgyzstan, early twentieth century

Man wearing *chapan* fastened by *kemer*
(leather belt) with ornate silver plaques
and *selde* (turban).
Southern Kyrgyzstan, late nineteenth century

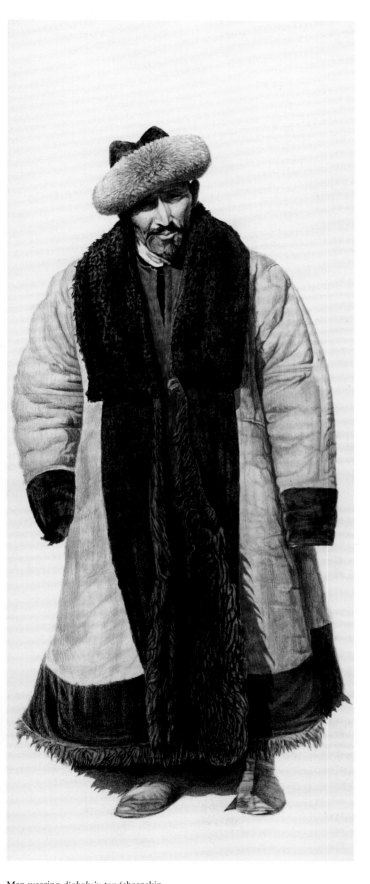

Man wearing *djakalu'u ton* (sheepskin
coat with a big fur collar) and a *tebetey*
hat bordered with fox fur.
Issyk-kul Kyrgyzstan, 1950–60

Man wearing felt *kementai* or *chepken* with
embroidery, felt embroidered *kalpak* and *ötük*.
Northern Kyrgyzstan, early twentieth century

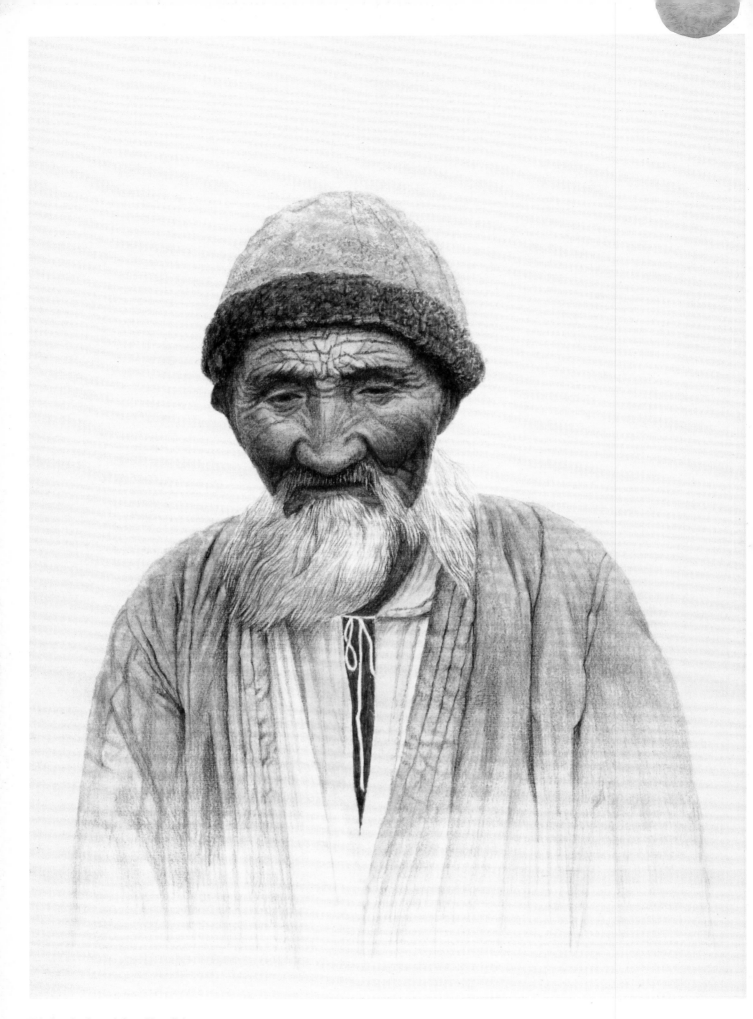

Telpek, a simple man's hat with no lining
or brim (fur border 4–5 centimetres) made
up of four sections and covered in fabric.
Southern Kyrgyzstan, 1920–30

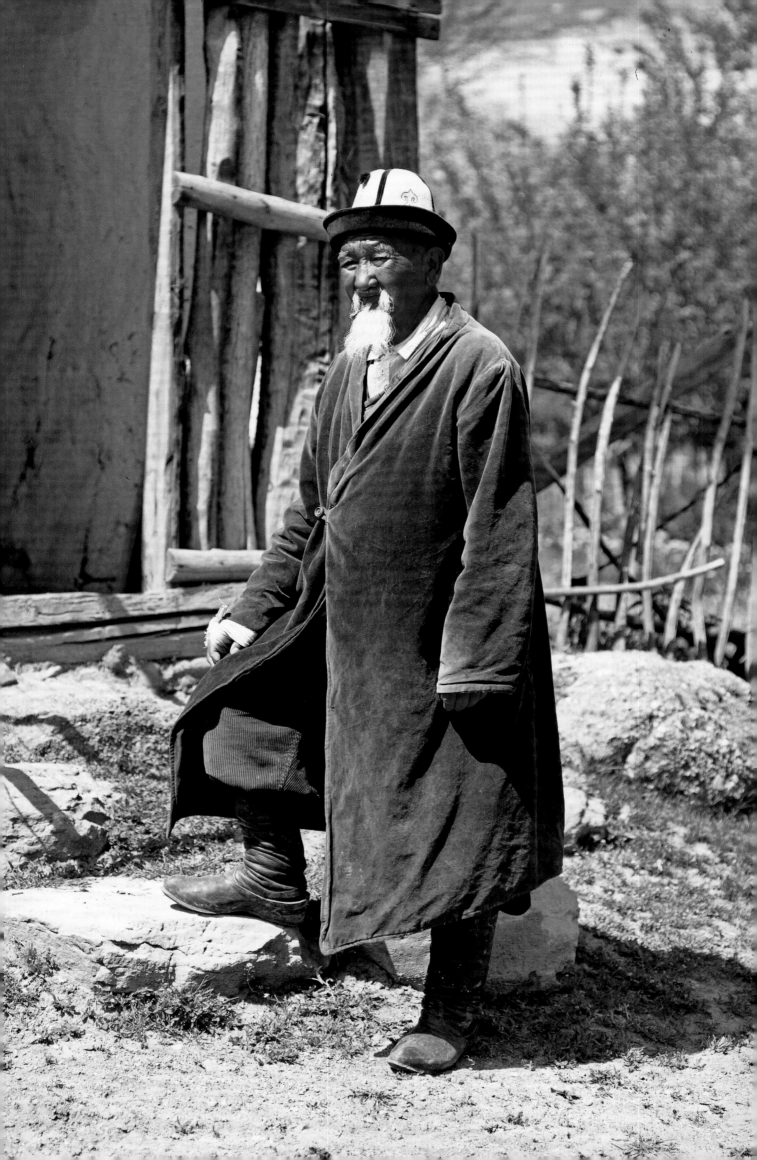

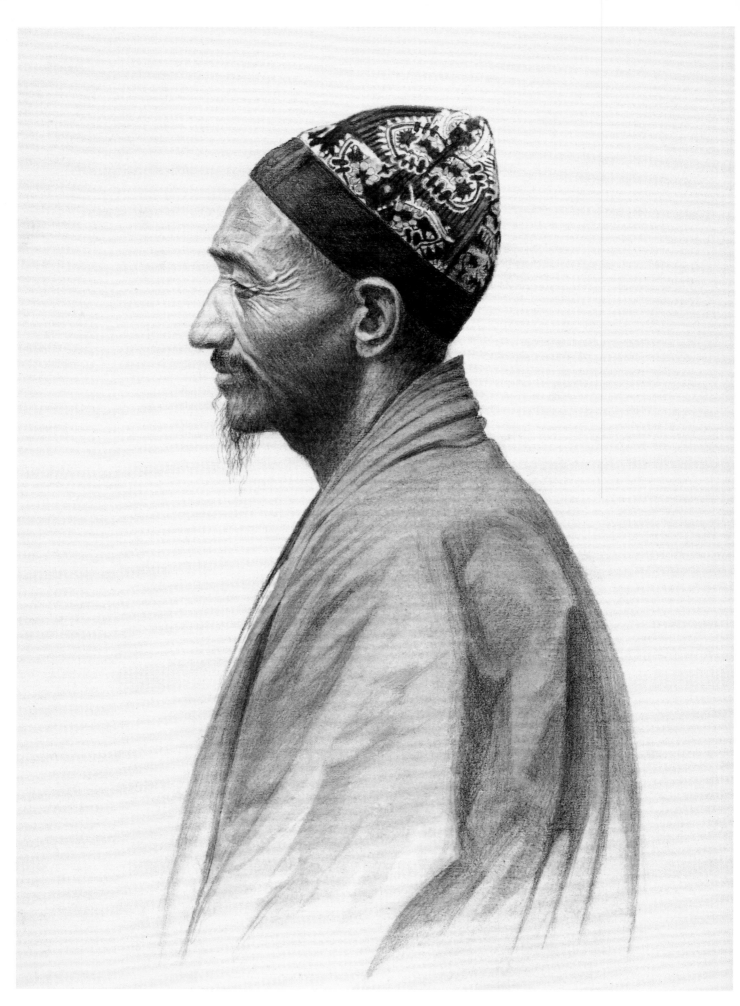

Sayma topu (embroidered skullcap).
Osh Kyrgyzstan, 1920–40

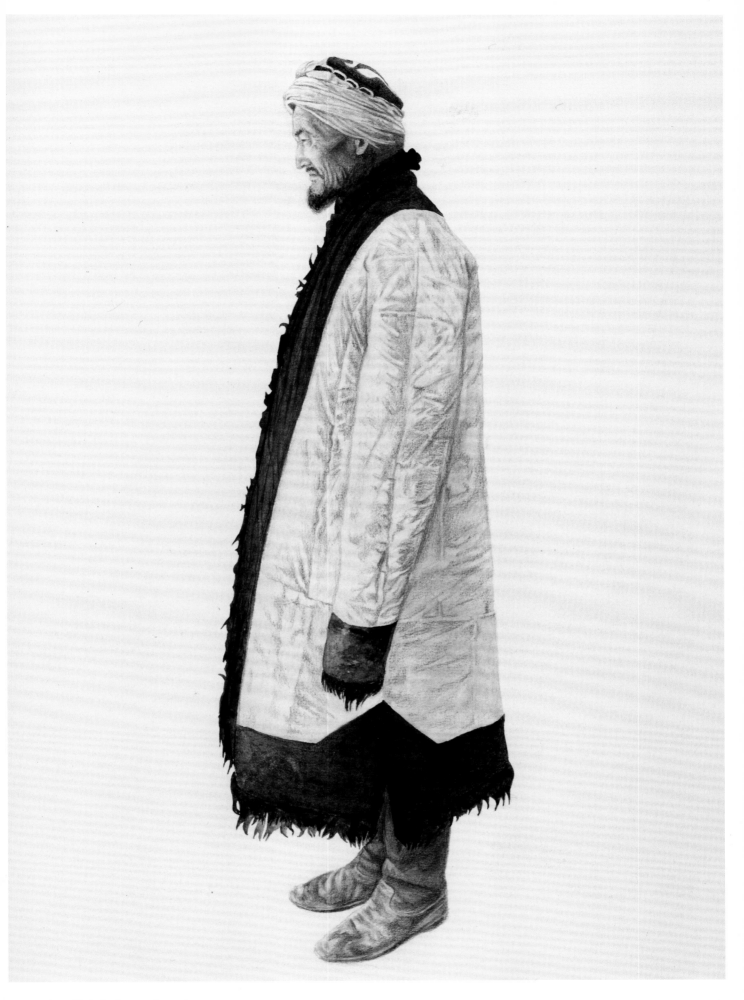

Man wearing *selde* (turban) wrapped around
topu (skullcap), a winter sheepskin coat
and boots.
Southern Kyrgyzstan, early twentieth century

Temirin (smith) wearing *ak kalpak*
(white *kalpak*).
Southern Kyrgyzstan, late nineteenth century

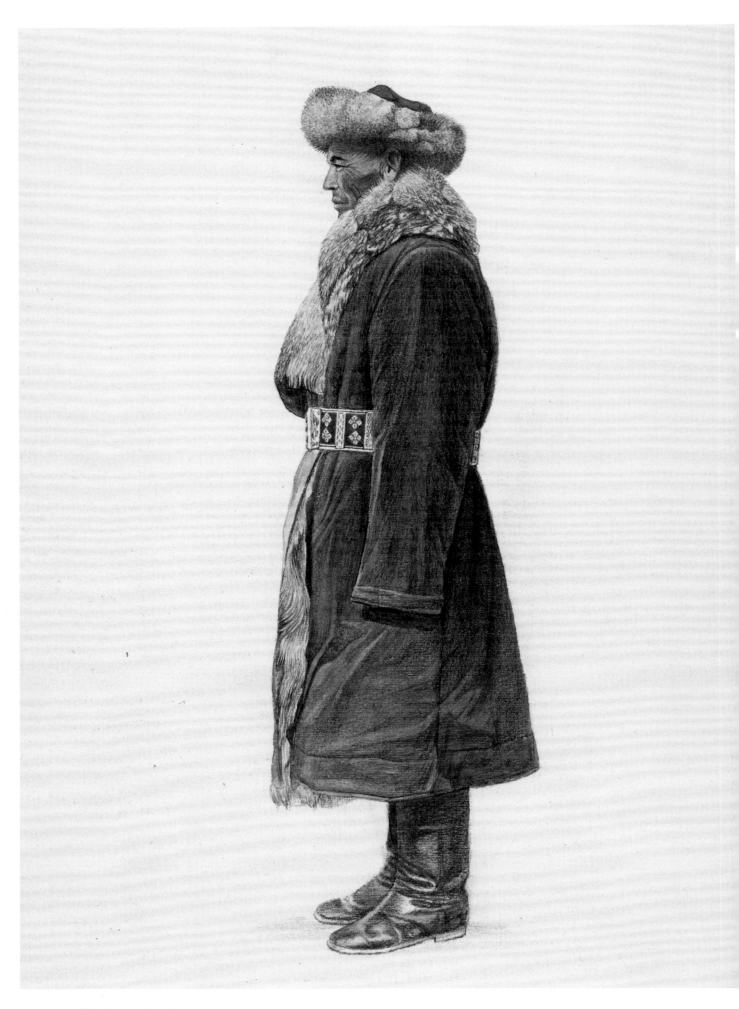

Man wearing *tülkü tebetey* (a *tebetey* bordered
with fox fur), *ton* with a big fur collar and
kemer (leather belt decorated with metal
plaques, possibly silver).
Northern Kyrgyzstan, 1940–50

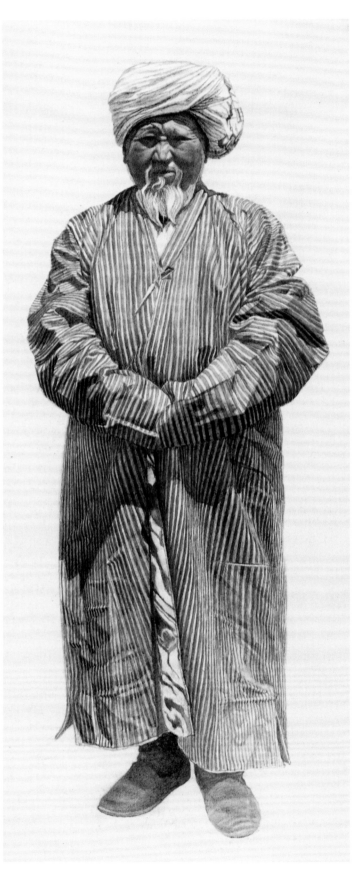

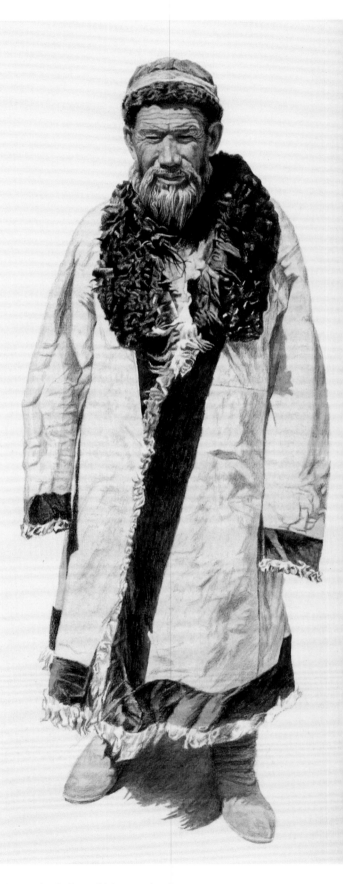

Man wearing white *selde* (turban) and *chapan*.
Southern Kyrgyzstan, late nineteenth–
early twentieth century

Man wearing *kyska ton* (high-mountain winter
sheepskin coat, with a big fur collar), *telpek*
(simple man's hat bordered in Astrakhan) and
ma'asy (boots with rubber galoshes).
Osh Kyrgyzstan, 1940–50

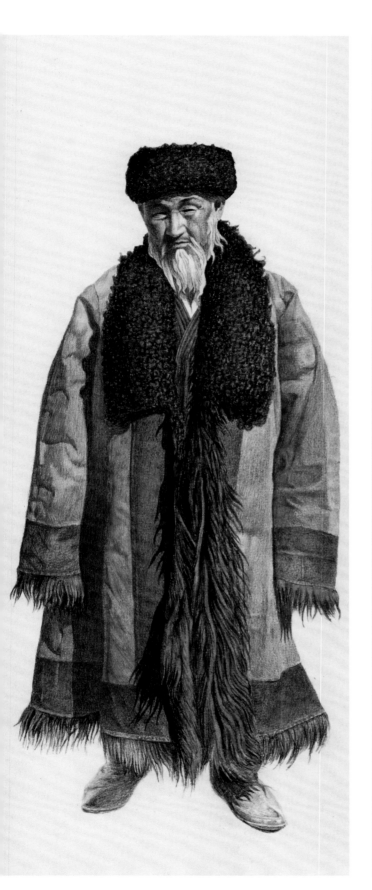

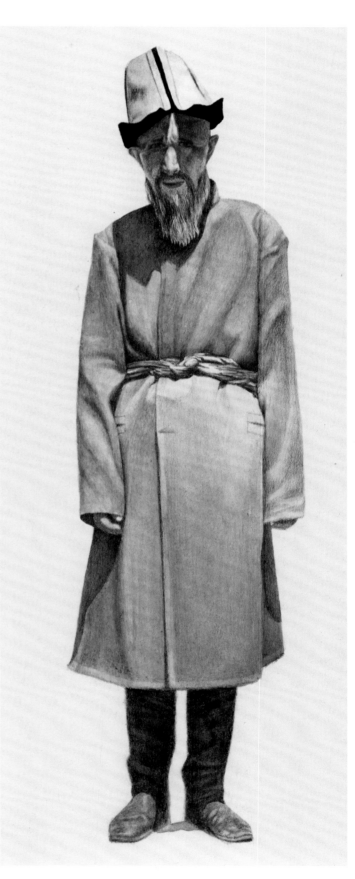

Man wearing *kara körpö tebetey* (*tebetey* edged in black Astrakhan) and *djakalu'u ton* (a rich sheepskin coat with a big collar). Northern Kyrgyzstan, early twentieth century

Man wearing *beshmant*, tied with a *belbo'o* (sash), and white felt *kalpak* edged in black velvet. Osh, Kyrgyzstan, 1940–45

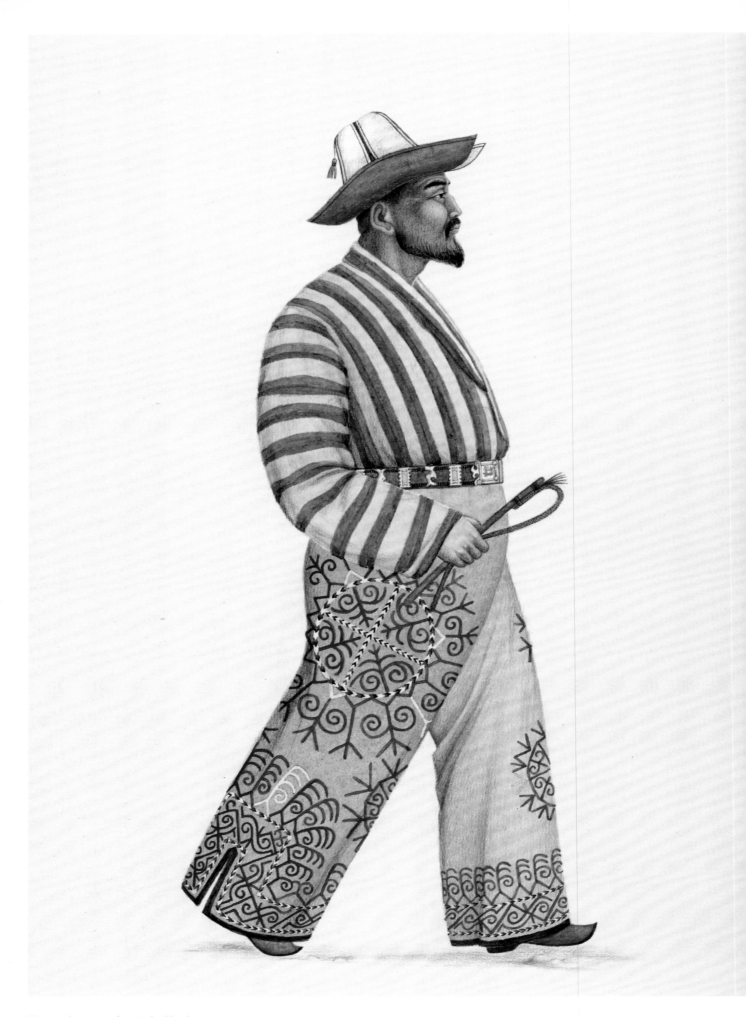

Man wearing *sayma shym* (embroidered
buckskin trousers) with *kemer* (belt) from
leather with metal ornaments, and white felt
kalpak (hat), bordered in black velvet. His
chapan is tucked into his trousers for riding.
Northern Kyrgyzstan, late nineteenth century

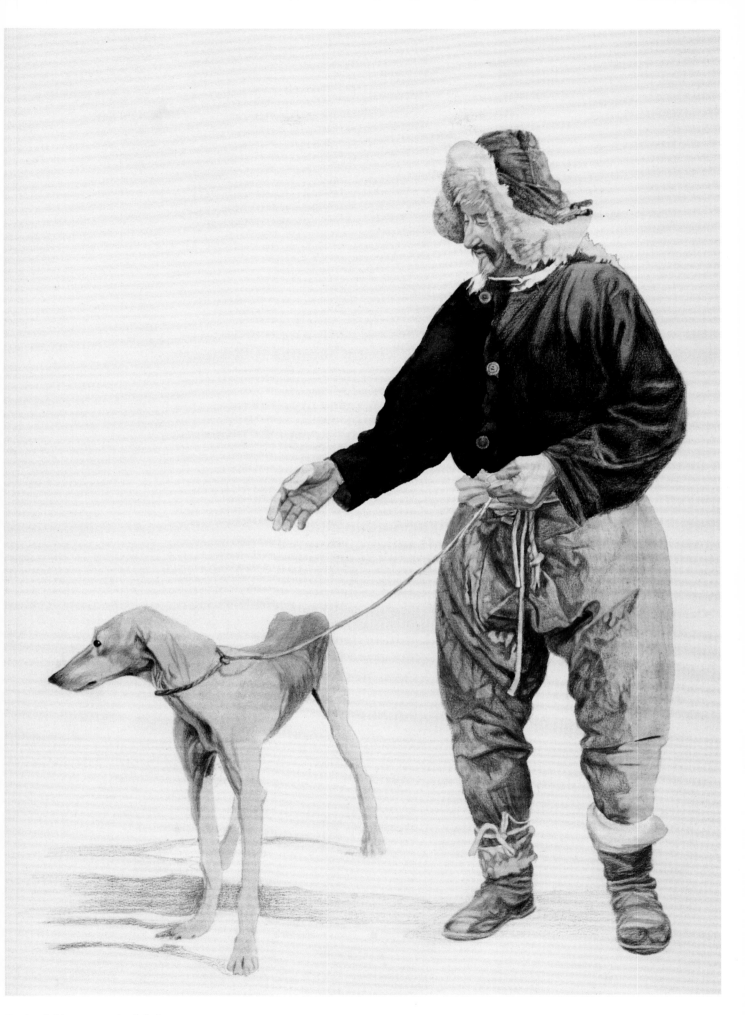

Hunting clothing: man wearing *bulga'ary
shym* (trousers from Russian leather),
beshmant (light coat) tucked into his trousers
and a *malakay* (fur hat with ear flaps).
Northern Kyrgyzstan, 1930–40

In the nineteenth century, wooden clogs with high nailed heels (*djigach-kepich*) were still worn among the Kyrgyz who lived in the south-west and in the Alai Mountains. These were like those made and worn by the Tajiks in the neighbouring Pamir.

For walking on rocks or climbing mountain escarpments, Kyrgyz hunters fixed horse hoofs (*tay tuyak*) to their shoes, which were replaced later by special metal crampons attached under the soles. In winter, snowshoes were also used. These were round, wooden, 25 to 30 centimetres in diameter and fixed to the shoes with ties.

Boots

Horse-riders of Central Asia wear tall thick leather boots (*ötük*). Kyrgyz boots go very high up on the leg, sometimes above the knee. Traditionally, the base was gently curved up around the ankle. They had tall heels made of superimposed layers of leather; the rich used to hollow out these high heels to place metal bells (*djiladjin*) inside, which would ring when they walked. The heels were often reinforced with a metal copper plate (*djez okcho*).

Under Uzbek influence, the Kyrgyz in the south-west of the country wore soft leather boots with a thin sole. To go out, the wearer put on leather overshoes (*kabysh*) on top of the *ma'asy*, which were replaced during the twentieth century by short rubber boots known as *galoshe* (Page 150). On returning home, the men removed their overshoes whilst keeping on their soft boots.

During the course of the nineteenth century felt boots such as the Russians wore were introduced. These were called *ki'iz chokoy* ("felt boots"), or *orus chokoy* ("Russian boots") and were sometimes protected with a leather sole. Finally, rubber boots were imported from Russia from the start of the twentieth century; they were particularly popular with old men, who wore them with felt leggings, *baypak* (from the Persian *pay*, or foot).

CONTEMPORARY KYRGYZ CLOTHING

What has been presented up to this point relates to the Kyrgyz costume from the middle of the nineteenth century up to the early twentieth century. Kyrgyz clothing has, however, considerably transformed during the course of the twentieth century. Russian colonization, followed by the 1917 revolution, obviously caused Kyrgyz society and its culture to change and develop a great deal.

Contemporary clothes are more relevant to the new working conditions and ways of modern life than the old ones. But the new style has integrated quite harmoniously with different elements inherited from the past and still respects Kyrgyz national identity. For example, men still like to wear the traditional summer hat, the *kalpak* of white felt, with their modern city suits. And high mountain shepherds still use some traditional items of clothing, which are more suited to life in the mountains than factory-made clothing. The *tebetey* and *malakay* hats, for example, can still be seen occasionally.

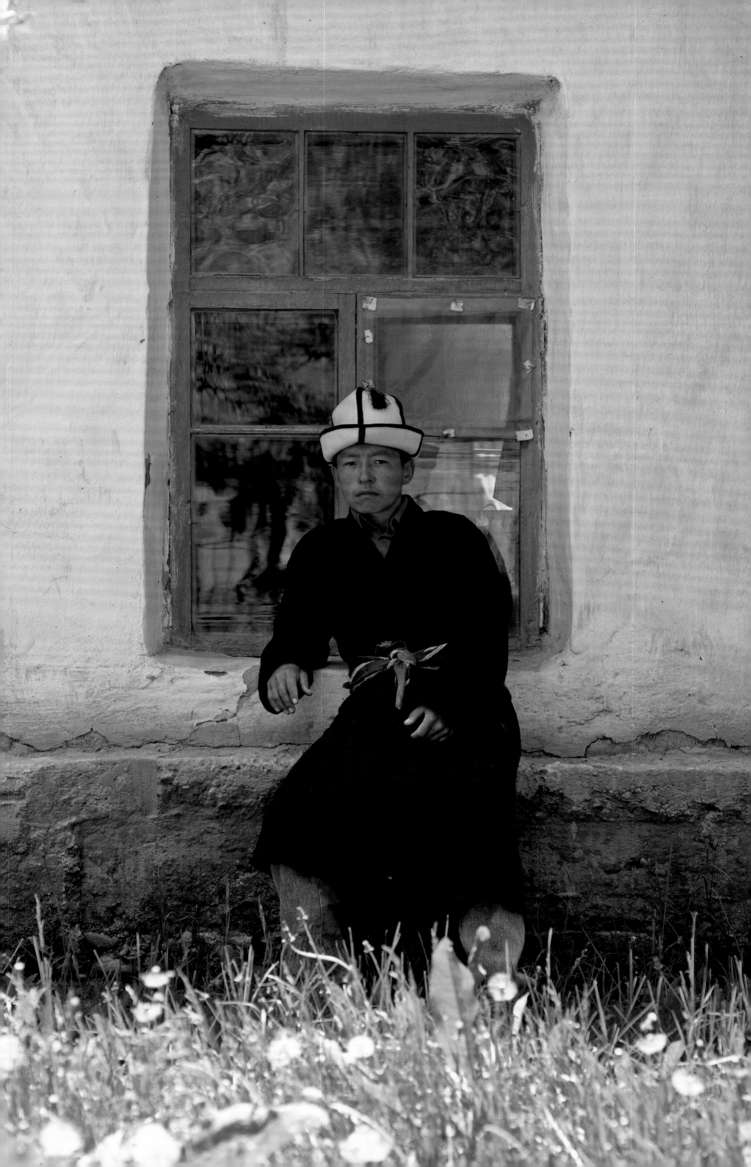

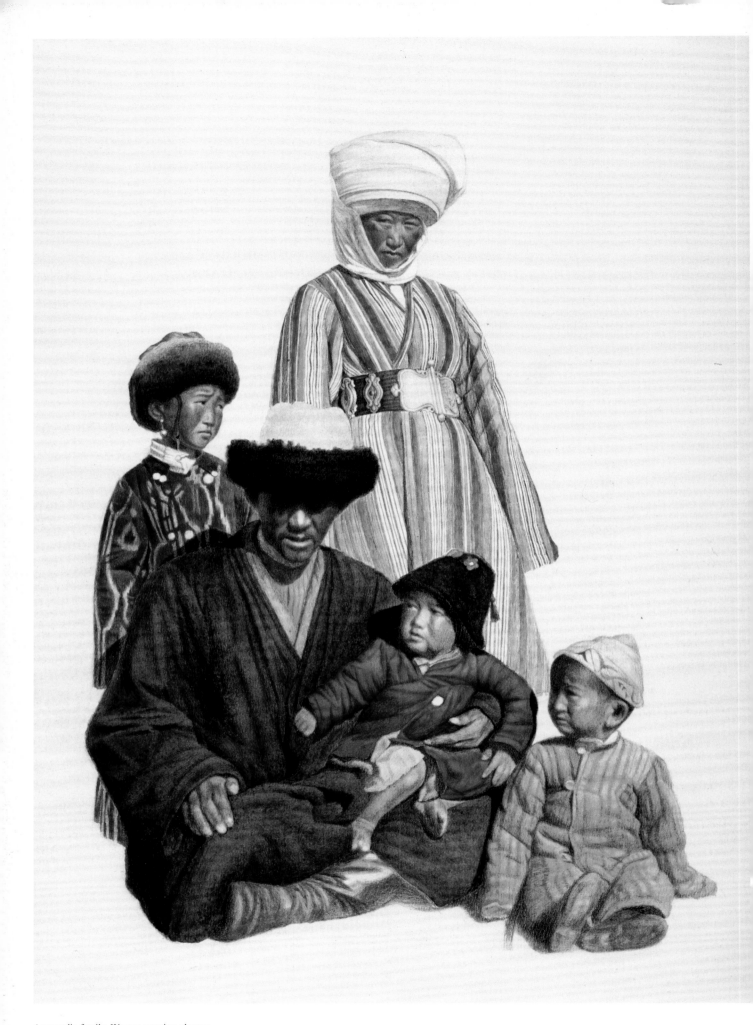

A nomadic family. Woman wearing *chapan*
from *beykasam*, a southern-style *kemer* (belt)
from leather, decorated with metal plaques,
and *elechek*. Man wearing a *chapan* and
tebetey (hat) of black Astrakhan. Both children
wear *chapans* and hats.
Northern Kyrgyzstan, nineteenth century

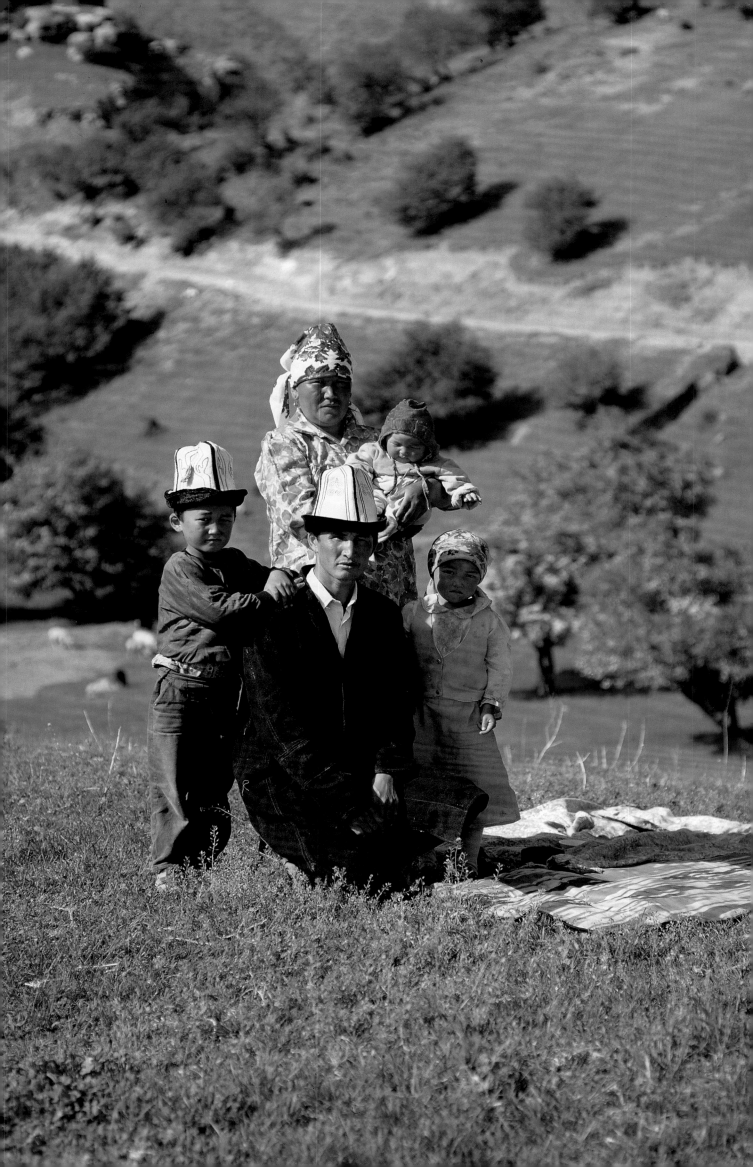

The modern history of Kyrgyz costume can be divided in three or four periods, each marked by new political, economic, social and cultural circumstances.

1. The first period is that of Russian influence. This began in 1820 and developed progressively until the whole Kyrgyz region was annexed by Russia in 1876. Industries grew up (exploiting minerals and coal), as well as towns. Numerous workers and colonists from diverse regions of Russia emigrated and settled in Kyrgyzstan to find work and land. The capital, then called Pishpek, had 1,500 inhabitants in 1910, the majority of whom were Russian. Kyrgyz dress evolved under the influence of these new ethnic and cultural contacts.

2. The second period was from 1918, and marked the progressive control of Turkestan by the Bolsheviks, up to the 1950s. This period, preceded by the great Uzbek, Kazakh and Kyrgyz revolts against Russian colonization, saw the establishment of a modern socialist economy and way of life.

The Kyrgyz were sedentarized into collective farms during the 1930s by Stalin's government. The urban way of life developed, alongside collective grazing and agricultural initiatives. Clothing was modified to a great extent in this period of profound upheavals.

During the difficult "Great Patriotic War" period of 1939–45, craft-work, which had begun to be abandoned, developed again in the Kyrgyz villages, as the textile factories were turned entirely towards war production. The old craft of ground loom weaving (*termé*) and a variety of macramé work reappeared in the encampments and villages, to satisfy local needs.

The war years left considerable traces on clothing. Many soldiers kept up the habit of wearing a tunic, fastened by a leather strap, with baggy trousers tucked into rubber boots. Caps and industrial felt hats, which are seen nowadays, also appeared in this period.

3. The third period from the 1950s to Kyrgyz independence in 1991 is that which saw the biggest changes in clothing habits, for a variety of different reasons.

Industrial production of silk, cotton and wool clothes developed greatly. Clothing workshops opened in the towns and villages. People could order clothing of traditional cut, modern outfits, and even modern outfits but decorated in traditional patterns: all at the same time.

Fabrics obtained from synthetic fibres made their appearance, although the Kyrgyz still initially preferred silk, cotton, velvet or velvet cotton velour. Cotton velour was in this period very widely used in the northern regions of the country, both by men and women. Young girls liked brightly coloured velvets—red, green and blue, for their waistcoats and coats.

Designers, painters and stylists designed textile patterns, which were constantly changing. Kyrgyz silk, cotton and wool fabrics were at this time exported to neighbouring Tajik and Uzbek Republics.

Frequent contact tended to make the diversity of traditions and habits more homogeneous. Different nationalities came into frequent contact now in the towns and villages.

Peoples of different ethnic origins worked together in the same factories, cooperatives and in collective agricultural enterprises. People who worked together also tended to wear the same kind of clothes, even if they were from different geographical origins.

This degree of standardization favoured the elimination of those features of dress, which formerly characterized differences in status and way of life. Shepherds, labourers and *kolkhoz* (collective farm) workers until the recent past dressed in a quite similar fashion. The embroidered overcoats and brocaded silk materials, which indicated membership of a rich family in the old society, were put away in museums. In the same way, there no longer existed clothes specifically for the poor or for tenant shepherds.

Some former items of clothing completely disappeared, others stayed the same, whilst yet others evolved, and at the same time, the use of completely new clothing items imposed itself progressively all over the country.

For women, the voluminous turban *elechek* or *ileki*, so characteristic of Kyrgyz women's fashion until the beginning of the twentieth century, seemed condemned to disappear. This heavy, cumbersome turban, which enabled wives of Kyrgyz or Kazakh men to be distinguished from afar in the steppes and pasturelands, was replaced by a variety of large scarves to cover the hair. The festive skirt, the *beldemchi*, also progressively disappeared during this period because it was no longer so relevant to the needs of daily life. Only a few older women in the villages and *ails* wore this apron-skirt at festivals, and even then, they were not as carefully embroidered as formerly.

In all the Central Asian Republics, the heavy fur coats, and the *chapans*, or the quilted coats with extra long sleeves, were nearly all replaced over this time by lighter, more practical coats.

The old men or women's leather belt, *kemer*, decorated with heavy plates of engraved silver, was abandoned, only to occasionally be seen at festivals, and one rarely encounters the large fabric belt, *kushak*, these days.

Also, unfortunately, the *tebetey*, the traditional men's fabric cap trimmed with fur, began to be forgotten, and was only worn by older men.

On the other hand, the sleeveless waistcoat, characteristic of Kyrgyz women, was adopted by many different peoples in the region. It was the same with the *kalpak*, the Kyrgyz summer hat of embroidered white felt. This can now be found in other parts of Central Asia. Among the Kyrgyz, young and old wear it often still, especially in the villages and at festival times.

The degree of conservation of traditional dress depended upon socio-economic factors, education, age and habits. It was above all in the south that these traditional clothes were best conserved, particularly among the old people, and this was due to the greater conservatism of the region and to the influence of Tajik and Uzbek neighbours. Even here though, cattle breeders and shepherds during this period possessed a city suit, a white shirt and tie and factory-made shoes, worn when it was necessary to appear modern. But for everyday work in the cold of the mountains, it was still quite possible to come across traditional warm clothes being worn: the sheepskin coat, *ton*, worn with the skin facing in-

wards, the ancient woven overcoat *chepken* (of lamb or camel wool) covered nowadays with industrial fabric, the fur hat, felt slippers and felt or leather boots. Wide, warm leather trousers, *chalbar*, disappeared. But cotton trousers, worn as underwear, exist today still, especially in the south. Over-trousers are now worn tucked into the boots. In the villages, old people continued, certainly until recently to wear traditional winter clothes, including sheepskin coats, lined fur coats, *ichik*, fitted coats, *beshmant*, *chapans* of striped, padded and woven hand-made cotton and unlined *djeleks*, although these are far less frequent.

The loose blouse or undershirt, *köynök*, for the women, *achik köynök* for the men, disappeared in the north. They are still found in the south in the form of a similar shirt, *djegde*, still worn among the Uzbeks and the Tajiks.

This shirt is now fastened most often by a leather belt, whilst an embroidered cotton belt is still being used among the Uzbeks. In the north, older men now wear a short shirt with an open collar, but still in the obligatory white colour.

Older women also kept to traditional dress forms. Old people were highly respected and their close relatives saw to it that they wore quality clothes, made with costly materials. The fastened waistcoat, sometimes with a high collar, was worn at times by women of all ages, who found it practical. A row of 5 to 6 buttons, sometimes still in silver decorated metal, made by local jewellers, fastened these waistcoats. Old women still liked to wear satin waistcoats lined in black; sometimes they were still lined with padding and woven. The oldest forms of long sleeveless waistcoats, as well as the short-sleeved coats which were formerly worn in the north-east (Chou Valley and Issyk-kul region) were still in this period worn mainly in the north-west of the country (in Talas and Chatkal Valley). Elderly women still wore traditional soft leather boots, along with rubber overshoes for going out.

Russian and Ukrainian colonists, who settled en masse in the north of Kyrgyzstan, had a great influence on dress style over the last fifty years. From the 1960s, town coats with modern styles were made industrially and replaced more traditional ones.

Having abandoned the traditional large turban, headscarves were now worn by most village women. In winter, women wore woollen scarves, which were woven or knitted. In summer, they were much more varied, in diverse colours and materials and usually obtained from factory made printed fabric, often imported from China. Many old women wore two scarves in winter, one over the other, to keep the head very warm. The first was white and covered the head and half the forehead; the second was bigger, made from wool or silk and was worn over the first and knotted under the chin.

Ways of knotting the scarf varied from region to region. In the north, Kyrgyz women, perhaps to preserve the memory of the traditional turban (*elechek*), arranged their scarf so that it covered the chin and the neck well. They favoured Russian scarves printed with large multicoloured flowers on a black or red background. In the south, elderly women still favoured plait extensions, *chach papik*, tresses of black silk ending in silver balls and tassels. Young women might wear necklaces made from coral and mother-of-pearl, but it was rare.

Men often adopted Ukrainian embroidered shirts, as well as Russian waistcoats and rubber boots. In the south, everywhere they adopted embroidered Uzbek cloth skullcaps, as well as the Uzbek sash which holds their coat closed.

Young people of this time were very aware as to what was new and modern and followed the fashion as much as possible. Men might have long hair, women short, and hairdressers appeared in town. In the past, men had shaven heads. Each adult cut his own hair, or else they helped each other in shaving each other's head at the edge of a road, a stream or an irrigation canal (*arik*). From the 1950s, travelling barbers went around on bicycle from village to village, offering their services.

4. The fourth period is from Independence in 1991. City clothing of European cut, coats, dresses, trousers and shirts have been adopted now in all the villages as festival and going out clothes. Contemporary clothing consists of clothes bought in the shops and new street bazaars that have grown up since Independence. Clothes are now imported from India, Turkey and Europe.

Modern young women seek to dress with imagination, following the fashion. They have forgotten the traces of the past and the time when women didn't have the right to go out alone to the market or in the shops. They dress themselves in the international fashion, with trousers, skirts of all lengths, short or long. Young girls no longer wear plaits and, in the towns, not even a scarf to cover their hair. Older relatives bemoan the cutting of girls' hair. The plait ornaments of silver and multicoloured silks have been abandoned, except by a few old village women, and are henceforth hung on the wall as a memory of a former lifestyle.

In the past, young women wore long dresses with long sleeves. Under dresses, legs had to be hidden by long wide trousers (*chalva*), and old people would scrupulously surveil the dress of the young to make sure it was in conformity with tradition. All this has changed now. Although in the high mountains it is still improper for a woman to reveal her ankles, these social rules are largely forgotten in the towns.

The marriage dress has also evolved and is much simpler. The fiancée no longer has to veil her face at the moment of catching sight of her intended. She no longer wears the tall marriage headdress, nor the heavy ornaments of yesteryear. There is no need to wear rich, heavy clothes and jewellery to make visible her family's prosperity. The modern wedding dress of today is white, red or pink silk. In the city, the fiancée covers herself for marriage in a light veil, adorned with white artificial flowers and tied under the chin. In the villages, the traditional white scarf (*ak djo'oluk*) remains, hanging down the back to cover most of the hair as a symbol of beauty and purity. After the wedding day, the bride will secure the scarf under her hair at the back of her neck to indicate her new married status.

The bridegroom has city clothes: a suit, a white shirt and tie. Only the white felt *kalpak* and the high boots differentiate him from a western bridegroom. Contemporary signs of wealth are now manifest in cars and modern comforts, rather than hand-made silver jewellery and heavy silk fabrics.

Glossary of General Terms

Adrass. Half-silk cloth made by hand. Also known as *atlas*. Kind of satin.
Ail, ayil. Kyrgyz community (camp or village).
Alacha. Fabric.
Ashkana chij. Decorated sedge screen to separate off the kitchen area of the yurt.
Bay, bey. Rich man, important figure in an *ail*.
Beyz. Raw cotton hand-woven fabric.
Börü. Wolf.
Boz üy. Kyrgyz yurt.
Bugu. Deer.
Bulga'ary. Leather clothing, made from Russian leather.
Bürküt. Eagle.
Chyglyi teri. Raw-hide, untanned leather.
Dikek. Ornamental horse cloth from felt. Also *oromo*.
Djapalak. Owl.
Djesir. Widow.
Enchi. Bride's marriage gift of cattle, part of dowry which comes to daughter from her parents after one year.
Ikat. Uzbek woven silk cloth with tie-dyed warp thread.
Istanboul. Closely woven white cloth used for women's turban.
Iyik. Spindle.
Jailo'o. Summer pastures.
Jamby-atmay. Archery.
Jigits. Young men.
Jylky. Horse.
Kalym. Bride price.
Karlygatch. Swallow.
Kayik. Stitch.
Kiyit tartu'u. An exchange of gifts, sometimes at betrothal.
Koy. Sheep.
Kuchak. Measurement: spread of the arm.
Küdöpü. Very soft buckskin or suede.
Kurech. Form of wrestling which involves grappling with the opponent's belt.
Ku'umüsh. Silver.
Kymiss. Fermented mares' milk.
Kyshto'o. Winter pastures.
Kyska. Short.
Kyz ku'umay. Game "catch the girl and kiss her", played on horseback.
Manap. Traditional leader.
Markhan. Coral.
Mata. Hand-woven cotton sewn together in bands.
No'otu. A woollen cloth.
Odarych. Horseback wrestling.
Payga. Horse races.
Piazy. Brown hand-woven camel's wool cloth.
Sayma. Embroidery.
Sedep. Mother of pearl.
Shumkar. Falcon.
Su'ur. Marmot.

Ta'ar. Canvas.
Teri. Leather.
Termé. Woollen band, woven on a ground loom.
Ters kayyk. A type of pattern for embroidery (reverse stitch).
Tö'ö. Camel.
Topoz. Yak.
Toy. Big festival or celebration such as a wedding.
Tush kiyiz. Embroidered screen inside yurt.
Uy. Cow.

Glossary of Clothing Terms

Achyk köynök. Northern man's shirt, open to the waist, often trimmed with turned down collar, and fastened by a lace.

Ak djo'oluk. A white head scarf worn by a married woman.

Ak kalpak. A kalpak without a split brim.

Arkalyk. Metal plaque or plate used as a decoration for a woman's plaits.

Bach beldemchi. Wide waistband of *beldemchi*.

Bacma chapan. A *chapan* from printed fabric.

Baypak. Socks, felt leggings.

Bedene kemer. A chrome belt.

Bedene ötük. Chrome boots.

Bel kur. Fabric belt around the waist.

Belbo'o. Waist sash.

Beldemchi. Woman's apron skirt.

Beshmant. Lined, waisted or fitted overcoat, with a stand-up collar or open neck (not quilted).

Beykasam. A half-silk (and usually half-cotton) shiny fabric with fine stripes. Or a light coat made from *beykasam*.

Bilerik. A bracelet.

Bo'o. A band, cord, lace.

Boto kur. A wide silk sash or scarf tied around the waist.

Boy tumar. Large amulet.

Buchkak ichik. A fur coat made from the fur of animals' feet or paws.

Büchülük. Tie at the neck of a tunic dress or shirt. Also big circular metal button.

Büyürmö ton. Pleated overcoat.

Büyürmö köynök. Pleats or gathers (as in a pleated dress).

Büyürmö topu. A pleated skullcap made from white cloth, unlined (worn under a warm head covering).

Chach kap. Embroidered plait holder (lit. hair bag), long and narrow, made from black velvet and decorated with tassels, silver, mother-of-pearl or pom-poms.

Chach kep. Small embroidered bonnet which women wear under the *ileki* (southern Kyrgyzstan).

Chach monchok. Hair ornament, hanging from a woman's plait holder (glass beads, pendants or keys may be hung—they jangle when women walk).

Chach pak. Woollen tassel incorporated into a plait (as a hair decoration).

Chach papik. Plait decoration of Uzbek and/or Tadjik origin, consisting of pom-poms of hair bound with black silk and extended by silver conical ornaments.

Chach üchtük. Plait decoration. Rows of silver pieces interspersed with coral beads. Usually in threes.

Chachvan. Uzbek horsehair veil.

Chalbar. Leather trousers decorated around the bottoms with embroidery.

Chalgai. Gusset.

Chapan. A light quilted overcoat, worn all over Central Asia. Long, with long sleeves which cover the hands.

Charkchi, oromol. Silk or cotton sash from southern Kyrgyzstan, used as a belt.

Charyk, paycheki. Shoes made from uncured hide with a thick sole and low uppers.

Chepken, chekmen. Man's quilted overcoat.

Chi'idan. Shepherd's overcoat made from hand-woven woollen cloth, lined with felt, sometimes made from camel hair.

Chokoy. A coarse shoe.

Cholpu. Silver hair ornaments, hung from a woman's plait(s).

Chyptama. Short-style waistcoat.

Da'aki. An overcoat made from foal's skin with the hair on the outside.

Dambal. Trousers, pantaloons or long-johns.

Djagtak. Man's loose undershirt, similar to *djegde*, worn in southern Kyrgyzstan and still worn by Uzbeks and Tajiks.

Djaka. A collar.

Djakalu'u ton. A rich man's fur coat with a big fur collar.

Djargak shym. Leather trousers.

Djegde. A long blouse worn by older men (without a collar and slit to the navel). Worn in the south and around Talas.

Djekene. Old name for leather belt, mentioned in Manas epic.

Djelburö'öch. Chains.

Djelek. Traditional lightweight, unlined summer coat.

Djez okcho. Metal (usually copper) plate used to reinforce boot heel.

Djigach kepich. Wooden clogs with high-nailed heels, worn in south-west Kyrgyzstan and in the Alai mountains.

Djiladjin. Small bells attached to the feet of hunting birds. Also put in the heel of boots so they tinkle when the wearer walks.

Djo'oluk. A woman's scarf.

Dürüyö. Silk headscarf for women.

Dürüyö keshte. Embroidered silk band or scarf.

Elechek. A white married woman's turban worn in northern Kyrgyzstan (variants known as *ileki*, *kalak*).

Eshme. A decoration made from black wool, attached to a woman's plait to lengthen it. Traditional hair extension.

Etek. Skirt part of *beldemchi*.

Galoshe. Rubber overshoes put on over inner light leather boots (*ma'asy*).

Goul-e keshte. Flower-embroidered silk band or scarf.

Gudmuk. Plait decorations made of coins held together with little straps of leather.

Ich köynök. Underclothes.

Ich shym. Under-trousers, made from white cotton.

Ichik. A fur coat, covered on the outside with fabric.

Ichtan. Wide women's (and men's) under-trousers.

Ileki. A form of *elechek*. A woman's white turban worn in southern Kyrgyzstan. The neck and chin are uncovered.

Iymek. Earrings.

Kalak. Scarf hung over *ileki* or *elechek*, embroidered with multicoloured flowers and bordered by a fringe of red silk.

Kalpak. White felt hat.

Kandagai shym. Men's wide trousers or britches, made from the skin of the wild mountain goat. The old Kyrgyz called trousers made from elk skin or chamois leather *kandagai*. They are referred to in the Manas epic.

Kap takiya. A white skullcap or small bonnet worn by women under the *elechek* in the northern regions (also *bash kap*, lit. head bag).

Kaptama chapan. A covered *chapan*.

Kaptama ton. Covered sheepskin coat.

Kara körpö tebetey. Black Astrakhan hat.

Kayyima djaka. A turned-down collar.

Kebenek, kementai. Shepherd's large felt coat.

Kelteché, chyptama. Waistcoat.

Kementai. An outer garment (overcoat) made from felt in natural wool colours.

Kemer. A belt (sometimes with metal decorations).

Kemsel, kemsal. A man's short-sleeved jacket (down to the elbows). Also *kemzir* or *kamzur*.

Kepich. Leather overshoes put on over *ma'asy*, the light leather boot. Worn before rubber galoshes were introduced.

Keshenyé. Sash.

Keshte. Embroidery, embroidered patterns.

Ki'iz chokoy. Felt boot or *velinky*.

Kimechek. Eighteenth-century Kyrgyz and Kazakh hood for the ceremonial journey the bride makes on horseback on her wedding day.

Körpö. Astrakhan lambskin. See also *kara körpö tebetey*.

Körpö tebetey. Astrakan *tebetey*.

Kour. Belt.

Köynök. A woman's dress or blouse.

Köynök kosh etek. A dress with a gathered or pleated skirt.

Koz monchok. A protection against the evil eye.

Kulun ton. A pelisse made from foal's skin.

Kunduz tebetey. Otter *tebetey*.

Kunu. Foal skin.

Kupu. A fur coat made from the fur of a young camel.

Kushak. Large cloth belt.

Kyrgak. A band of good cloth, usually silk, which encircles the *elechek* (turban). Among rich families, it may be made from linked silver plaques, from which hang silver and coral pendants. Also known as *tartma*, *dürüyö keshte* or *goul-e keshte*.

Kyska ton, cholok ton. A short, sheepskin coat.

Ma'asy or ichigi. Men's or women's boots, with no heels and soft soles, to fit inside galoshes for outside wear.

Malakay. Man's fur hat, without brim but with ear flaps.

Monchok. Beads.

Orus chokoy. Russian felt boot, also called *velinky*.

Orus ton. Russian overcoat.

Ötük. Boot.

Piazy. Brown hand-woven camel's wool cloth.

Piazy chepken. Overcoat made from *piazy*.

Piazy shym. Winter trousers woven from *piazy*.

Postune. Sheepskin fur coat worn in Kyrgyzstan.

Sagak. Coral beads (hung from ear flaps).

Sagak söyköy. The above linked together by a silver chain which passes under the chin.

Sallya. Man's turban.

Sayma shym. Embroidered trousers.

Sayma topu. Embroidered skullcap.

Selde. A man's turban.

Shakek. Ring.

Shökülö. A very old-style headwear for young women. From the second half of the nineteenth century, it became a ceremonial wedding headdress. Conical in form.

Shuru. Coral, a coral necklace.

Shym. Trousers.

Silsila. Woman's frontal jewellery.

Sölköbay. Button, woman's clothing decoration, made from coins known as *sölköbay* or *tselkovyy* (one rouble, from Russian compound word "tselkovyi rouble").

Söyköy. Big conical earrings.

Söyköy djeburöch. Conical shaped earrings, attached to the ears and linked by chains of coral and silver beads hanging across the neck and breast.

Takiya. A young girl's skullcap (usually decorated with plumes from the eagle owl or owl).

Tartma. Cloth band used to secure a woman's turban.

Tay tuyak. Horses hooves fixed to shoes for mountain climbing.

Tebetey. Well-to-do man's hat, with fur trimming. A version is also worn by young girls. The trimming may be fox, otter and so on. See also *tülkü tebetey*, *kyndyz tebetey*, etc.

Teke shym. Goatskin trousers.

Telpek. A simple man's hat, unlined, with a fur border (3–5 centimetres wide).

Tepmé. Thick felt made from lamb's wool.

Tepmé chepke. A felt overcoat, popular among shepherds.

Termé kushak. Large cloth belt.

Tik djaka. A stand-up collar.

Ton. A sheepskin coat or pelisse, where the fur is on the inside, but not covered on the outside with fabric (sometimes made from the fur of other animals).

Töönöruch. An English safety pin or button.

Topchu. Button.

Topu. Skullcap (sometimes decorated on the outside with embroidery or mother-of-pearl).

Tukaba, dukaba. Plush.

Tukaba chapan. *Chapan* made from plush.

Tülkü tebetey. Fox *tebetey*.

Tumak. A Pamir Kyrgyz round hat with earflaps made from sheepskin. Type of *malakay*.

Tumar. Amulet or talisman. Usually a prayer or entreaty written on paper sewn into a cloth triangle. Sewn onto or attached to clothes.

Tu'ura chapan. *Chapan* with straight flaps.

Tu'ura djaka köynök. Dress with a horizontally cut neckline (from one shoulder to the other).

Uzun jaka köynök. Dress with a horizontally and vertically cut neckline.

Ychkyr. Ribbon, braid, lace or plait.

Zirye. Linked chain of silver roubles or money used as a plait extension. Name for earrings in southern Kyrgyzstan.

Bibliography

Abbreviations

S.M.A.E. Collection of the Museum of Anthropology and Ethnography Petra Velikova, Academy of Science, SSSR (Sbornik Muzea anthropology i ethnografii im. Petra Velikogo Akademii nauk SSSR).
T.I.E. Work of the Institute of Ethnography N. I. Miklukho-Maklaya, Academy of Science, SSSR (Trudy Instituta etnografiya im. H. I. Miklukho-Maklaya Akademii nauk SSSR).
K.S.I.E. Short report of the Institute of Ethnography, Academy of Science, SSSR (Kratkiye soobshcheniya Instituta etnografiya Akademii nauk SSSR).
T.K.A.E.E. Work of the Kyrgyz Archaeological and Ethnographical Expeditions, Moscow (Trudy kirgizskoy arkheologo-etnograficheskoy ekspeditsii).
T.Kh.A.E.E. Work of the Khoresm Archaeological and Ethnographical Expeditions, Moscow (Trudy khorezmskoy arkheologo-etnograficheskoy ekspeditsii).

Abramzon 1971
S. M. Abramzon. *Kirgizy i ikh etnogeneticheskiye i istoriko-kulturniye cvyazi* (The Kyrgyz and their ethnogenetic and historico-cultural links). Kyrgyzstan Press, Frunze, 1971.

Abramzon, Antipina, Vasileva, Makhova and Suleymanov 1958
S. M. Abramzon, K. I. Antipina, G. I. Vasileva, E. I. Makhova and D. Suleymanov. *Byt kolhoznikov kirgizskikh selenii Darkhan i Chichkan* (The way of life of Kyrgyz kolhozniks in the Darkhan and Chichkan settlements). T.I.E., T. XXXVII. Moscow, 1958.

Aitmatov 1979
Ch. Aitmatov. *Mother Earth*. Kyrgyzstan Press, Frunze, 1979.

Antipina 1962
K. I. Antipina. *Osobennosti materialnoy kulturny i prikladnovo iskusstva yuznykh kirgizov* (Special features of the material culture and applied arts of the Southern Kyrgyz). Naooka, Frunze, 1962.

Antipina and others 1970
K. I. Antipina and others. *Kirgizia.S.S.R.* Mysl, Moscow, 1970.

Antmambetov 1967
D. Antmambetov. *Kultura kirgizskova naroda vo vtoroi polovinye XIX i nachalye XX veka* (Culture of the Kyrgyz people in the second half of the nineteenth and beginning of the twentieth century). Frunze, 1967.

Arts Traditionnel 1990
Arts Traditionnel en Union Sovietique [Les]. Chêne, Paris, 1990.

Barthold 1956
V. V. Barthold. *Four Studies on the History of Central Asia*. E. J. Brill, Leiden, 1956.

Basilov 1989
V. N. Basilov (edited by). *Nomads of Eurasia.* University of Washington Press, Washington, 1989.

Belitser 1951
V. N. Belitser. *Narodnaya odezhda udmurtov* (Traditional clothing of the Udmurts). Moscow, 1951.

Benningsen and Quequejay 1960
A. Benningsen and Ch. Quequejay. *Les mouvements nationaux chez les musülmans de Russie*. Mouton, Paris, 1960.

Bernshtam 1940
A. N. Bernshtam. *Kenkolskiy Mogilnik* (Kenskol burials). Leningrad, 1940.

Bichurin 1871
N. Ya. Bichurin. *Sobraniye svedenii o narodakh obitavshik v Sredney Azii v drevniye vremena* (Collected information about people living in Cenral Asia in ancient times). St Petersburg, 1871.

Bobrinskoy 1900
A. A. Bobrinskoy. *Ornament gornykh Tadjikov Darvaza (Nagornaya Bukhara)* (Patterns of the Mountain Tajiks of Darvaz). Moscow, 1900.

Brodovskiy 1875
M. I. Brodovskiy. *Tekhnicheskiye proizvodstva Turkestanskom kraye* (Technical production in the Turkestan region). St Petersburg, 1875.

Burkovskii 1957
A. K. Burkovskii. *K voprosu obrabotki jivotnovodcheskovo syrya u kirgizov* (On the question of processing raw animal materials among the Kyrgyz). Frunze, 1957.

Delaby 1981
L. Delaby. "Un chapeau pour toute fortune chez les Kazakhs et les Kirghizes", in *Objects et Mondes*, Autumn 1981.

Djamankaraev 1965
A. B. Djamankaraev. *Razvitie torgovli v Kirgizii v kontze 19 – nachale 20 v.* Development of trade among the Kyrgyz from the end of the nineteenth to the beginning of the twentieth century). Frunze, 1965.

Dor 1975
R. Dor. *Contribution á l'étude des Kirghiz du Pamirs Afghan.* Publications Orientalistes de France, Paris, 1975.

Dor 1982
R. Dor. *Chants du Toit du Monde.* Maisonneuve et Larose, Paris, 1982.

Dor and Naumann 1978
R. Dor and C. M. Naumann. *Die Kirghizen des Afghanischen Pamir.* Akademische Druk-u Verlagsanstalt, Graz, 1978.

Dudin
S. M. Dudin. *Fotoalbom i otchet o poezdkye,* photo album and account of journey kept in the Archive of the State Museum of Ethnography, St Petersburg.

Dunmore 1894
Earl of Dunmore. *The Pamirs, being a narrative of a year's expedition on horseback and on foot through Kashmir, Western Tibet, Chinese Tartary and Russian Central Asia.* 2 volumes, London, 1894.

Dutreuil du Rhins 1898
J. L. Dutreuil du Rhins. *Mission scientifique dans la Haute Asie (1890-1895).* 3 volumes, F. Grenard, Paris, 1898.

Fyelstrup 1925
F. A. Fyelstrup. *Otchet o poezdkye v Srednyuyu Aziyu dlya sbora kollektsii po etnografii kirgizov* (Account of a journey to Central Asia to gather a collection about the ethnography of the Kyrgyz). Leningrad, 1925.

Forde 1934
C. D. Forde. *The Kazak, Kirghiz and Kalmuck: Horse and Sheep Herders of Central Asia,* in Forde, *Habitat, Economy and Society.* London, 1934.

Gadjieva 1975
S. Sh. Gadjieva. *Materialnaya kultura nogaytsev v 19 – nachale 20 v.* (Material culture of the Nogai at the end of the nineteenth and beginning of the twentieth century). Moscow, 1975.

Hambly 1969
G. Hambly. *Central Asia.* Weidenfeld and Nicholson, London, 1969.

Hiuan-Tsang 1884
Hiuan-Tsang. *Si-yu-ki: Buddhist records of the Western World.* Translated from the Chinese of Hiuan-Tsang (A.D. 629) by S. Beal. 2 volumes, Trübner, London, 1884.

Imart 1981
G. Imart. *Le Kirghiz (Türk d'Asie Central Sovietique): description d'une langue de litterisation récente* (with an article by Remy Dor, "Le dialecte pamirien"). Université de Provence, Aix-en-Provence, 1981.

Imart and Dor 1982
G. Imart and R. Dor. *Le chardon déchiqueté (Être kirghiz au 20ème siècle).* Université de Provence, Aix-en-Provence, 1982.

Istoria Kirgizi 1963
Istoria Kirgizi (History of Kirghizia). 2 volumes, Frunze, 1963.

Ivanov 1884
D. L. Ivanov. *Puteshestviye na Pamir* (Journey into the Pamirs). St Petersburg, 1884.

Ivanov 1959
S. V. Ivanov. *Kirgizskii ornament kak etnogeneticheskii istochnik* (Kyrgyz patterns as an ethnogenetic source). T.K.A.E.E., III. Naooka, Frunze, 1959.

Ivanov and Antipina 1968
S. V. Ivanov and K. I. Antipina (edited by). *Narodnoe dekorativno-prikladnoye iskusstvo Kirgizov* (The People's Decorative and Applied Arts of Kyrgyzstan). T.K.A.E.E., V. Naooka, Frunze, 1968.

Jan
M. Jan. *Le voyage en Asie Centrale et au Tibet, anthologie des voyageurs occidentaux du Moyen-Age à la première moitié du XXe siècle.* Robert Laffont "collection Bouquins", Paris.

Kerimzanova 1962
B. Kerimzanova. *Kirgiz Poeziyasinin rifmasi.* Frunze, 1962.

Khudyakov 1982
Yu. S. Khudyakov. *The Kirghiz on the Tabat River.* Novosibirsk, 1982.

Kondratyev 1958
A. A. Kondratyev. "Istoricheskiye svedeniya o kirgizakh v kitayskiye istochnikakh", in *Materialy Pervoy Vsyesoyuznoy nauchnoy konferentsii vostokavedov v Tashkentye* ("Historical information about the Kyrgyz in Chinese sources", in Material of the first all-union scientific conference of Oriental studies in Tashkent). Tashkent, 1958.

Kostyenko 1870
L. F. Kostyenko. *Srednaya Azia i vodropeniye v ney russkoy grajanstvennosti.* St Petersburg, 1870.

Krader 1963a
L. Krader. *Peoples of Central Asia.* Uralic and Altaic Series, 26. Bloomington, 1963.

Krader 1963b
L. Krader. *The Social organisation of the Mongol-Turkic pastoral nomads.* Mouton, The Hague, 1963.

Kuczynski 1925
M. H. Kuczynski. *Steppe und Mencsh. Kirgisiche Reiseeindrücke und Betrachtungen über Leben, Kultur und Frankleitin ihren zusammenhängen,* V, 1925.

Kushelvskii 1891
V. I. Kushelvskii. "Material dlya meditsinskoy geografii i sanitarnye opisaniya Ferganskoy oblasti" (Material on medical geography and sanitary descriptions of Fergana province), in *Novyi Margelan,* T. 2, 1891.

Kyzlasov 1956
L. P. Kyzlasov. *Issledovaniya na Ak-Beshimye v 1953-54* (Research on the Ak Beshim between 1953 and 1954). T.K.A.E.E., II, Moscow, 1956.

Lecoq 1916
A. von Lecoq. *Volkskundliches aus Ost-Turkestan.* Berlin, 1916.

Leeuwen, Emeljanenko and Popova 1995
C. van Leeuwen, T. Emeljanenko and L. Popova. *Nomads in Central Asia.* Royal Tropical Institute, Amsterdam, 1995.

Levshine 1832
A. Levshine. *Descriptions des hordes et des steppes des Kirghiz-Kazaks.* St. Petersburg, 1832 (and Paris, 1840).

Lindisfarne-Tapper and Ingham 1997
N. Lindisfarne-Tapper and B. Ingham (edited

by). *Language and Dress in the Middle East.* Curzon, London, 1997.

Lobacheva 1989
N. P. Lobacheva. "Clothing and Personal Adornment", in V. N. Basilov (edited by), *Nomads of Eurasia.* University of Washington Press, Washington, DC, 1989.

Maillart 1985
E. Maillart. *Turkestan Solo.* Century Hutchinson, London, 1985.

Mair 1993
V. H. Mair. "A Study of the Genetic Composition of Ancient Desiccated Corpses from Xinjiang (Sinkiang), China", in *Early China News*, V.6, Fall 1993, pp. 1–9.

Marco Polo 1993
The Travels of Marco Polo: The Complete Yule-Cordier Edition. Dover Publications, 1993.

Makhova 1959
E. I. Makhova. *Materialnaya Kultura Kirgizov kak istochnik izucheniya ikh etnogeneza* (Material culture of the Kirghiz as a source for studying their ethnogenesis). T.K.A.E.E., III. Naooka, Frunze, 1959.

Makhova 1979
E. I. Makhova. *Nekatorye Elementy Kirgiskovo Natsionalnovo Kostyuma* (Several elements of Kirghiz National Costume), in O. A. Sukhareva. *Kostyum Narodov Sredney Azii.* Naooka Publications, Moscow, 1979.

Maksimov and Sorokin 1986
V. Maksimov and Ye. Sorokin. *The Kirghiz Pattern.* Kyrgyzstan Press, Frunze, 1986.

Meyer 1830
C. A. Meyer. *Reise durch die Soongorische Kirghizensteppe.* Berlin, 1830.

Mukambayev 1976
Z. Mukambayev. *Dialektologicheskiy Slovar kirgizskovo yazikha.* Frunze, 1976.

Nalivkine 1889
V. P. Nalivkine. *Histoire du Khanat de Kokand.* Paris, 1889.

Olufsen 1904
O. Olufsen. *Through the Unknown Pamirs.* London, 1904.

Polosmak 1996
N. Polosmak. "La Prêtress Altaique",

in *Dossiers d'Archaeologie*, no. 212. Paris, 1996.

Potapov 1952
L. P. Potapov. *Odyezhda Altaytsev* (Clothing of the Altai). SMAE, Moscow–Leningrad, 1952.

Potapov 1957
L. P. Potapov. "Iz istorii kochevnichestva" (From the history of shepherds), in *Materialye narodov S.S.S.R.*, 1957.

Prjevalski 1879
N. Prjevalski. *From Kuldja across the Tian Shan to Lobnor.* London, 1879.

Rakmatullin 1968
K. A. Rakmatullin. "The Work of the Manaschi", in *Manas, heroic epic of the Kirghiz people.* Frunze, 1968.

Rickmers 1913
W. Rickmers. *The Duab of Turkestan.* Cambridge University Press, 1913.

Rototayev 1939
A. Rototayev (edited by). *Iskusstvo sovietskoy kirgizii* (Art of the Soviet Kyrgyz). Iskusstvo, Moscow–Leningrad, 1939.

Rudenko 1927
S. I. Rudenko. *Ocherk byta severo-vostochnykh kazakhov basseyna rek Wila i Sagyza* (Essays on the way of life of the north east Kazakhs of the Wil and Sagyz Basin). Kazakstankaya, Leningrad, 1927.

Ryndin 1943
M. V. Ryndin. *Kirgizskii uzor* (Kyrgyz pattern). Frunze, 1943.

Scarce 1987
J. M. Scarce. *Women's costume of the Near and Middle East.* Unwin Hyman. London, 1987.

Scarce 1995
J. M. Scarce. "Continuity and modernity in the Costume of the Muslims of Central Asia", in Shirin Akiner (edited by), *Cultural Change and Continuity.* Kegan Paul, London, New York, 1995.

Schuyler 1877
E. Schuyler. *Turkestan: Notes of a Journey in Russian Turkestan, Khokand, Bukhara and Khuldja*, 2 vols. Sribner, Armstrong and Co, New York, London, 1877.

Semenov-Tyan-Shanskii 1946
P. P. Semenov-Tyan-Shanskii. *Puteshestviye*

v Tyan-shan v 1856-1857 (Travels in Tien-Shan between 1856–1857). Moscow, 1946.

Sher 1966
Ya. A. Sher. *Kamennye uzvayaniya Semi rechya.* Moscow–Leningrad, 1966.

Shibayeva 1956
Yu. A. Shibayeva. *Materialy po odezhdye murgabskikh Kirgizov* (Material about the clothing of the Murgab Kyrgyz). K.S.I.E. Archive, 1956.

Slobin 1969
M. Slobin. "Kirgiz instrumental music", in *Society for Asian Music* XIV. New York, 1969.

Smeshko 1979
T. N. Smeshko. "Tkani v odezhdye Kirgizov (vtoraya polovina XIX – nachalo XX V)" (Weaving in Kirghiz clothing from the second half of the nineteenth century to the beginning of the twentieth century), in O. A. Sukhareva (edited by), *Kostyum Narodov Sredney Azii.* Naooka publications, Moscow, 1979.

Sukhareva 1957
O. A. Sukhareva. *Drevniye cherty v formakh golovnikh uborov narodov Srednei Azii* (Ancient features in the form of Central Asian headwear). Moscow, 1957.

Sukhareva 1979
O. A. Sukhareva (edited by). *Kostyum Narodov Sredney Azii* (Costumes of the peoples of Central Asia). Naooka Publications, Moscow, 1979.

Sychova 1984
N. Sychova. *Traditional Jewellery from Soviet Central Asia and Kazakhstan.* Sovietsky Khudozhnik Publishers, Moscow, 1984.

Tolstov and others 1962–1963
S. P. Tolstov and others. *Narody Srednei Azii i Kazakhstana* (Peoples of Central Asia and Kazakhstan). 2 vols, Moscow, 1962–1963.

Vainshtein and Kryukov 1966
S. I. Vainshtein and M. V. Kryukov. "Ob obliky drevnix Tyurkov", in *Tyurkologicheskiy sbornik* (About the appearance of the Ancient Turks, in Turkological Collections). A. N. Kononova, Moscow, 1966.

Vainshtein 1991
S. I. Vainshtein. *Mir Kochevnikov Tsentral*

Azii (The World of Nomads in Central Asia). Naooka, Moscow, 1991.

Valikhanov 1985
Ch. Valikhanov. "Kirghiz Weaponry in Ancient Times and their Martial Armour", in *Sobranie Sochinenija*, vol. 4. Alma-Ata, 1985.

Vambery 1873
A. Vambery. *Travels in Central Asia*, 1873.

Vereshchagin 1974
V. V. Vereshchagin. "Albom Turkestan" (Turkestan Album), in V. V. Vereshchagin, *Etyudy s natury* (Studies in Nature). St Petersburg, 1974.

Vertkov and others 1963
K. Vertkov and others. *Atlas muzykal'nykh instrumenta narodov S.S.S.R. gosmuzizdat* (Atlas of musical instruments of the people of the Soviet Union). Moscow, 1963.

Vinik 1963
D. F. Vinik. *Tyurkskiye pamyatniki Talasskoy doliny* (Turkic monuments of the Talas Valley). Frunze, 1963.

Vinogradov 1958
V.S. Vinogradov. *Kirgizskaya narodnaya muzyka* (Kyrgyz popular music). Kirgizgosidat, Frunze, 1958.

Wardell 1961
J. W. Wardell. *In the Kirghiz Steppes (voyage 1914–19)*. London, 1961.

Yudakin 1965
K. K. Yudakin. *Kirgizskovo-russkii slovar* (Kyrgyz-Russian dictionary). Sovietskaya Entsiklopediya, Moscow, 1965.

Zagryadskii 1874
G. C. Zagryadskii. *Kara-Kirgizy. Etnograficheskii ocherk* (The Kara-Kirgiz. Ethnographic essay). Turkstankiye vedomosti, 1874.

Zakharova and Khodjaeva 1963
I. V. Zakharova and R. D. Khodjaeva. *Kazakhskaya natsionalnaya odyezhda (19 – nachalo 20 V.)* (Kazakh national dress, nineteenth century to early twentieth century). Alma-Ata, 1963.

Zaleski 1865
B. Zaleski. *La vie des steppes Kirgizes (About Kazakhs in 1860s)*. Paris, 1865.

Zataevich 1934
A. V. Zataevich. *Kirghizkiye instrumetalnye poezi i napevy* (Kyrgyz instrumental poetry and tunes). Moscow, 1934.

Zhdanko 1959
T. A. Zhdanko. *Narodnoye ornamentalnoye iskusstvo Karakalpakov. Materialy i issledovaniya po etnografi karakalpakov* (Popular ornamental art of the Karakalpaks. Studies of Karakalpak ethnograpy). T.Kh.A.E.E. 3, Moscow, 1959.